Also by James Craig

Designing with Type:
A Basic Course in Typography

Production for the
Graphic Designer

Phototypesetting:
A Design Manual

Thirty Centuries
of Graphic Design

By James Craig

GRAPHIC DESIGN CAREER GUIDE

Watson-Guptill Publications

*Dedicated to everyone
who has read my books and
still can't find a job!*

Copyright © 1983 by James Craig

First published 1983 in New York by
Watson-Guptill Publications,
a division of Billboard Publications, Inc.,
1515 Broadway, New York, N.Y. 10036

**Library of Congress Cataloging
in Publication Data**
Craig, James, 1930–
 Graphic design career guide.
 Bibliography: p.
 Includes index.
 1. Commercial art—Vocational guidance—United States.
I. Title.
NC1001.C72 1983 741.6'023'73 82-25916
ISBN 0-8230-2151-3

Distributed in the United Kingdom by
Phaidon Press Ltd., Littlegate House,
St. Ebbe's St., Oxford

Manufactured in U.S.A.

7 8 9 10 11 12/96 95 94 93 92 91

Edited by Betty Vera
Designed by James Craig
Graphic Production by Ellen Greene

ACKNOWLEDGMENTS

As I write these acknowledgments, I can't help thinking about the speeches made by the Oscar winners at the annual Academy Awards Presentation. While they express their gratitude to everyone who helped to make their films a success, they also apologize in advance to all the people they may have forgotten to thank. Keeping this dilemma in mind, I shall now try to thank everyone who has made my lot a little easier during the past two years.

I would like to begin by thanking the twenty-one graphic designers who graciously share their early job-hunting experiences with the readers of this book: Ed Benguiat, Betty Binns, Pieter Brattinga, Aaron Burns, Cipe Pineles Burtin, Seymour Chwast, Dave Epstein, Lidia Ferrara, Colin Forbes, Adrien Frutiger, Allen Hurlburt, Walter Kaprielian, Jim Miho, Tobias Moss, Alan Peckolick, Ed Rondthaler, Gordon Salchow, Eileen Schultz, Jack Tauss, Weingart, and Henry Wolf. Their stories are both touching and inspirational.

Next, I would like to express my gratitude to the graphic designers, advertising agencies, and companies who gave me permission to reproduce their work. Their names are listed throughout the book and in the Credits.

I am grateful to those who took the time to read sections of the book and offer valuable advice: Dean Edward Colker of the State University of New York at Purchase, Klaus Schmidt of Young & Rubicam, Inc., Lily Silipow of Ace Repping Company, John Noneman of Noneman and Noneman, and Anne-Marie Widner-Sumner of The Cooper Union.

I owe thanks to Ned Melman, who—in three short minutes—reorganized the entire book and rejected my original jacket design. This added to my labors but resulted in a better book. I am also grateful to Betty Vera, who took over the editorial chores at a very critical stage, and to Eli Kince for his help with both the design and content.

I also owe a special debt of gratitude to two friends who gave more than any author has the right to ask: William Bevington and Jane Eldershaw. They have read and reread every word so many times that they can probably recite the entire book by heart. In their case, the cliché is really true: "Without their help, the project never would have been possible."

Finally, I apologize to anyone I might have forgotten!

CONTENTS

PREFACE

Getting started in the field of graphic communications is no less difficult today than it was for my generation in 1946, right after World War II. However, I think there are many more opportunities for the beginner today than there were in 1946. At that time there was no such field as graphic communications as we know it today; graphic design was then called advertising design, and designers normally got jobs with advertising agencies, studios, publishers, and other segments of the graphic arts industry. Television was just getting started, and there were hardly any corporate design departments at that time.

In one way, the field was similar to what it is today, for new horizons were opening up everywhere for creative people—and if you were fortunate enough and had the vision to position yourself in the right place at the right time, you could have almost controlled the direction of your future. And that is exactly what many of us did.

The same is true today, only more so, because of the enormous creative possibilities that the new communications technologies offer the aspiring graphic designer. Everywhere you look, you see new ways to do things, new methods of solving problems—computer graphics, digitized typography, color scanners, and so forth. All of these technical developments make possible finer-quality results, with less labor and expense than ever before. This is indeed a time for learning.

In the United States today, we are competing with countries all over the world for trade, for new products, for economic leadership, for survival. It has been said that by the year 2000, the largest industry in the United States will be the communications industry. And that is the industry that we as graphic designers will be part of. It is now being created by scientists and engineers. It will remain to be shaped by artists and graphic designers. Technology cries out for art.

Aaron Burns, President,
International Typeface Corporation

INTRODUCTION

Graphic design is the art of visual communication; its primary function is to communicate a message or promote a product or service.

Graphic design is a new name for an old art whose origin can be traced to the prehistoric images found on the walls of caves. These symbols represent man's earliest attempts to communicate a message visually, which is the essence of graphic design.

The term *graphic design* was first coined during the early part of this century and referred to images that were written, printed, or engraved. As technology advanced, the art of graphic design also expanded to accommodate images that were not only printed but projected (film), transmitted (video), and generated (computer). Along with these changes came a new and broader meaning to the term *graphic design*.

To choose a career in graphic design is to become a part of a profession which over the centuries has been practiced by artisans, scribes, printers, and commercial artists. Today, it is you, the graphic designer, who carries on this tradition.

Art created by some early practitioners of graphic design.

1. Prehistoric cave dwellers.
2. Johann Gutenberg.
3. Benjamin Franklin.

1

2

3

Career. 1a: course, passage **b:** full speed or course of activity **2:** encounter, charge **3:** a field for or pursuit of consecutive progressive achievement especially in public, professional, or business life **4:** a profession for which one trains and which is undertaken as a permanent calling.

Graphic. 1: formed by writing, drawing, or engraving **2a:** marked by or capable of clear and lively description or striking imaginative power **b:** sharply outlined or delineated **3a:** of or relating to the pictorial arts **b:** of, relating to, or involving such reproductive methods as those of engraving, etching, lithography, photography, serigraphy, and woodcut **c:** of or relating to the art of printing **d:** relating or according to graphics **4:** of, relating to, or represented by a graph **5:** of or relating to the printed word or the symbols or devices used in writing or printing to represent sound or convey meaning.

Design. 1: a mental project or scheme in which means to an end are laid down **2a:** a particular purpose held in view by an individual or group **b:** deliberate purposive planning **3:** a deliberate undercover project or scheme **4:** a preliminary sketch or outline showing the main features of something to be executed **5:** an underlying scheme that governs functioning, developing, or unfolding **6:** the arrangement of elements that go into human productions, such as art or machinery **7:** a decorative pattern.

CAREERS IN GRAPHIC DESIGN

The graphic design field is so diverse that most people have difficulty understanding just what careers are available. They often see graphic design in terms of end products, such as books, ads, posters, stationery, logos, TV commercials, and so on.

A better approach is gaining an understanding of the major segments of the industry (such as publishing, advertising, and corporations) or areas of specialization (such as packaging, exhibition design, and computer graphics) and then deciding which one is most appealing and best suited to your talents.

ADVERTISING

Advertising is a fast-paced, dynamic business, and if you're that type of person you will feel right at home on "Madison Avenue." If you are talented, ahead of the competition, and if making money is one of your main goals, then consider advertising. Of all the career choices discussed in this chapter, advertising pays the best.

There are a number of reasons why advertising is able to pay so well. One is that, comparatively speaking, the cost of design is a small part of the overall budget. When an advertiser pays tens of thousands of dollars to run an ad once in a national magazine, or hundreds of thousands of dollars for a 30-second TV commercial, the creative fee has to seem like a bargain! This is not the case in publishing, where the designer's fees and type costs represent a much larger part of the budget.

Because clients are always changing agencies, job security can be a problem. For example, if you work for a small agency and are assigned to an account, everything is fine while the client likes what you are doing and the sales figures are up. However, if the client decides someone else can do a better job, the account will simply be moved to another agency. This may not be a problem in one of the larger agencies; if they like your work, they will merely assign you to another account. However, if the agency is small and the ex-client represented a considerable portion of its income, it's probably immaterial how much the agency liked you or your work; you'll probably find yourself on the avenue, portfolio in hand, looking for a job.

Some people feel that advertising is for the young; you have a few good years and if you don't excel you are put out to pasture—a little like professional sports. There are, of course, those who do succeed over the long haul, both artistically and monetarily. Some even go on to form their own agencies.

Print and Broadcast

The advertising industry can be broken down into two main categories: print and broadcast (TV and radio). Print involves everything that is printed, such as magazine ads, posters, and point-of-purchase displays. Broadcast involves television and radio commercials. It is possible for one to be involved in both print and broadcast.

Who's Who in Advertising

In an advertising agency the account executive is the liaison between the agency and the client. The account executive, who generally has a background in marketing and advertising, works with the client to determine the campaign strategy. When this has been decided, the account executive sits down with the creative director, art director, and copywriter to develop the campaign. The art director handles the layouts, the copywriter writes the copy, and the creative director is responsible for the overall project.

There are a number of people in an agency whose job it is to support the art director. The assistant art director, for example, develops the layouts or storyboards further. Finished layouts (also called comprehensives, or comps) may be refined by a rendering artist. The type director helps with the typeface selection and marking up the copy for typesetting. The mechanical artist is responsible for everything from pasting up stripping guides for the camera to preparing mechanicals for print advertising.

If the job is approved by the client, the art buyer sees that the right illustrator or photographer and models are hired and prepares the final artwork for reproduction. The print producer works with the production department (or printer) to ensure that the printed piece, such as a magazine or newspaper advertisement, is properly produced. If the job happens to be a TV or radio commercial, the TV or radio producer handles the production.

1. Ad reduced to its essentials; dramatic shot of product with a simple headline.

2. Coca-Cola ad from the early twenties still looks good today; attractive illustration with short copy and bold product name.

3. Frequently used design approach: large, attention-getting photograph with body text below.

4. In this ad, concept is the key ingredient. Bob Gill's ad for a private secretary proves you do not always need a large budget to create a successful design.

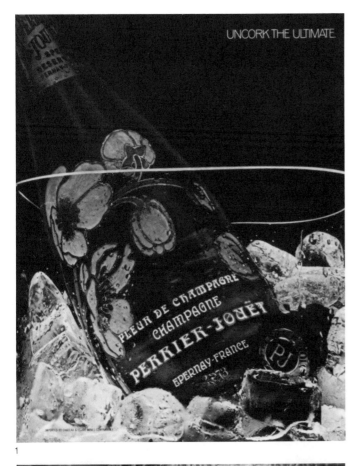

UNCORK THE ULTIMATE.

1

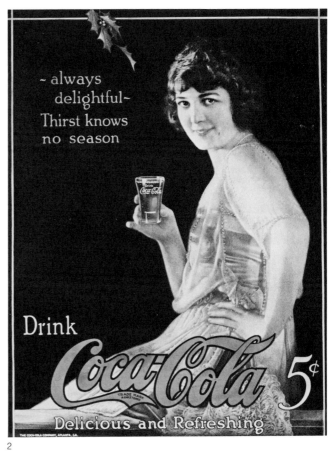

~ always
delightful ~
Thirst knows
no season

Drink

Coca-Cola 5¢

Delicious and Refreshing

2

Drive yourself today
and tomorrow you may not have to.

There's a lot to be said for hard work. It's the straightest route to the top and all the perks that go with success.

And it can be downright fun when you're out there testing yourself against the best and the brightest.

The nice thing is, you don't have to hide your ambition under a bushel. Now you can

be out in the open about your drive. That's what the fast track is all about.

If you're driving hard for success, your basic business reading has to be Fortune.

It's the authority. The last word. The source you rely on when you've just got to get it right.

Fortune helps the movers and shakers

decide how to move and what to shake. It's where you get a vital couple of steps on the competition. In marketing, the economy, technology, everything.

It's how to make it. And keep it.

Which means that for advertising to the fast-track people, no other magazine comes close to Fortune.

FORTUNE
How to succeed.

3

private
secretary
....
CBS television

4

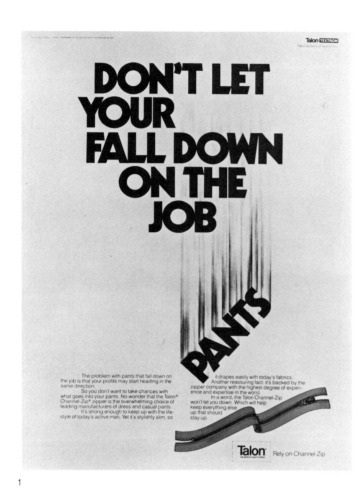

1

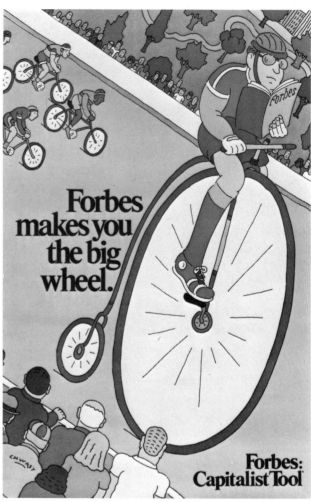

2

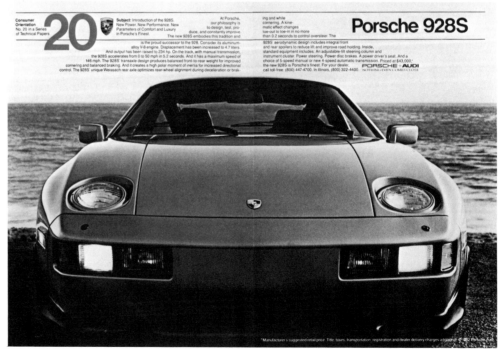

3

1. Humor can be an important element in advertising. Here the type is also used to illustrate the message.

2. Illustrations can make effective ads. This ad is one of a series by Seymour Chwast for *Forbes* magazine.

3. In the highly competitive automotive industry, agencies strive to make their products look attractive and capture the reader's imagination. This Porsche ad succeeds on both levels.

4. Television ads are first developed on a storyboard, which shows the images and dialogue in their proper sequence. The storyboards are shown to the client for approval.

5. After the commercial is shot, a photoboard is made as a record.

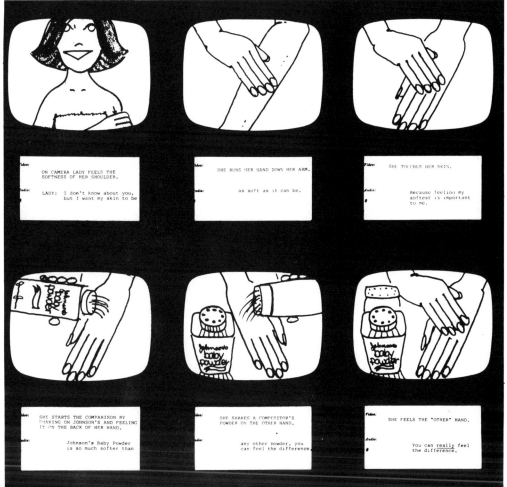

4

5

AUDIO-VISUAL PRESENTATIONS

If your design interests tend toward photography and you enjoy working with projectors, sound equipment, tape decks, amplifiers, and computers, you may wish to pursue a career in audio-visual presentations.

Audio-visual presentations, or AV's, have come a long way from the familiar slide show with a single projector. Today, an effective presentation is more apt to be a multi-projector and multi-screen spectacular involving pre-recorded narration, music, and sound effects, all controlled by a computer. Some presentations even include film or video segments.

There are five basic steps involved in the actual production of major audio-visual presentation. First, there's the writing and design of the visuals, which should be developed in close harmony with the client. Second, there is the preparation of the artwork and photography. Third, there is the selection and arrangement of the music and narration, which must be recorded and mixed on the sound track. Last is the programming, which is the writing into a computer of a set of instructions that will command the projectors to perform as directed.

One of the challenges for the designer in audio-visual presentations is proper pacing. While books and AV's can present the same information, they differ greatly in the way they interact with their audience. Unlike reading, where the individual has control over the pace at which the information is read—and also the place where it is to be read—in audio-visuals, the designer controls the images, their sequence, and the pace at which they are presented. Therefore, the designer must know just how much time should be spent on each image in order to inform and educate the slower viewer without boring the faster or more intelligent viewer.

If you are interested in a career in audio-visual presentations, you will find that an understanding of film and video is important, as they involve the creation of art in space and time. A course in book design may also be helpful in understanding the organization and presentation of material.

As the field of audio-visual presentations is continually expanding and diversifying, you will find that the career possibilities are unlimited.

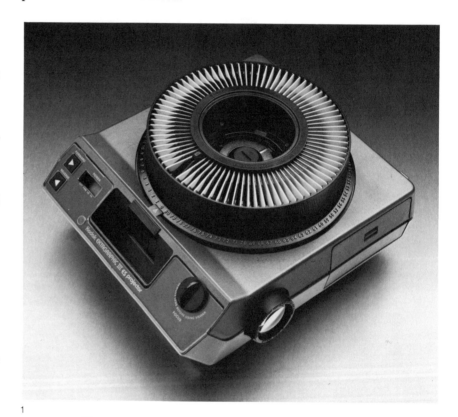

1

2

3

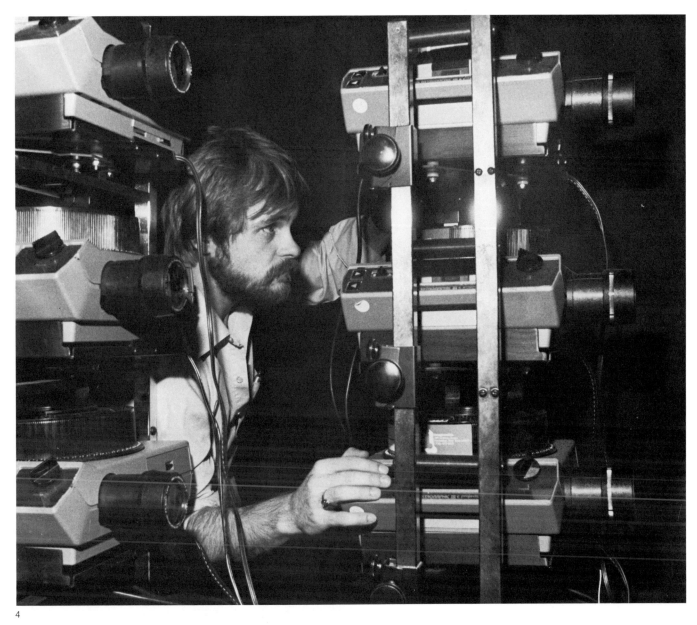

4

5

1. Standard projector used for audio-visual presentations, the Kodak Ektagraphic is a heavy-duty Carousel.

2. Double lamp socket carries two bulbs in case one burns out.

3. Combining motion pictures with your presentation can be effective.

4. Multi-image presentations can create a spectacular effect: Kodak once put on an elaborate show with 120 projectors.

5. Dissolve control can be used to create unusual effects: freeze-frame, animation, superimposition, dramatic flash, as well as dissolves.

BOOK PUBLISHING

Book publishing represents one of the largest employers of graphic designers; each year approximately 45,000 books are published.

Although book publishing represents one of the lower-paying areas of graphic design, there are compensations. For example, there is the satisfaction that comes from being part of the long tradition of book design, which you won't find in other jobs. Books have greater permanency compared with ads and other printed matter. If you enjoy books, you will undoubtedly enjoy working with publishers, authors, and editors. Also, you will probably find that a well-run publishing house offers a less pressured atmosphere than an advertising agency.

The book publishing industry classifies publishers according to subject matter or field of activity. The problem with classifying by subject matter is that there are just too many subjects! For us, the more useful classification is according to fields of activity, which break down as follows:

Association presses
Bibliographies
Braille
Calendars and posters
Directories
Encyclopedias and dictionaries
Fine editions
Foreign-language publishers
General trade book publishers
Hardcover reprint publishers
Large print book publishers
Maps, atlases, guides
Paperbound books
Programmed learning and multi-
 media
Reference book publishers
Scholarly
Subscription and mail order
Textbooks—elementary ⎫
Textbooks—secondary ⎬ Elhi
Textbooks—college ⎭
University presses

One category that may require an explanation is general trade book publishers. Trade books are books published for the general public, such as novels, cookbooks, juvenile (children's) books, art books, and books on graphic design.

Book Design

Although books are published during one of two seasons: Spring/Summer and Fall/Winter, design and production of books continue throughout the year.

Book design encompasses an extremely broad range of formats, from simple novels to complex scientific manuals. You have only to walk into the nearest bookstore to see the work done by book designers. Perhaps the best way to understand book publishing is to follow a manuscript through its various stages of development.

Before a book can be published, the cost of producing it is estimated, based on the number of manuscript pages, the number and type of illustrations, how they are to be printed, and the costs of typesetting, paper, printing, and so on. Once the publisher knows the cost, the selling price can be determined.

Only after the book is completely written, edited, and the specifications determined, will the job be handed over to the designer. It is the designer's responsibility to take the manuscript and illustrations and make them fit the publisher's specifications. To do this the designer determines the total number of typewritten characters in the manuscript by a method called copyfitting. Next, a typeface is chosen and a design is made, based on a grid. (A grid is a plan for laying out the type and illustrations on the printed page.) The challenge of the book designer is not simply to make all the elements fit, but also to create an attractive, well-organized, and readable book.

Book Jackets

While the design of the book itself is generally the responsibility of an in-house designer, book jackets, or dust covers, are often designed by freelance designers. One reason is that book design and jacket design employ different skills. The book designer usually deals with type and illustration in a rather quiet manner, while the jacket designer concentrates on creating a design that will attract attention. The jacket is really a small poster. A second reason is that greater diversity in jacket design can be achieved by using a wide range of freelance designers.

1

2

3

4

1. Publishers' catalogs are good sources of information.

2. Grids are used as positioning guides for type and illustrations. Shown here is the grid for this book.

3. Layout, or dummy, of the following spread shows type and illustrations laid out.

4. Mechanical, or paste-up, shows all elements in position and ready for the printer.

1

2

3

Some jackets, however, do remain in-house. There are several reasons for this: the budget may not be adequate to pay a freelance designer, an outside designer may have failed to come up with an acceptable solution, or the art director may like a particular book and want to design the jacket.

Who's Who in Book Publishing

Book publishing companies vary in size: some are divisions of larger companies, while others are small, privately owned companies. How the company is run and how the job titles are used varies from one company to another.

The department of most interest to the graphic designer is the editorial department. At the head of this department is the editor-in-chief, who may also be called editorial director or some similar title, who is responsible for the content and quality of the books produced. There is also the managing editor, who makes sure that everything gets done on schedule and within the budget.

Then there are editors on various levels—with titles such as associate editor, senior editor, editor, assistant editor, and editorial assistant—who are responsible for the acquisition, development, and editing of the books. Editors work with the authors to ensure that the manuscripts are well-written and properly organized. Editors also work closely with both the art and production departments to make sure books are produced as planned.

After the manuscript has been edited, a production or copy editor goes over it one last time to make sure it is acceptable in terms of style, grammar, and spelling. After the book has been designed, the production manager sees that it is properly printed.

Not all designers in publishing houses are responsible for book design; some specialize in promotion, which involves the preparation of ads, brochures, catalogs, and other mailing pieces designed to promote the sale of books. These designers usually report to a promotion manager.

1. Rough layout of book jacket for preliminary approval of concept. Design by Wendell Minor.

2. After approval, the designer makes a tight comp, taking all suggestions into consideration.

3. Note the refinements in the printed jacket.

4. Strong typographic approach; bold, condensed type gets attention. Design by Jurek Wajdowicz.

5, 6, 7. Three jacket designs by Chermayeff & Geismar Associates give an indication of the variety of concepts and materials possible in book-jacket design.

5

6

4

7

COMPUTER GRAPHICS

Computer graphics is the art of combining the computer's unique capabilities with the TV screen to produce everything from simple charts to complex visual images. This is one of the fastest-growing fields in American industry. It is predicted that in the twenty-first century, information processing will be the major U.S. industry. Computers and computer graphics will be a major force in that industry.

If you love computers and want a stake in the future, study computer graphics, attend computer graphics conferences, and follow the new computer graphics publications. If computers intimidate you, just take the advice of an industry spokesperson: "You don't have to know how an engine works to drive a car, and you don't have to know how a computer works to operate one."

Computers can be used to create charts, graphs, animation, illustrations, and abstract or surreal images. You can also feed a simple drawing into the computer and it will memorize the structure in 3-D and reproduce it from all angles. If you want color, that too can be added.

The computer, however, will *not* replace the graphic designer. Computers simply offer the designer another tool to expand the possibilities of mind and eye. They can be programmed to assist the designer with everyday problems such as book, magazine, and typographic design. The designer can study a wide range of solutions and choose the one that best solves the problem.

In the past many of the people involved in computer graphics came from schools of engineering and computer science. Today, more and more graphic designers are discovering the potential of computer graphics. This is healthy because engineers bring to computers the necessary technical training but lack the artistic background to exploit the system's creative potential.

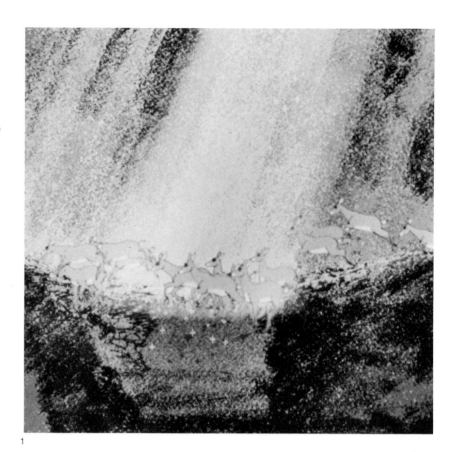

1

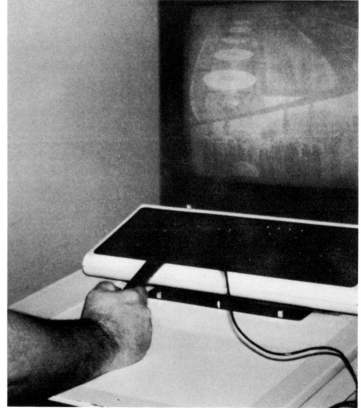

2

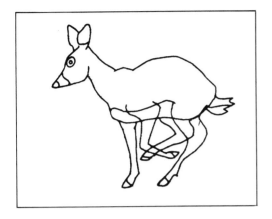

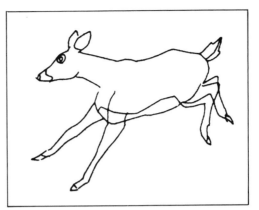

Computer graphics have captured the imagination of graphic designers around the world. On this spread is shown an animated sequence of deer leaping.

1. The image of the deer leaping through a glade is a composite of leaping deer and a painted background done by computer.

2. Designer works on an electronic tablet using a "pen" or "wand" as if it were a pencil or brush. As the designer draws, the images appear on the screen above.

3. Artist draws first and last stages of the deer leaping and the computer creates the intermediate stages. Drawings can then be used to create new scenes.

4. Color is added by defining the area with the "pen" and specifying the color as a percentage of the four process colors (red, yellow, blue, and black). The computer does the rest. Well over one million colors are available.

The animation sequence shown on this spread was developed by The Japan Computer Graphics Lab in cooperation with the New York Institute of Technology Computer Graphics Laboratory.

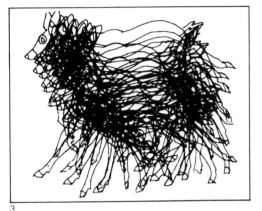

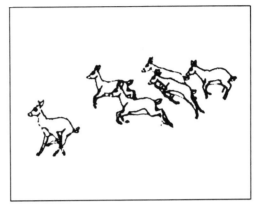

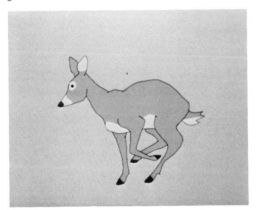

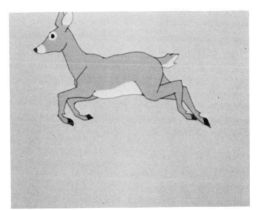

3

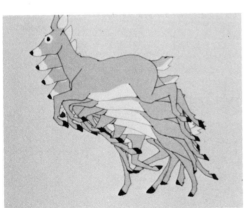

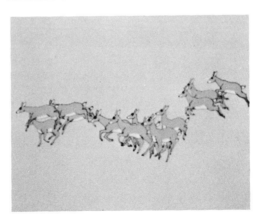

4

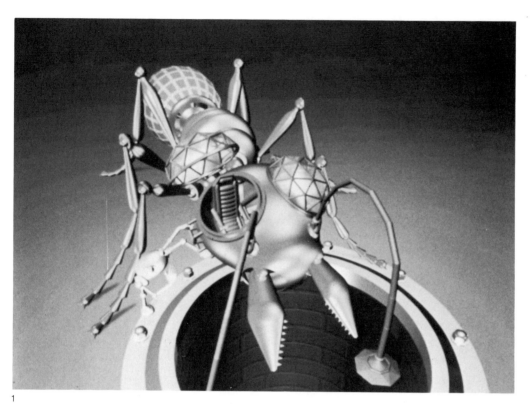

1

1, 4. Computers may serve as an excellent aid to illustrators. Time is reduced and opportunity to experiment is increased. The Ant (1) is by Dick Lundin and Saxobone (4) is by Lance Williams and Dick Lundin. Both courtesy the New York Institute of Technology's Computer Graphics Laboratory.

2. Globe divided into segments, each containing moving pictures of world events. Developed for NBC by Digital Effects, Inc.

3. Space-travel imagery lends itself to computer graphics, which can create anything from a spaceship hurtling through space to a client's product spinning around on the TV screen. Courtesy Digital Effects, Inc.

5. Computer graphics are at their finest when handling complex information in the form of charts, graphs, or illustrations like the one shown here by Nigel Holmes for Time, Inc.

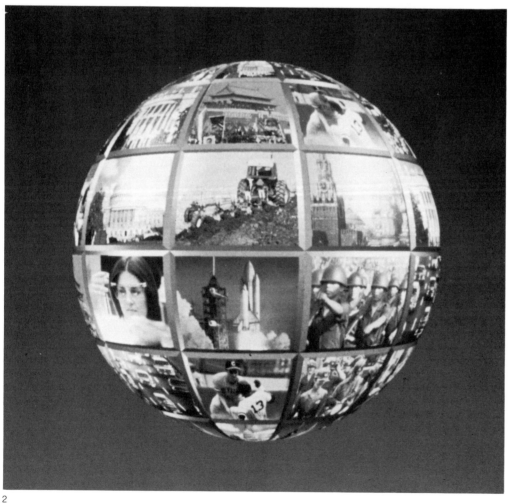

3

4

5

CORPORATIONS

Most people generally do not think of corporations when they are considering careers in graphic design, yet every major company has a graphic design department. Some corporations—such as IBM, Container Corporation of America, and Xerox Corporation—have exceptional graphic design departments and take great pride in their design programs.

The design work varies with the company. Large companies are more apt to take on major projects, such as creating a new corporate image, packaging, signage, and so on. Smaller companies, with smaller design staffs, limit themselves to such things as the redesign of stationery and in-house bulletins. For larger jobs they are more likely to hire a graphic design consultant (see Corporate Design, page 28).

Among the advantages of working for corporations is the sharing of company benefits: paid vacations, medical plans, sick or maternity leave, profit sharing, savings and pension plans, and so on. Salaries are competitive with what designers earn for comparable jobs, probably more than in publishing and less than in advertising.

For those who prefer to work in suburbia, a job with a corporation may be ideal. During past years a number of major industries have left the large cities to relocate in more rural areas, usually not too far from a large city.

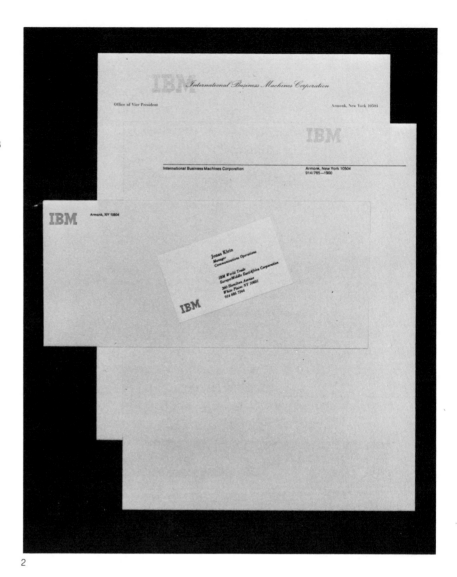

2

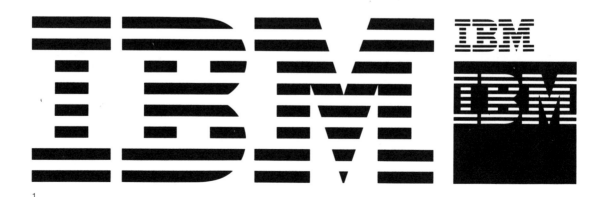

1

3

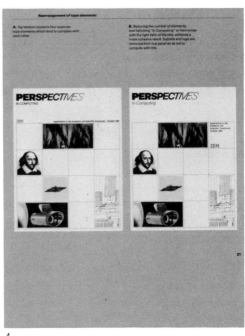

4

On this spread are a few examples from a single corporate design program. Courtesy of IBM.

1. The logo is a key part of any corporate design program, and must communicate clearly in all sizes. The IBM logo was designed by Paul Rand.

2. Stationery design, including business card.

3, 4, 5. Cover and two inside pages of a design guide that explains how the logo is to be used in applications such as publications, packaging, and signage.

6. Cover design for the annual report.

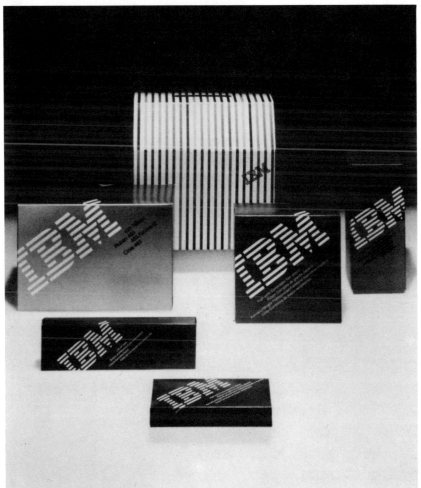

5

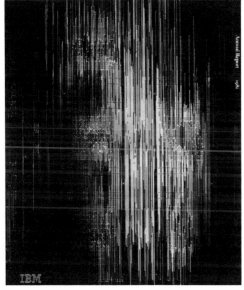

6

CORPORATE DESIGN

Most corporations do not have large graphic design departments, and so if they decide to update their graphics or develop an entirely new image, they usually call in a graphic design consultant who specializes in corporate design. Jobs of this type could mean redesigning the stationery or developing an entire corporate identity program that covers everything from a new logo to outdoor graphics.

Working on corporate identity programs can be demanding; it is time-consuming and can be very expensive, depending on the scope of the project. The design of the logo alone may involve doing dozens of subtle variations of a single design before coming up with one that is acceptable.

The type of graphic designer suited to this field is usually a person with a strong interest in pure graphics, that is, one who loves design theory, solving problems, working with symbols, and developing logos, along with a strong sense of organization in order to coordinate all the diverse elements into a single workable program. As corporate design involves working with management and executives, it is very important that the designer be capable of communicating with them. It also helps to have a thorough knowledge of production techniques to ensure that the job will be completed according to specifications.

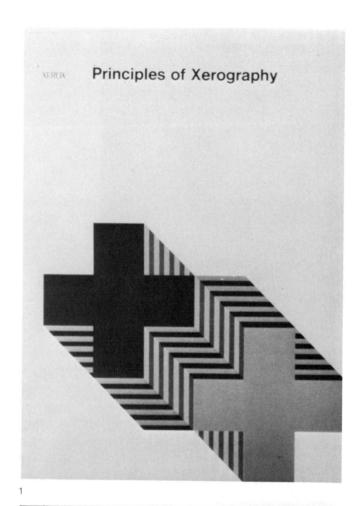

1

2

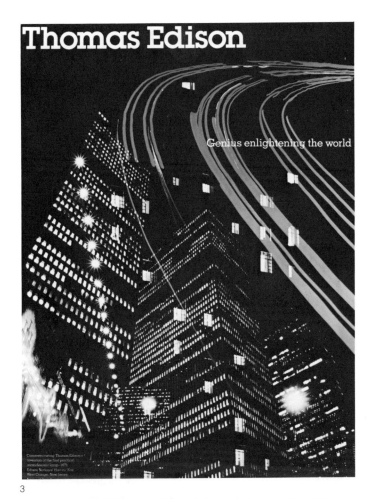

Thomas Edison

Genius enlightening the world

Commemorating Thomas Edison's
invention of the first practical
incandescent lamp—1879.
Edison National Historic Site
West Orange, New Jersey

3

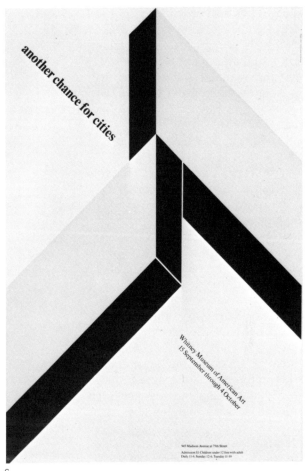

another chance for cities

Whitney Museum of American Art
15 September through 4 October

945 Madison Avenue at 75th Street
Admission $1 Children under 12 free with adult
Daily 11-6, Sunday 12-6, Tuesday 11-10

6

THE PORT AUTHORITY
OF NY & NJ

4

5

Corporations prefer a clean,
efficient look in their graphics.
This is reflected in their bulletins,
brochures, and annual reports.

1. Booklet published by Xerox
Corp. to explain the principles of
xerography. Designed by Joe
Watson.

2. Another Xerox publication
designed by Chermayeff &
Geismar Associates.

2, 3. Two corporate bulletins
designed by Chermayeff &
Geismar Associates.

4. Designing a logo is only a
part of the job; it must be ap-
plied effectively to everything
from stationery to trucks.

5. Graphic designers often
require the services of specialists.
This logo was developed by Alan
Peckolick but hand-lettered by
Tony Di Spigna.

6. Patricia Noneman's strong
diagonal arrangement and
minimal elements combine to
create a strong poster design
for the Whitney Museum of
American Art.

DESIGN STUDIOS

Design studios vary in size and in the services they offer. Some consist of a few designers doing book or magazine design, while others are as large as advertising agencies and handle everything from annual reports and corporate graphics to major exhibitions. The average studio has an art director/owner and perhaps a half-dozen assistants.

One of the great advantages of studio work is the wide variety of jobs that come across your drawing board; one week you can be working on a book design, the next a poster, and the following week an annual report.

Because staffs are generally small, you are close to the decision-making process and, at times, the client. This offers an excellent opportunity to learn a great deal about the graphic design business in a short time. To succeed you must be versatile and dependable. This is not the place for a nine-to-five mentality; deadlines must be met, even if it means working nights and weekends.

Salaries depend a great deal on the size of the studio and the type of work it does. If it's book design, you cannot expect to earn as much as you would working for a studio specializing in advertising or corporate graphics.

1

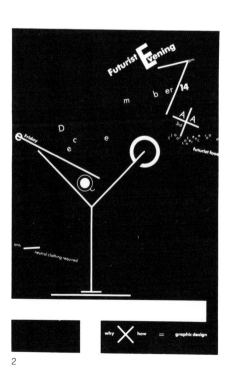

2

3

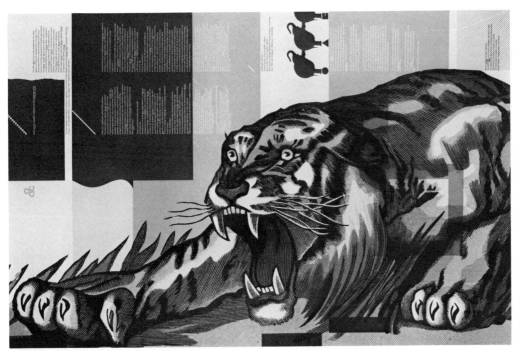

4

5

6

Design studios offer a wide range of creative opportunities.

1. Most annual reports are done by studios that specialize in this particular graphic design area.

2. Announcement for a futuristic evening designed by Eli Kince reflects both an era and a party mood.

3, 6. Seymour Chwast's illustrations bring a sense of joy and humor to an assignment.

4. Dramatic poster designed by Gordon Salchow for the Ohio Arts Council Grants in the Design Arts combines horizontal woodcut with vertical typography.

5. Art director Eileen Schultz collaborated with the illustrator Bob Peak to create an imaginative design for the Society of Illustrators.

1

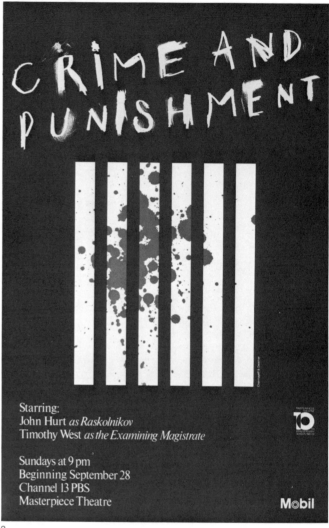

2

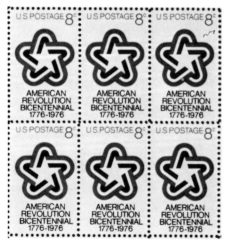

3

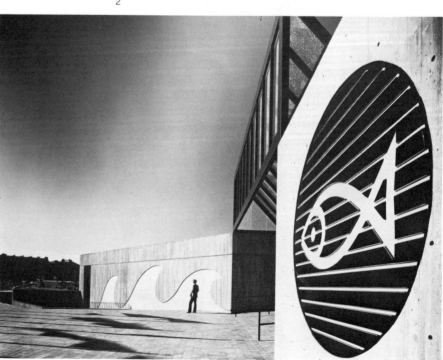

4

The images on this spread show the diversity of work produced by a single studio: Chermayeff & Geismar Associates.

1, 2. Posters commissioned by Mobil to announce their series of television shows

3. Bicentennial postage stamps.

4. Application of corporate graphics to a building.

5. Water fountain for children. The child puts head in lion's mouth to drink.

6. Poster not only tells you how to get to New York Botanical Garden but makes you want to go there.

7. Logo for Chase Manhattan Bank.

8, 9. Shopping bags, when attractive, become walking billboards.

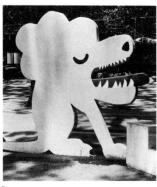

5

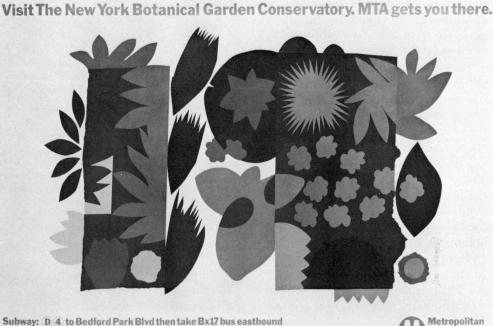

Visit The New York Botanical Garden Conservatory. MTA gets you there.

Subway: Ⓓ Ⓐ to Bedford Park Blvd then take Bx17 bus eastbound
Ⓐ to Allerton Ave-White Plains Road then take Bx17 bus westbound
Bus: Bx17 Bx31 Bx41 Bx55
Transit Information: (212) 330-1234

Conrail: Harlem Line from Grand Central or 125th St to Botanical Garden
Conrail Information: (212) 532-4900

Ⓜ Metropolitan Transportation Authority

Provided as a public service by Mobil

6

7

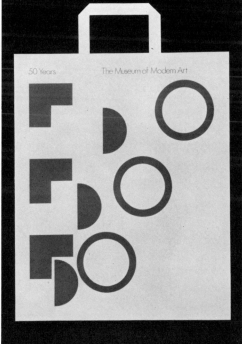

50 Years The Museum of Modern Art

8

BRENTANO'S
BRENTANO'S
BRENTANO'S
BRENTANO'S
BRENTANO'S
BRENTANO'S
BRENTANO'S
BRENTANO'S
BRENTANO'S
BRENTANO'S
BRENTANO'S
BRENTANO'S
BRENTANO'S
BRENTANO'S
BRENTANO'S
BRENTANO'S
BRENTANO'S

9

EXHIBITION DESIGN

Until quite recently the field of exhibition design was dominated by architects, industrial designers, and display manufacturers. Today, exhibition design has become another area of specialization for the graphic designer.

Exhibition design is an attractive choice for anyone interested in both the two- and three-dimensional potential of graphic design, from small-scale to large-scale. The size of an exhibition may range from twenty square feet to an entire museum or international exposition. The costs and design fees range accordingly.

The graphics, too, may vary from simple typography to striking combinations of type and images. These displays often include film, video, animated displays, or audio-visual presentations. The designer should have an understanding of structural materials and special ways of creating graphic effects, such as silk-screening, back-lighting, and so on.

In short, exhibition design offers the opportunity to become a total designer working in all dimensions and media.

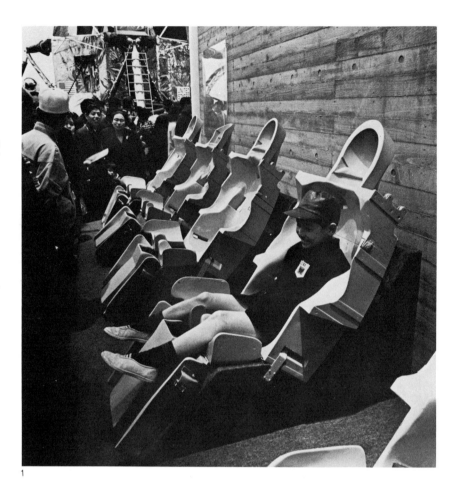

1

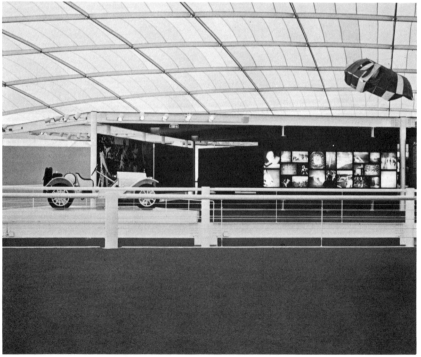

2

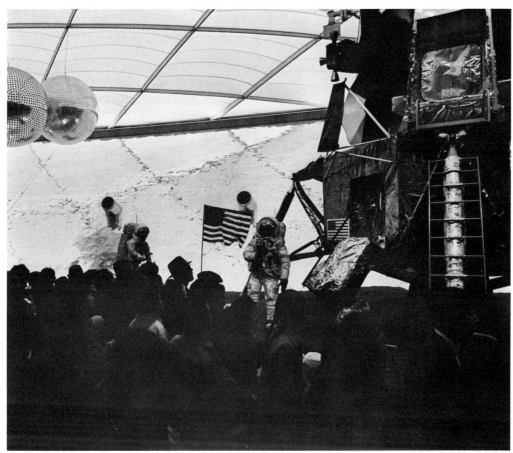

This spread shows the extensive design and planning that go into a major exhibition such as the American Pavilion for Expo '70 in Osaka, Japan. Courtesy Rudolph de Harak & Associates, Inc.

1. Visitors are encouraged to participate by sitting in molded seats designed for space travel.

2. Early days of American car racing are symbolized by a single car.

3, 4. Figures of astronauts and actual equipment are dramatically combined to recreate the American space program.

3

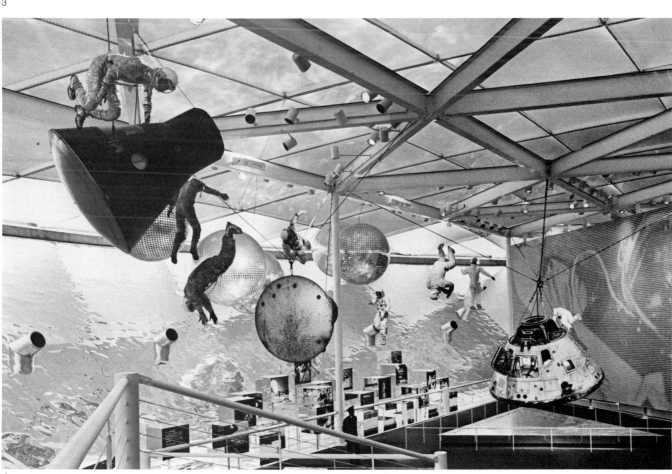

4

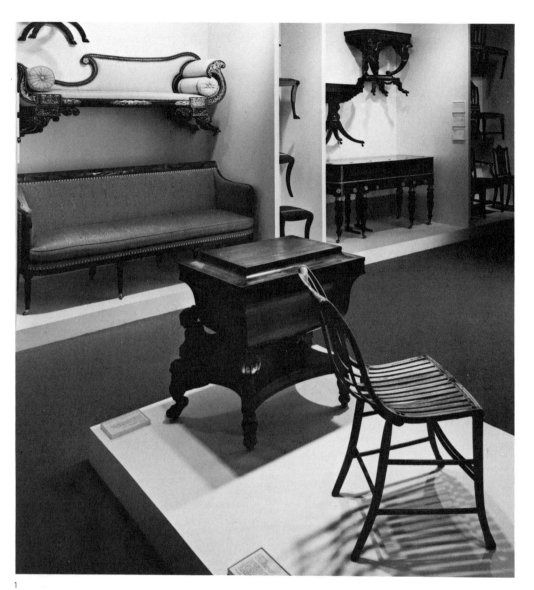

1

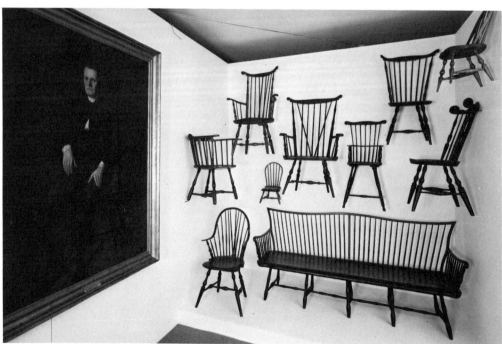

2

3

Some successful exhibits are relatively inexpensive.

1, 2. Simple arrangement of furniture creates an attractive display. Chairs appear to float on the white wall and give the viewer a unique opportunity to appreciate their abstract beauty. Courtesy Chermayeff & Geismar Associates.

3. Logos screened onto corrugated boxes for the AIGA International Trademark Exhibit. It is both effective and easily dismantled for travel. Rudolph de Harak & Associates, Inc.

4. Well-selected elements, open spaces, and information silk-screened directly on walls make an elegant display. Rudolph de Harak & Associates, Inc.

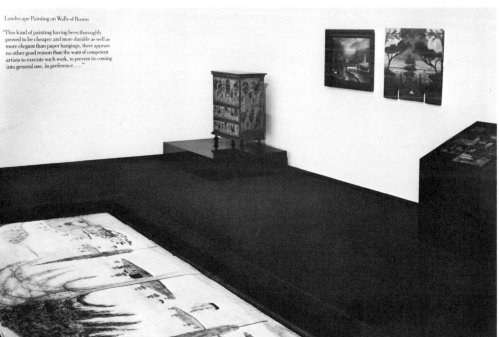

4

FILM AND VIDEO

If you have ever gone to the movies or watched a TV show, then you know what film and video represent. And with the explosion of visual communications, this has to be a career with a future.

A good beginning for a career in either film or video is a love of the movies—not just the story line, but also the technical matters such as the use of the camera, lighting, editing, and so on.

The potential of this field is limited only by the imagination of the artist—and the client! Among the many possibilities are dramas, industrials, commercials, documentaries, animated cartoons, experimental and educational films, and videotapes. Many of these are used today in conjunction with major exhibitions.

Film and video is one of the fastest growing segments of the graphic design and visual communications industry and will continue to be so into the twenty-first century.

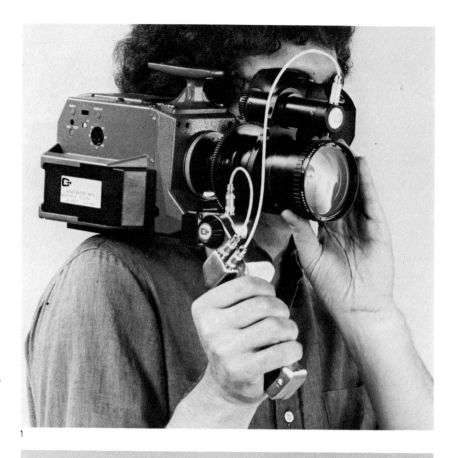

1

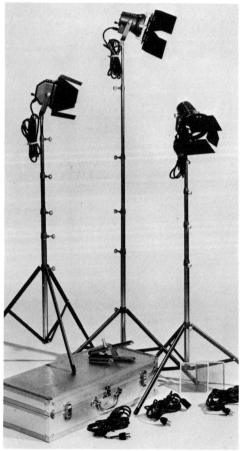

2

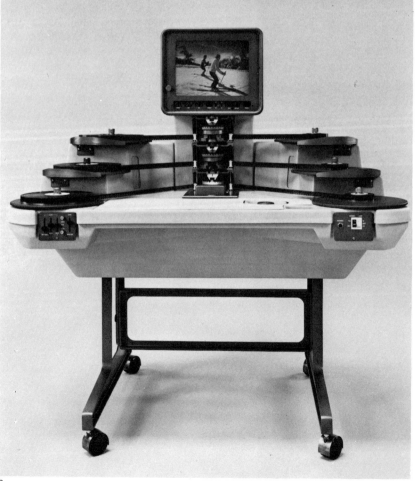

3

1. 16mm camera with zoom lens and power zoom control suitable for news, documentary, and studio production.

2. Knowledge of lighting techniques is necessary for anyone interested in a career in film or video.

3. Flatbed editing console with sound and picture tracks.

4. There are two basic video systems available today: VHS and Beta. Shown here is the VHS video camera. Videocassette recorder captures images on a tape similar to those used for recording music. Model shown here is portable and used for fieldwork.

5. After the images are recorded, the cassette is put on a playback unit and viewed through a standard TV.

6. Relatively inexpensive video editor is ideal for home use.

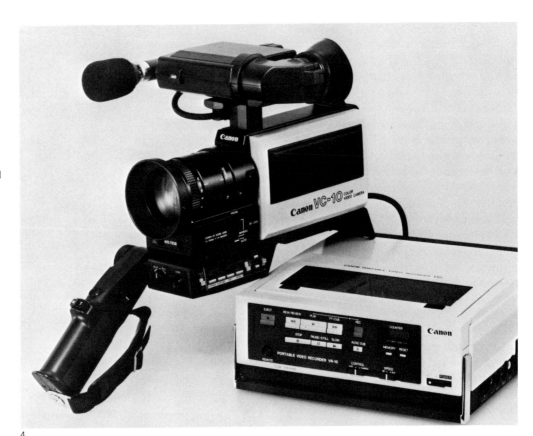

4

5

6

ILLUSTRATION

Some illustrators seem to have found that happy medium between fine art and graphic design. They spend their days drawing and painting, and they get paid for it.

Illustration covers a wide range of areas, and most illustrators prefer to specialize in one or two, such as advertising, book and jacket illustration, magazine illustration, promotional brochures, posters, and storyboards. There are also some areas that require highly specialized skills, such as medical illustration, where the illustrator must have a medical background as well as artistic skills. Engineering drawings, such as exploded views of cameras and automobile engines. also require special skills.

If you are interested in a career as an illustrator, you would do well to take courses in typography. Not only will this help you reach a broader market, but it will also help you understand the problems of the designer who has to add type to your illustration.

Many of today's most successful illustrators are also successful graphic designers capable of doing complete jobs—design, illustration, and typography. In fact, many would have it no other way: they feel that this is the only way they can control the quality of the finished piece.

Staff jobs for full-time illustrators are few and far between and so most illustrators work freelance. This means that a great deal of time can be lost looking for work. It is for this reason that many illustrators use agents, which frees them to do what they do best—illustrate.

As getting established may take years, it is a good idea to develop your skills in creating black-and-white as well as full-color illustrations. Black-and-white illustrations are less expensive to reproduce, and therefore more attractive to a wider range of clients.

1

ILLUSTRATION 41

Illustrations cover an endless range of styles, techniques, and subjects.

1. Pen-and-ink illustration by Marshall Arisman.

2. Record jacket by Leslie Cabarga uses airbrush technique to recreate the atmosphere of the thirties.

3. "Blondie," by Kim Whitesides, also uses airbrush to create a striking portrait of Debra Harry and band members.

4. Dave Epstein uses cut paper to create an unusual and effective illustration.

3

4

5. Announcement for the *Bal Banal* by Alexis Brodovitch.

6. Clients who cannot afford an illustrator will often settle for "clip art," which is inexpensive to reproduce and copyright-free.

5

6

MAGAZINE PUBLISHING

There are thousands of magazines published in the United States every year, and they cover every conceivable subject. Most people know only the one or two dozen magazines they either subscribe to or see on the newsstands. What they don't see are the thousands of magazines serving the business world and the hundreds of city and regional magazines designed to attract people and businesses to particular regions. When you realize how many magazines there are, you begin to see the possibilities for a career in magazine publishing.

Magazines can be broken down into three categories: consumer, business, and farm. Most people are familiar with only the consumer group, which includes magazines such as *Time, Good Housekeeping, Vogue, Reader's Digest,* and *Sports Illustrated.* Although this is the most visible group of magazines, it is not the largest. Business publications designed to serve the various industries, trade groups, and professions constitute a much larger category. The third category, farm publications, caters to the agricultural industry. Most consumer magazines are published in the major cities—especially New York—while the others are produced across the country.

Magazines can be further categorized by how often they appear: weekly, biweekly, monthly, quarterly, semiannually, and annually. Naturally, a magazine published weekly would require a larger design staff than one published quarterly or annually.

When applying for a job, bear in mind that although a magazine has a national reputation, it may not have a large art department. It is not uncommon for a small art department to handle an entire magazine, with the help of freelancers.

Magazine Design

Designing a magazine is a little like designing a book; again, you are working with type, illustrations, and page layouts. However, there are significant differences. Each book is designed to look different, while a magazine must have a sense of continuity from issue to issue. Within the book, the individual chapters are treated in a similar manner: same type size, position on the page, etc. In a magazine, each article is treated independently, and the design and illustration reflect the nature of the article.

The art director works very closely with the editor, who is responsible for the articles chosen—and, in many ways, for the look of the magazine. Together they determine just how the individual articles should appear and which elements should be given emphasis. This is usually accomplished with thumbnail sketches or rough layouts. The designer then works out the details and presents finished layouts for approval.

Cover designs are usually designed in-house between the art director and editor. Advertisements, on the other hand, are generally sent to the magazine by the client or an agency.

Who's Who in Magazine Publishing

The people described below represent the staff of a typical magazine. As no two companies are alike, their titles and responsibilities may vary from one company to another.

In most magazines the publisher is in charge; however, in large conglomerates the publisher may report to a company president. The publisher is responsible for coordinating all the activities: editorial, sales, circulation, production, and finance. The department of most interest to the magazine designer is the editorial department. At the head of this department is the editor, who may also be called the editor-in-chief or executive editor. Reporting to the editor are a number of people responsible for putting the magazine together. There is the managing editor, who makes sure everything is done within budget and on schedule. Associate editors, assistant editors, and editorial assistants help put the magazine together by finding writers, writing and editing articles, etc. The designer also reports to the editor but may work with the above people.

Some magazines also have large promotion departments, where the designer is responsible for promotional or advertising matter. In this case the designer reports to a promotion manager.

1. Henry Wolf combined his talents for design and photography to create an evocative cover design.

2. Not all magazines require conceptual designs; many use images from articles within them.

3. A mundane object, such as a workman's glove, can make an effective cover.

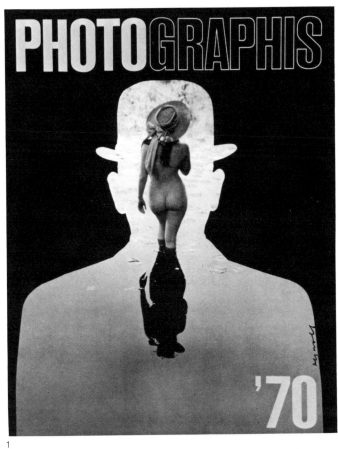

1

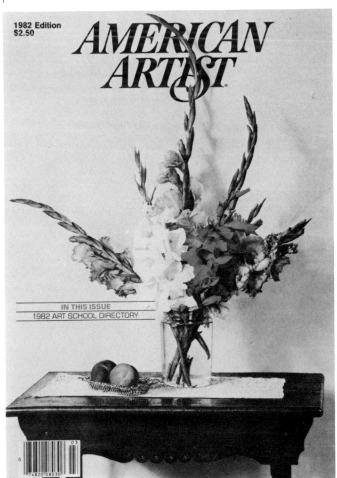

2

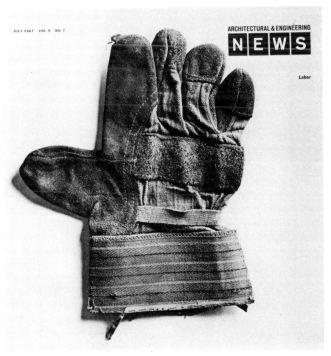

3

1

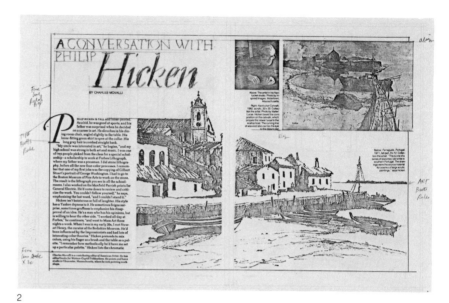

2

3

4

1. Magazine layouts for *American Artist* usually begin with a design conference between the editor and the designer, Robert Fillie. Ideas are expressed in the form of thumbnail sketches.

2. Next, the designer develops full-size layouts with type and illustrations in position. After layout is approved, a mechanical or stripping guide is made for the printer.

3. Shown here is the printed page.

4. Another opening spread for the same magazine. Here the designer brings to the design the same grand scale the artist brought to his painting. Extra space between letters in *Wesselmann* is to allow for gutter.

5. Designers are often asked to redesign existing magazines. Here are a number of covers designed by John Peter and shown to the client. The first cover shown is the original and the last is the one chosen by *High Fidelity* magazine.

6, 7. Top spread shows the original design and the lower spread, the new design. Design changes are not simply cosmetic, but also functional. They involve editorial and sales personnel and can have a major effect on how the magazine is organized.

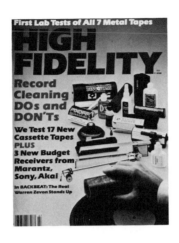
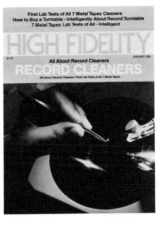
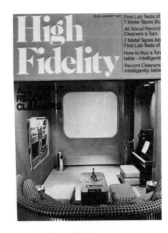

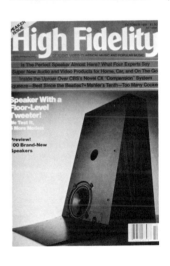
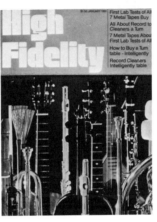
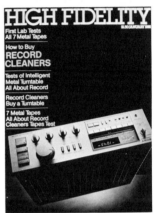

5

6

7

MARKETING, PUBLIC RELATIONS, AND MEDIA BUYING

At one time most advertising agencies were "full-service" agencies. They could provide the client with all the necessary services: research, marketing, creative, and media buying (purchase of advertising space in magazines and newspapers, or of time on TV and radio). Recently there has been a move toward independent companies specializing in one particular facet of the industry, such as marketing, public relations, or media buying. As specialists they feel they can offer higher-quality services to both clients and advertising agencies.

Anyone interested in a career in advertising may want to consider one of these firms, as they require similar skills.

As with advertising, the money is good, but there could be a great deal of pressure, and you will be expected to work overtime—nights and weekends—when a deadline must be met. Dedication to meeting deadlines may take priority over your personal plans.

1

2

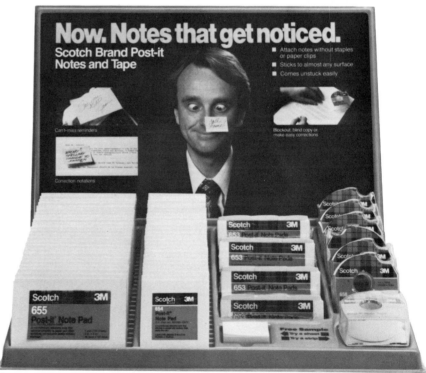

3

1. Elegant brochure extols the attractions of a retirement community. Courtesy Barton - Gillete Co.

2, 3. Point-of-purchase (P.O.P.) displays must attract attention and be functional. Shown here are floor-standing and counter-top displays.

4. Public-relations firms often design specialized magazines, such as *High Harvest* by Gibbs & Soell, Inc.

5. Large three-dimensional letters are combined with photographs to create a bold window display.

6. Strong graphic brochure designed by John Noneman for ABS Computers, Inc.

5

4

6

NEWSPAPERS

Books and magazines are planned months in advance, but newspapers are turned out daily. This takes a certain type of person who enjoys living with short deadlines everyday.

With most daily newspapers there's limited opportunity for typographic creativity; getting the paper out on time is more important than graphics. Also, the quality of the paper—newsprint—and the high speed of the presses do not enhance the graphics.

Sunday papers with leisure or magazine sections are an exception; they can be designed in advance and offer greater opportunities for creativity. The design approach is often more like that of a magazine than a newspaper.

Although a large part of a newspaper's visual impact comes from ads, most are not done in-house but are sent in by advertising agencies. Ads done in-house are usually minimal and tend to be more functional than creative.

1

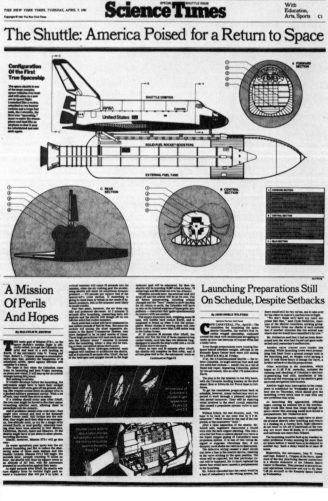

2

3

Newspaper and tabloid graphics do not have to be dull just because publishers use inexpensive paper and high-speed presses.

1. *The New York Times* takes great pride in its graphics and uses only the top talent. The cover for the Sunday magazine section was illustrated by Robert Grossman.

2, 4. Editorial pages aid communication and readability through well-organized design and interesting graphics.

3. *U&lc* is an example of the graphic excellence attainable in a tabloid. Designed by Jurek Wajdowicz.

5. The *Boston Globe* is another newspaper that has recently up-graded its graphics. Designed by Ronn Campisi.

4

5

PACKAGING

If you enjoy working three-dimensionally and solving complex design problems, then you'll enjoy a career in packaging. Most packages can be divided into three major categories: industrial, consumer, and promotional. The consumer category can be further subdivided as follows: food and beverages, cosmetics, pharmaceuticals, household, sports and recreation, personal, automotive, and various other smaller groups.

Good packages are powerful marketing tools. To be successful, a package must be attractive in all sizes, from all angles, and when grouped with others on the shelf. And, needless to say, it must be functional.

A typical package design job may run as follows: for example, a company wishes to introduce a new product onto the market. The client has already researched the market and determined the size of the individual package and given the following information to the designer: the package should appeal to both men and women from age nineteen to thirty-five and should look attractive whether displayed on a shelf, counter, or rotating display. It will be printed in full color.

The client gives the designer the typewritten copy stating product names, list of ingredients, etc. The designer is also made aware of any government regulations dictating type size and where information can and cannot appear. An example of this sort of regulation is the one that applies to the health warning printed on cigarette packages.

The designer uses all the above information to create one or more sample packages for presentation. Packaging often requires a great number of refinements before a final design can be agreed upon.

1

2

3

4

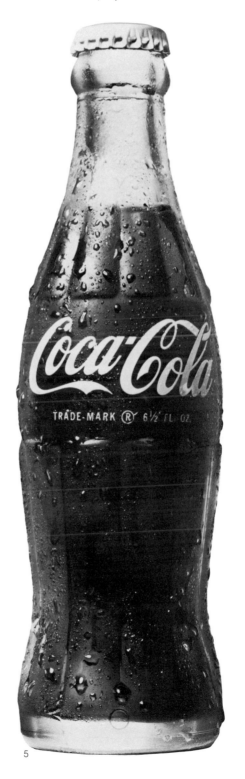

5

1. Packaging for the very competitive liquor industry offers many design challenges.

2. By adding toy models, Dave Epstein clearly indicates that this is the travel edition of *Scrabble*.

3, 4. Cosmetics and toiletries depend heavily on attractive packages to entice buyers.

5. Some designs are timeless. Courtesy The Coca-Cola Company.

1

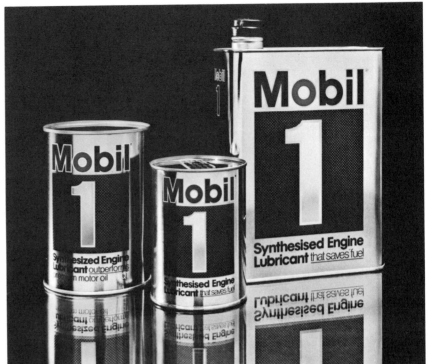

2

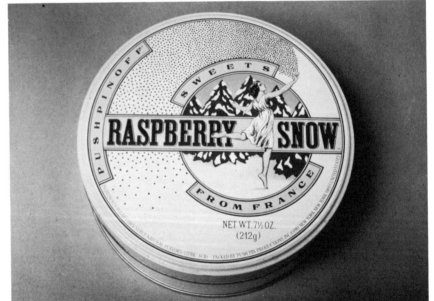

3

Warning: The Surgeon General Has Determined That Cigarette Smoking Is Dangerous to Your Health.

4

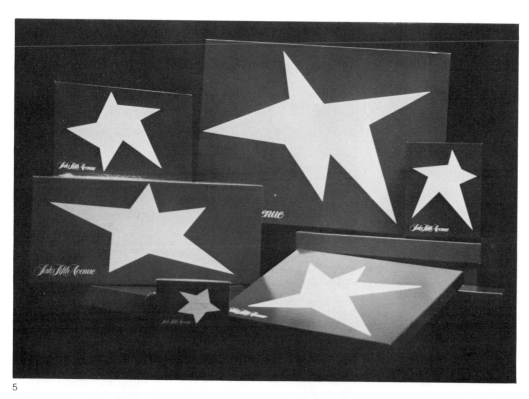

5

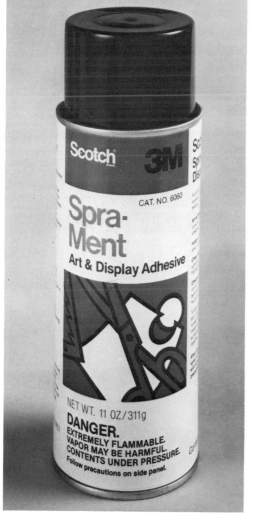

6

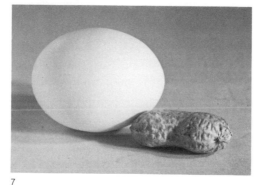

7

8

1. This package tries to create the impression that the product is old, trustworthy, and endorsed by royalty.

2, 5. Serious, no-nonsense packaging. Chermayeff & Geismar Associates have used a bold figure on the Mobil oil can to suggest the product's authority, and a star on the Saks boxes to create a feeling of elegance through simplicity.

3. Raspberry Snow package by Seymour Chwast gives the product an old-fashioned, playful look.

4. Some products are required by law to print warnings, such as this cigarette warning. Notice how, in contrast to the package, the design is intentionally downplayed so as *not* to attract the buyer's attention.

6. A 3M product familiar to many graphic designers. Note that the warning statement is clearly legible.

7. Two of nature's many well-designed packages.

8. Ivory soap with its authentic nineteenth-century wrapper.

PHOTOGRAPHY

There are two basic kinds of photography: cinematography and still. The cinematographer (see Film and Video, page 38) specializes in film and applies his or her skills to TV commercials, documentaries, or other commercial projects. The still photographer supplies the graphic designer with the photographs to be reproduced in print. Still photographers tend to specialize in one area, such as advertising, corporate/industrial, photojournalism, public relations, portrait, or fine art photography.

Photography is a very competitive business and requires a great deal of talent and initiative to get started. If you are to be successful at it, your work should be distinctive and, preferably, unique. As most photographers are freelance, you also need a good head for business and promotion—not only for your work but also for yourself.

You will need money to cover the high cost of photographic and darkroom equipment, studio space, and insurance. You can cut some of these expenses by using outside services and renting studio space as you need it.

Besides a thorough understanding of your craft, you should have a knowledge of production as it pertains to the reproduction of photographs in books and magazines. You may be expected to know what type of photograph will reproduce best when printed on a particular paper or by a particular printing method.

A common way to start in this business is to become an assistant to a well-known photographer. This way you can learn about the art and business of photography, make contacts in the field, and get paid.

1

3

Photography is a very competitive and demanding field; here are but a few examples.

1. Fashion photograph by Robert Farber.

2. The challenge of the product photographer is to make the subject desirable. This often involves special lighting and other devices to heighten reality.

3. The photojournalist's job is to get a dramatic shot that tells the story. This photograph was taken by Tony Spina, Chief Photographer of the *Detroit Free Press*.

4, 5. Photograph for this layout (4) was set up by art director Robert Fillie and a sample photo (5) was given to the photographer, Tom Okada, to follow.

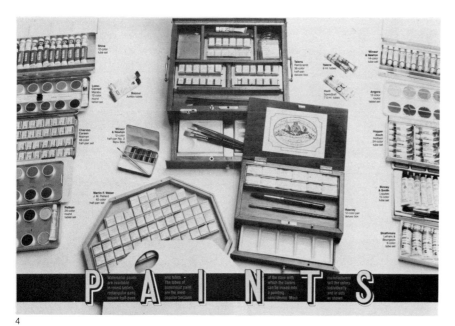

4

5

SIGNAGE

Signage can take many forms: room numbers, signs on storefronts, signs on highways, signs at airports, and so on. These signs may be painted on wood, formed by plastic, cut in stone, or made with neon lights. Signs are as varied as the typefaces and materials from which they are made.

As with exhibition design, the designer may be working alone or with an architect who is responsible for an entire building project, the signage being just one facet. While there are designers who specialize in signage, you will find that most exhibition designers are more than capable of handling signage assignments.

Any designer interested in a career in signage should have a strong background in typography. This includes an understanding of type legibility—at various distances—and how color and movement affect legibility. For example, which typeface, size, and color would you recommend for a sign that is to be read from a speeding train?

You should also have an understanding of the various materials used for both interior and exterior signage, the techniques for their construction, and lighting methods. An ability to read or create architectural drawings will come in handy when it's time to implement your designs.

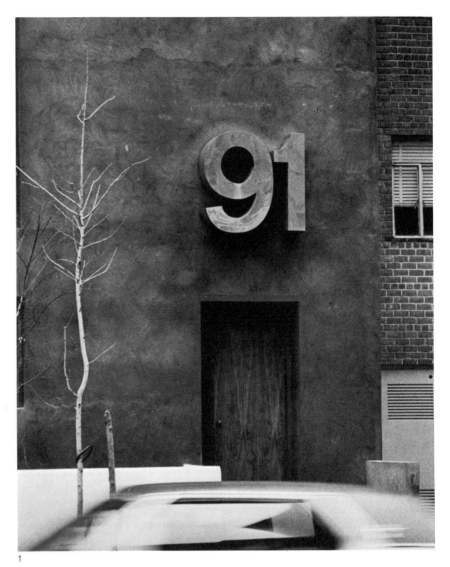

1

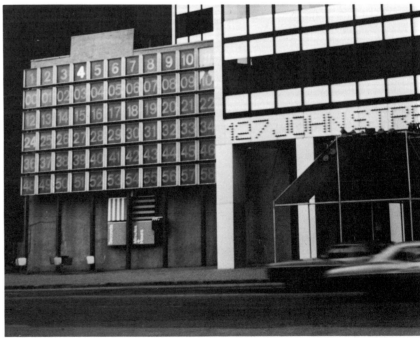

2

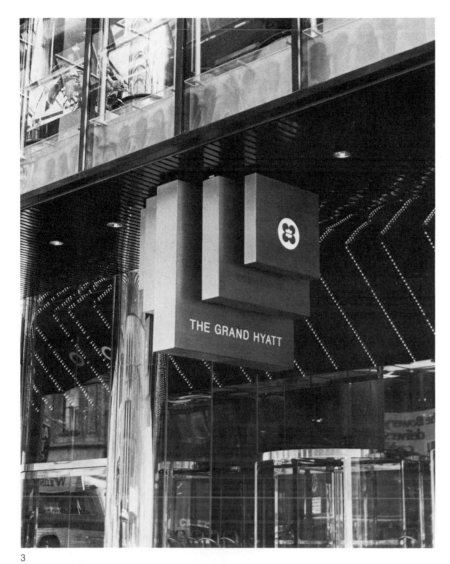

3

4

Signage on this spread was designed by Rudolph de Harak & Associates, Inc.

1. The large, three-dimensional number indicating the address for this residential building is constructed of stainless steel.

2. The sign for 127 John Street in New York City, constructed of stainless steel. The assignment included the large digital clock that measures approximately forty by fifty feet.

3, 4, 5. The Grand Hyatt Hotel required signs of many sizes and applications. Shown here are three examples of signs that are suspended, mounted, and free-standing.

5

1

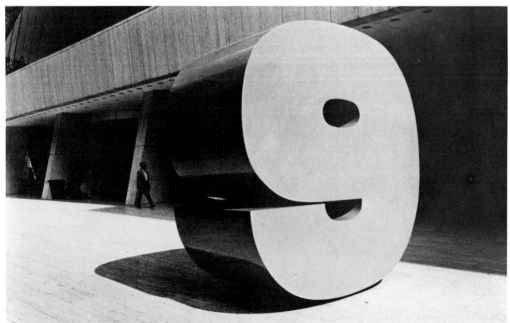

2

3

1, 2. Builders and construction companies realize that fences and barriers offer great graphic opportunities. Here are two excellent examples designed by Chermayeff & Geismar Associates.

3. The number 9 on West Fifty-Seventh Street in New York City acts as both address and sculpture. Designed by Ivan Chermayeff.

4. Construction sign for office building at 747 Third Avenue, New York City. The combination of three-dimensional numbers and highly reflective stainless steel creates a dramatic effect. Designed by Rudolph de Harak & Associates, Inc.

5. International signage must communicate without written language.

6. What may appear as a simple arrow often takes great planning. This was designed by Adrien Frutiger for the Paris Metro.

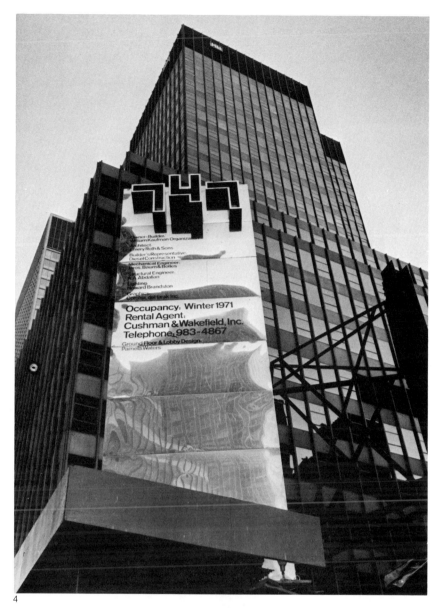

4

5

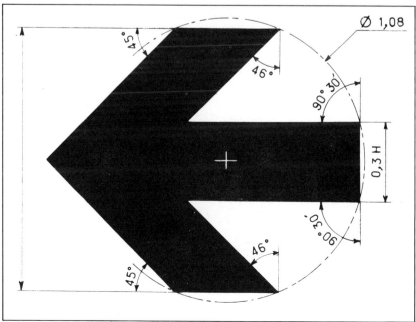

6

TEACHING

Most teaching opportunities will come from universities, colleges, and private art schools; few high schools teach graphic design per se. If the school is good, you will be expected to have design experience and teaching skills. If the opportunity is with a university or college, you may also be expected to have a degree—or two. The pay will depend on your experience and what the institution can afford. With some institutions the salary is negotiable; others have a fixed fee, especially for part-time instructors.

Many designers are part-time teachers; the rest of the time they are pursuing their careers. This situation can be very rewarding for both the instructor and the students; being active keeps the instructor up-to-date on the latest design trends and technologies, all of which can be passed along to the students.

2

1

3

TYPE DESIGN

There is probably nothing more difficult to create—and less appreciated by the average reader—than the design of a new typeface. In fact, most people tend to take the design of a typeface for granted, as though it had come about all by itself. In most cases, if the designer had not named the typeface after himself—as was the case with Caslon, Baskerville, and Bodoni—no one would know who had designed it.

Typeface design may be the highest form of graphic design—pure graphics—and one of the most difficult in which to excel. When you consider the hundreds of text typefaces designed since Gutenberg in the fifteenth century, and the fact that most designers work with only about a dozen—many of which are hundreds of years old—it is indicative of the difficulty of this art.

Not all typeface designers work at such lofty heights; many companies hire designers to create type styles that are fashionable; they are popular for a few years before being replaced by others. These typefaces are usually display, or headline types, and often they are simply revisions of old type styles.

Schools require instructors who can teach subjects on all levels. The illustrations shown here are primarily typographic.

1. Project designed by James Craig to introduce students to the basics of typography.

2, 3. Other projects explore the realm of experimental typography. *Cloud/Horizon/Water* and *LOVe/LIVe* designed by Tom Ockerse, chairman of the Graphic Design Department at Rhode Island School of Design.

4. Adrien Frutiger's diagram shows the mathematical steps between different typefaces of the same family.

4

Portfolio. 1: a hinged cover or flexible case for carrying loose papers, pictures, or pamphlets **2:** the office and functions of a minister of state or member of a cabinet **3:** the securities held by an investor: the commercial paper held by a financial house, such as a bank.

Résumé or **resume** or **resumé.** summary, specifically a short account of one's career and qualifications prepared typically by an applicant for a position.

Interview. 1: a formal consultation usually to evaluate qualifications (as of a prospective student or employee) **2a:** a meeting at which information is obtained (as a reporter, television commentator, or pollster) from a person **b:** a report or reproduction of information so obtained.

PORT-FOLIOS, RESUMES AND INTER-VIEWS

When the time comes for you to get a job, your success will not be determined so much by your last job, the school you went to, or the degree you earned as by your portfolio, resume, and interview.

The portfolio is important because it shows your talent and abilities. The resume is important because it serves as an introduction to a prospective employer. The interview is important because it gives you the opportunity to make a favorable impression while presenting your skills.

PORTFOLIOS

Your portfolio is your most prized possession. It not only shows what you can do, but probably says more about you than you think. At its most obvious, your portfolio tells an art director about your understanding of design principles, typography, photography, illustration, color, and so on. However, the care with which you assemble your portfolio reveals whether you are neat, indifferent, or just plain sloppy. The sequence of the individual pieces shows your sense of organization. Even your sense of humor is reflected.

1

1. Probably the most widely used portfolio is the multi-ring zippered case.

2. Display initial by Tom Kluepfel is a small, but excellent, example of contemporary calligraphy.

2

What to Include

"What do I put in my portfolio?" is probably the question most widely asked by both students and designers. A simple answer would be to include those pieces you feel best represent you and your interests while keeping in mind that they should also reflect the prospective employer's needs.

There is no single portfolio that is ideal for every interview, so be prepared to take pieces out and add new ones, depending upon the position for which you are applying. The more your portfolio relates to the company's needs, the more attractive you will be as a potential employee.

Another factor to consider is the type of job you are applying for. Studio work is apt to require a broader range of skills than, say, packaging or a position as a photographer's assistant. Your portfolio should reflect this.

Here are some of the pieces, listed alphabetically, that you may want to consider putting in your portfolio. Some, such as type and layouts, are suitable for all segments of the print industry, while others—such as illustrations, photographs, packages, and storyboards—are aimed at specific fields.

Book Designs. For anyone interested in a career in book publishing, some book design pieces are an absolute necessity. These can range from all-type spreads to more complex pieces showing type and illustration layouts such as may be found in picture books. If this is your first job interview, don't worry if you have no pieces with set type. Sometimes comped type says more about your skills.

Book Jackets. Book jackets make excellent pieces to include in your portfolio, especially if they show your ability to use type creatively—with or without images. Although the prospective employer may not be a book publisher, the same skills that produced the book jacket can be applied to a poster or an ad. If you feel you have too many illustrations, photographs, or fine art pieces, you should consider turning some of them into book jackets by adding type.

Calligraphy. Calligraphy is the art of beautiful handwriting. If you have had a course in calligraphy and have produced a piece of work you are proud of, by all means include it. Calligraphy is appreciated by anyone with a love of type and written forms, which should cover most art directors. You may also impress a prospective employer or two, as almost everyone at one time or another has aspired to achieving a beautiful hand. However, too many calligraphic pieces may give the impression that your interests are specialized and may make your portfolio seem limited.

Design Projects. It is not uncommon for a group of designers to have worked together on a project, whether it is an ad campaign, a civic project, or developing a corporate image. These make good portfolio pieces, as they show your ability to work as part of a team. They also show your ability to work on complex projects, such as corporate graphics involving the development of logos and their many applications. When you present design projects as portfolio pieces, it is a good idea to indicate exactly what your contribution was. The other designers will, no doubt, be showing the same project.

Film and Videotapes. When your interest is in film or video, the only way your work can be properly evaluated is by having it viewed. Unfortunately, not every office is equipped with the proper viewing equipment, and there is not much to be gained by showing a film or tape in a can. Before leaving for an appointment, make sure that the prospective employer has the correct equipment—and that it is in working order. If equipment is not available, then you will have to arrange to have stills made from the film or videotape.

Fine Art. It is not unusual to see portfolios that are better suited to a gallery than a design studio. These portfolios, containing charcoal sketches, drawings, and oil paintings, show no commercial applications and are not really appropriate for someone seeking a job as a graphic designer.

As with both illustration and photography, one or two art pieces can be of interest and indicative of your potential. Too many pieces, however, will only make an art director hesitant. You will be seen as lacking the skills necessary to be a graphic designer and so immersed in fine art that a career in graphic design obviously would be a compromise for you. This is especially evident when your portfolio is compared with that of someone who shows a decided interest in graphic design as a career.

Illustrations. Including a number of illustrations in your portfolio is a possibility; it indicates another dimension of your design skills. The illustrations can be simple black-and-white drawings or full-color paintings. One advantage of black-and-white illustrations, from an employer's point of view, is that they are inexpensive to reproduce and can enhance a printed piece. If your illustrations are good, an employer may be able to use you on a freelance basis even if there is no opening for full-time employment.

Too many illustrations and too little type in a portfolio usually indicates a lack of interest or training in graphic design. Either way, it is difficult for the employer to consider the person seriously as a job candidate. To strengthen your portfolio graphically, you may wish to make copies of some of your illustrations and turn them into book jackets or posters by adding type. This way the illustration can be shown both with and without type.

Layouts (Roughs) and Comps. Layouts are usually done in pencil or markers on layout paper and show your skill at visualizing a design. Layouts can be rough or tight, that is, finished. A rough layout is used to communicate ideas to other designers and sometimes clients. A tight layout, or comp, is used by designers to show clients how a job will look when printed. If you are a student just beginning your career, chances are most of your pieces will be comps. In order to strengthen your portfolio, you may con-

sider showing more than one solution to some problems as an indication of the depth of versatility of your work.

Logos. Company trademarks, or logos, make excellent portfolio pieces. It is not a simple matter to create a successful logo; the design must work alone without the support of photographs or illustrations. It should be unique and distinctive while reflecting the image of the corporation. Care should be taken to render the logo accurately, as the art director will probably take a critical look at details. Projects involving the design of logos offer an excellent opportunity to show the development of a design from thumbnail to comprehensive.

Magazine Designs. Before applying for a job at a magazine, make sure you have some pieces in your portfolio that show magazine design. For example, you could include spreads showing how you would open an article, illustrate a story with either photographs or artwork, use type for articles where there are no illustrations, and so on. Keep in mind the type of magazine you are visiting so you can show appropriate pieces.

Mechanicals. A mechanical, also referred to as a paste-up or keyline, is camera-ready copy (type and design elements) pasted in position and ready to be photographed and made into printing plates. If you are not applying for an entry-level job as a designer, it may not be necessary to include mechanicals. Your ability to do mechanicals should be reflected sufficiently by the individual pieces in your portfolio. If, however, you are applying for a job as a mechanical person, you should include a variety of mechanicals.

Packages. Packaging design pieces show a designer's skill in working with type and images in three dimensions. Because they are three-dimensional, however, they can present a problem as portfolio pieces. To be appreciated they have to be shown as packages and not folded up inside an acetate sleeve. If your carrying case cannot accommodate a package design, consider photographing it from a number of angles and having prints made.

1

2

ADVERTISING
LAYOUT

by Harry Borgman
A STEP-BY-STEP GUIDE
FOR PRINT AND T.V.

Photographs. Photographs, like illustrations, communicate design ability, but they have a limited appeal. A few photographs are fine; all designers work with photographs, and an art director can appreciate the fact that you are familiar with the principles of photography. However, too many photographs, unsupported by type, will suggest that your interests lie more in photography than graphic design.

Posters. Posters, like book jackets, make good portfolio pieces. One drawback with some posters is size: if they are too large they do not fit into a portfolio. If you have a poster that is too large, consider folding it or reducing it photographically so it will fit. Do *not* buy an oversized carrying case just to accommodate this single piece; the smaller pieces will suffer if you do.

Printed Pieces. If you are a professional designer your whole portfolio will probably consist of printed pieces. However, you may wish to include some of your better ideas or experimental graphics that have not been printed. These could even include alternative solutions for some of your printed pieces. If you are a student, by all means include good printed pieces, as they indicate you have had some professional experience.

Roughs. (See Layouts)

Stationery. Most job hunters, especially those just out of school, have a stationery design in their portfolio. This usually includes a letterhead, envelope, and business card, and in some cases a logo. Stationery designs make excellent portfolio pieces because they involve an understanding of design concepts, typography, layout, and presentation. It is also a job that all clients have had experience with.

Storyboards. If you are applying for a job in an advertising agency or marketing firm, there is a very good chance they will want to see storyboards. A storyboard is to a TV commercial what a layout is to a printed piece. The storyboard shows, in a series of frames, the flow of the action in a commercial. This is done by rendering the action with markers. When showing storyboards be certain to include information concerning the campaign; storyboards unsupported by this information will be ineffective. It's how well you illustrate the ideas that counts, not just your technique.

Thumbnails. These are small, rough sketches similar to doodles that designers use as a means of developing or communicating ideas. Thumbnails are generally not meant to be shown, but when they are, they give an insight into the designer's creative process and show graphically how a design was developed. You may consider showing a single project from thumbnail through to finished comp. However, thumbnails should always be displayed neatly or kept in an envelope in the back of your portfolio.

Transparencies. There are times when a piece is too large or bulky to be shown and therefore has to be photographed. The most common way of handling this situation is to shoot the piece in 35mm film as transparencies. The major problem with 35mm transparencies is that to view them properly you need a projector or a light table with a magnifying glass. Most of the time the art director will just hold your transparencies up to the light or the window; this is not the best way to have your work viewed! If a particular piece is important, have a print made and include the transparencies as backup. If you must use transparencies, make them 4 × 5's or 8 × 10's.

Type. Most designers deal with type on a daily basis; it is one of the most important elements in your portfolio. There are jobs that are all type and no illustrations, but there are no jobs that are all illustration and no type. Furthermore, pieces that contain type will appeal to most art directors or clients even if the subject matter does not relate directly to their interests. For these reasons pieces that display an understanding of typography are very valuable.

1. An easy-to-reproduce black-and-white illustration by Ellen B. Kahn entitled "Pigs have been known to enjoy curling up with a good book."

2. Comp shows a prospective employer a great deal about the designer's skill and imagination.

3. Logo by Eli Kince for the Alpha-Omega Tool and Die Factory.

4. If you intend to show slides, be certain the art director has a projector.

3

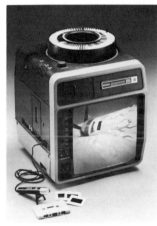

4

What Not to Include

Here are a few things that shouldn't be in your portfolio:

Don't include pieces that might be offensive. This would include anything that is racist, sexist, political, or religious. Even an innocent political cartoon might be risky; what a liberal art director might find hilarious, a conservative could find insulting. The only time this type of art is acceptable is when that's specifically what the art director wants—for example, for a publication such as *Mad Magazine* or *National Lampoon*. So, if you don't know the prospective employer, don't take chances.

Don't include inappropriate pieces for sentimental reasons, such as your first book jacket or a picture of your pet. If such pieces are not representative of your best work, leave them at home.

Don't show every piece in a design series—such as an ad campaign or a group of magazine spreads—if they are not good. Select only the best. If you don't have enough, rework the weaker ones before putting them in your portfolio.

Don't repeat pieces unless there is a reason; repetition will give the impression that your portfolio is being padded out.

Don't have blank pages in the middle of your portfolio; it looks as though something has been left out, removed, or lost. This creates a momentary distraction that you don't need.

Don't have pieces facing in different directions, unless it is unavoidable. The viewer should be able to examine your portfolio without having to turn it around continually. This may mean reducing some pieces, but it's worth it.

Don't mount art on heavy illustration board if it is to be placed between acetate sheets in a multi-ring binder. This tends to make your portfolio unnecessarily bulky. If the piece is already mounted, lift it from the board before positioning it in the acetate sleeve. If you feel the piece requires a mat, use a mat that is light in weight.

Don't have tags explaining every piece. Your portfolio should be self-explanatory. If you feel a piece is too obscure to be properly understood or appreciated, then type a simple description and position it where it will not distract the viewer.

Don't have pieces in your portfolio that have to be set up, pulled out, or unfolded. Make everything as accessible as possible.

How Many Pieces?

After "What do I show?" the next most frequently asked question is "How many pieces do I show?"

The number of pieces you include is not as important as their quality. If the work is excellent, an art director can look at dozens of pieces; if the work is bad, then two is too many. Perhaps the ideal number is somewhere between ten and twenty, providing they are not only good but also diversified.

You will find that the better you are, the fewer items you need. Some of the top designers manage to get all the work they need without a portfolio. They are hired because of their reputations; clients know what to expect and are seldom surprised.

Avoid showing too many pieces of widely varying quality. This often creates confusion, and the viewer doesn't know which piece truly represents your talent. A prospective employer wishing to hire you on the basis of your better pieces may be hesitant, fearing that most of your work might be on the level of your worst instead. If you are uncertain, only include your best work; a small, well-thought-out portfolio is better and suggests confidence.

Most people who review portfolios have a pretty good idea of your talents after looking at two or three pieces; usually the remaining pieces just confirm their earlier judgment.

In What Order?

The order of the various pieces in your portfolio is very important. While there is no rigid rule dictating the best way to lay out a portfolio, the sequence you choose should reflect some kind of conscious thought.

Just as you took time to make the hundreds of design decisions that went into creating the individual pieces, you must now do the same in determining the order in which they will be shown.

One method is to start with the simpler black-and-white pieces: logos, illustrations, hand-lettering assignments, and so on. Next, show two-color pieces, such as posters, book covers, and brochures. Following that, start to introduce full-color examples, such as magazine layouts, ads, and illustrations. Make sure you end with a strong piece so the viewer is left with a good impression.

The logic of this approach is twofold; the pieces go from simple black-and-white to full-color examples, and from the least expensive to reproduce to the most expensive. You might say, in musical terms, that the portfolio builds to a crescendo.

Another approach is to start the portfolio with a strong piece designed to create a positive initial reaction. The sequence that follows would be entirely personal and indicated by your design and esthetic judgment. For example, you could juxtapose pieces because they complement one another or because they contrast with one another. Once again, make sure you end with a strong piece.

The specific order you choose is not as important as the impression you want to communicate, that this portfolio was put together consciously and that the whole portfolio is greater than the sum of its parts.

Evaluating Your Portfolio

It is important that you feel confident, if not downright enthusiastic, about your portfolio. How you feel about it will be reflected in your manner when it comes time to look for a job.

The best way to find out if your portfolio is good is by asking people. Start by showing it to fellow designers; they know you and your work and can probably make valuable contributions. If you are taking design courses, ask one of the instructors to review your portfolio.

If you are a student, you may also wish to check with the local Art Directors Club or similar institution; some of these organizations set aside days to review students' portfolios. This way you can have a critique from half a dozen art directors in a single day!

After seeing a number of people, don't expect a consensus; each person will be giving you his or her opinion, and much of the feedback will be conflicting. Weigh all the comments seriously, consider where they're coming from, and act accordingly. Your portfolio should reflect your taste, not that of a committee.

Do not take criticism personally. Remember, it's your portfolio that's being criticized, not you.

Keeping Your Portfolio Up-to-Date

Always keep your portfolio up-to-date. You never know when an opportunity may present itself—or when the axe will fall. Either event may not give you the time you need to put together an effective portfolio. Pieces that you would like to include may no longer be available. If you leave a job under less-than-friendly circumstances, the company may not wish to be accommodating. Besides, keeping an up-to-date portfolio helps you evaluate your progress and may even prompt you to re-evaluate your worth.

If you are a student, start your portfolio while you are in school—preferably during the first year. This is particularly important if you are planning to look for part-time work or summer employment. Select your best pieces, and don't worry if they seem too basic. Remember, art directors were once students; they understand the type of projects given during freshman year and will make allowances.

As school progresses, you will naturally add to your portfolio, replacing the less effective pieces with better ones. This way your portfolio will always be up-to-date and ready for an interview.

> Your portfolio is often judged not by your best pieces but by your worst.
> *Lily Silipow*
> Graphic design headhunter

Portfolio Cases

Although there are many different types of carrying cases available, most graphic designers use one of two types: a zippered case portfolio or an attaché-style portfolio. Although black vinyl is the most common, cases are also available in many other colors, materials, and finishes.

Zippered Case Portfolio. The zippered case portfolio wraps around a multi-ring binder that can hold up to thirty acetate sleeves containing black mounting sheets. If you were to mount one piece of art on each side of the mounting sheet, you would have sixty pieces of art in your portfolio, which is more than you'll ever need. The zipper closes on three sides to protect your art, and there is a handle for carrying convenience.

1

Zippered case portfolios come in a number of sizes: 11″×14″, 14″×17″, 17″×22″, and 18″×24″. The most popular size for graphic designers is 14″×17″, which is large enough to accommodate all but oversized pieces and yet small enough to make both carrying and viewing comfortable.

Although larger sizes are available—usually without rings—they are impractical for the graphic designer, who generally works in much smaller formats. Furthermore, they are not only difficult to carry, but also take over an entire desk when opened for viewing.

One advantage of the zippered case portfolio is that it permits the designer to dictate the sequence in which the art is to be viewed. No matter how many people look at the portfolio, the art will remain in sequence, which is not the case when items are loose in an attaché-style portfolio.

Another advantage is flexibility. Not only can the sequence of sheets be changed, but new ones can be added or old ones deleted so that your portfolio is always up-to-date and geared to the needs of the client.

Any pieces that are bulky, such as books, brochures, and annual reports, should be kept in the pocket inside the cover along with extra copies of your resume.

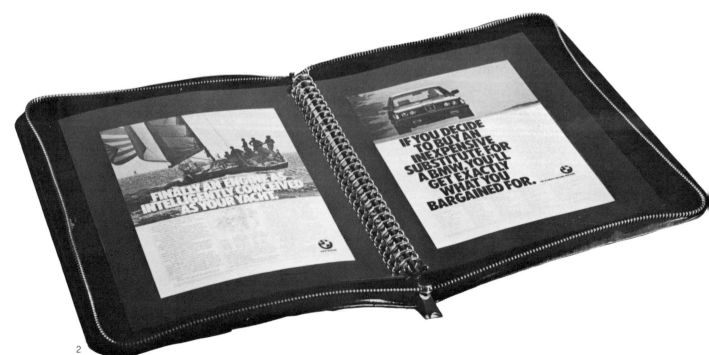

2

Attaché-Style Portfolio. The attaché-style portfolio—also called the Madison Avenue or executive-style—looks very much like the standard attaché case and is ideally suited to the designer who likes to keep the individual pieces loose. Attaché-style portfolios come in a wide range of sizes: $14'' \times 18'' \times 3''$, $17'' \times 22'' \times 3''$, $20'' \times 26'' \times 3''$, and $23'' \times 31'' \times 3''$.

Designers who use attaché-style portfolios generally have their printed pieces mounted on illustration board or Styrofoam or Fome-Cor; matted; or laminated between sheets of plastic. This not only protects the art but also allows art directors to pass around individual pieces to others who may be interested.

One advantage of the attaché-style case is that it allows you to include three-dimensional objects in the portfolio, making it ideal for designers specializing in packaging. Another advantage is the ability to add and subtract pieces quickly, in order to tailor your portfolio to the client. Perhaps the major disadvantage of the attaché-style portfolio is that you cannot always control the sequence in which the pieces are viewed.

1. Inserts for zippered case portfolio are black with acetate sleeves.

2. Portfolio should be neat and well organized.

3. Attaché-style, or Madison Avenue, portfolios are handy for bulky pieces and quick changes.

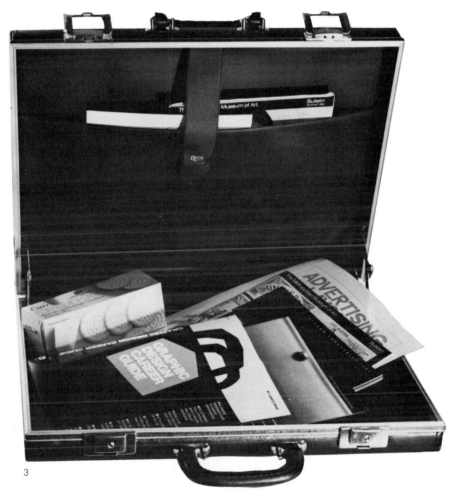

3

RESUMES

Although the term *resume* is used in the United States and Canada, many of the other English-speaking countries prefer *curriculum vitae,* or simply C.V. *Curriculum vitae* is Latin for "the course of one's life."

Preparing an effective resume requires time and effort to ensure that the information is well organized both editorially and visually.

In most cases, your resume will be your first contact with a prospective employer. It may also be only one of many resumes the company receives, each representing an applicant for the same job. What you say, how you say it, and how you choose to lay out the information will determine, to a great extent, whether you get an interview, let alone the job.

Nineteenth-century graphic designer typing her resume.

Writing the Resume

Although there are a number of ways to write a resume, for the graphic designer the simplest is probably the best. The information that is of interest to a prospective employer falls into three major categories: personal, educational, and work experience. Each of these categories contains information that must be given and information that should never be given.

Personal. You must give your name, address, and phone number. Optional items are age, height, weight, marital status, draft status, number of children, statement of health, and your personal history. You should never include the names of your spouse and children or a photograph of yourself, as this information is not relevant.

Educational. List all college degrees, with dates, starting with the most advanced first. Include academic honors, special skills, foreign languages, and any courses you are presently taking. If you have a college degree, there is no need to list your high school.

Work Experience. This category may also be titled *Employment* or *Professional Experience*. Show all work experience, starting with your present job, if any, and working backward. Do not leave any unexplained gaps. Give job titles and a brief description of your duties and any special skills you may have acquired, such as keyboarding. Recent graduates should list summer employment and significant freelance projects. You may list job objectives, but this is not necessary. You should never include past salaries or present salary requirements, or reasons for leaving past jobs. Salaries should be discussed during the interview, and reasons for leaving past jobs should not have any bearing on your present situation.

You should never give the name, address, and phone number of your references—although many people do! Just state "references upon request." There are very good reasons for this practice besides respect for someone's privacy. Withholding the names of your references until requested allows you time to notify the various parties that they will be getting a call. In this way they are better prepared and more receptive when they receive the expected call.

Besides the information you have organized into the three major categories, you may wish to round out your resume with other information you feel is important, such as exhibitions, awards, career goals, etc.

Whatever you choose to include, there are three factors you should keep in mind. Be selective; choose only the information that will make you look good. Be brief; ideally, your resume should fit on one page. And be organized; do everything possible to get the important facts down in a logical manner so they can be read comfortably.

Finally, have an editor look over the resume to make sure there are no grammatical errors. Although you are applying for a design job, good grammar is important, as you will be working with copywriters and editors. While a flawless resume may not get you the job, too many sloppy grammatical errors certainly will not help.

Designing the Resume

Designing your resume is one of the most important design jobs you will ever do. How well you organize and lay out your resume will say a great deal about your design skills. It should be simple, attractive, and above all, readable. Never send out a resume until you're completely satisfied with both its content and its design.

Organize the information so the reader can take in all the important facts at a glance. If you have been selective and the copy is well edited, you should have no trouble fitting it on a single page.

Your name, address, and telephone number should be prominent, usually at the top of the page. Next, organize the rest of the information under the appropriate categories: personal, educational, and work experience. The sequence is not crucial, although most applicants tend to show education next and then work experience.

Heads should be emphasized. This can be done by using positioning, caps, underlining, or, if the resume is set in type, bold type. Be selective; nothing will destroy the look of your resume more than too many elements demanding attention.

Remember, a resume is like a business letter and should be taken seriously. It should not be cute, gimmicky, or overly designed; if your attempts are neither appropriate nor brilliant, you may risk alienating a prospective employer.

Choice of Paper

Nothing improves a resume as much as having it typed on the right paper, especially when you consider that the recipient—probably an art director—is someone who appreciates the look and feel of a good piece of paper. Therefore, choose a fine quality paper, preferably white or off-white.

Choosing the wrong paper may detract from the content of the resume. For example, bright-colored paper may seem attractive and attention-getting, but is the attention you're getting favorable?

Typewritten vs. Typeset

At one time all resumes were typewritten. Today, with multi-font typewriters and inexpensive phototypesetting, it is possible to have your resume set in type. Whether to type or typeset your resume is a decision requiring some thought.

Should your resume be typeset, the employer can only assume that you made the layout, specified the typeface, prepared the mechanical, chose the paper, and had it printed. In this case, your resume also represents a sample of your work and will be so judged. Therefore, show restraint and limit yourself to one type style and size, using bold and/or italic type for emphasis. Your typeset resume should reflect good taste.

Typewritten resumes are universally accepted; however, they too must be well designed. Because legibility is important, the larger pica typewriter (10 characters per inch) may be a better choice than the smaller elite (12 characters per inch). Generous margins and ample space between the various categories of information will improve readability. Heads or other important information should be emphasized, but be selective.

To ensure a high-quality, professional job, clean the typewriter keys; you'll be surprised at the difference a little cleaning will make. Buy a new typewriter ribbon; this will improve the quality of both the original and the reproductions. Use two sheets in the typewriter; the second will act as a backing and ensure a better original.

If you are sending out a large number of typewritten resumes, don't feel that each must be an original; photocopies are acceptable. Make sure, however, that the photocopies are of high quality. You also may wish to consider inexpensive offset printing, which is capable of producing high-quality copies. Whatever you choose, make sure you use a good professional service; this is not the time to save money.

The resumes on the following four pages should not be copied. Your experience is unique, and that should dictate the best design for you. Do take note, however, of how well the information is organized; this, in turn, makes the resumes very readable.

Samples of both typewritten and typeset resumes are shown. On the following spread are two resumes by the same person, Eli Kince. Both are effective.

Resume

Robert Mansfield
232 East 6th Street Apt 1B
New York, N Y 10003
212 533-1361

Education

1978-1982	The Cooper Union, New York, N Y BFA Graphic Design Sarah Cooper Hewitt Prize recipient
1974-1978	Indian Hills High School, Oakland, N J Member of National Honor Society
Professors	Bruce Blackburn Herb Lubalin James Craig George Sadek Rudolph de Harak Norman Sanders

Work Experience

May 1981-present	Army Corps of Engineers, New York, N Y Assistant Designer Projects: Design and production of newsletters, brochures, displays, charts, and slide presentations
Jun 1982-Jul 1982	James H. Harris and Company, Inc., New York, N Y Freelance Project: Design logotype, stationery, and storefront sign
Dec 1981-May 1982	The Parrish Art Museum, Southampton, N Y Freelance Project: Design and production of poster and annual report
Nov 1981-Apr 1982	Renaissance Newark, Inc., Newark, N J Freelance Project: Illustration and design of brochure involving the rehabilitation of buildings
Mar 1981	Jordan, Case, and McGrath Ad Agency, New York, N Y Freelance Project: Assisted in animated television commercial for "The Pirates of Penzance"
Jun 1979-Sep 1979	Western Union Corporation, Upper Saddle River, N J Design Trainee Projects: Production of brochures, displays, and design of technical posters
May 1978-Aug 1978	Tom Sawyer Ad Agency, Midland Park, N J Designer Projects: Design and production of real estate display ads for local newspapers

Exhibitions

Houghton Gallery, The Cooper Union, New York, N Y
5/80, 5/81, 2/82, 5/82, 6/82

Wyckoff Gallery, Wyckoff, N J
9/79, 4/80, 9/80, 12/80, 5/81, 9/81, 12/81, 4/82, 6/82

Personal

Born April 12, 1960, Bethpage, N Y

References

George Sadek, Director of Cooper Union Design Center
212 254-6300

George Weinkam, Vice President, Renaissance Newark, Inc.
201 430-8000

e l v i n l e e k i n c e

personal	Sep 53/ -	Born: Cleveland, Ohio ; Single

education	Sep 78/May 80	Yale University, School of Art; New Haven, Connecticut; Master of Fine Arts in Graphic Design.
	Jun 74/Jun 78	University of Cincinnati, School of Design, Architecture and Art; Cincinnati, Ohio; Bachelor of Science in Design.
	Sep 71/Jun 74	Bowling Green State University; Bowling Green, Ohio; Accounting Major.
	Sep 68/Jun 71	Glenville High School; Cleveland, Ohio; College Prep and Commercial Art.

employment	Jun 79/Sep 79	**IBM** - San Jose, California Designed safety posters, brochures, and a temporary signage system.
	Jan 78/Sep 78	**The Art Warehouse** - Cincinnati, Ohio Designed and supervised the production of two exhibitions. Designed and illustrated posters, logos, and three packages.
	Sep 77/Jan 78	**Cuyahoga County Hospital** - Cleveland, Ohio Proposal for hospital signage system: which included design concepts for pictograms, material selection, a supergraphic system, and locating bidders.
	Apr 77/Jun 77	**G. Design Inc.** - Atlanta, Georgia Design consultant for a small advertising agency: designed brochures, display stands, wrote proposals and organized the office for production.
	Jun 76/Dec 76	**University Publications** - Cincinnati, Ohio Design responsibility from client to printer; included contact with in-house composers, photography staff, editorial staff, and printing house.
	Jan 76/Mar 76	**Danne & Blackburn** - New York, New York Responsibility included layout, type spec, paste up, and general assistance.
	Jun 75/Sep 75	**Bio Med Communications** - Cincinnati, Ohio General photography: developed film for 8x10 and 35mm, mounted slides, operated wash, mixed chemicals and some enlarging.

references	Yale University - School of Art 2004 Yale Station, New Haven, Connecticut 06520
	Alvin Eisenman, Paul Rand, Inge Druckery
	University of Cincinnati - College of Design, Architecture and Art Department of Graphic Design, Cincinnati, Ohio 45221
	Gordon Salchow, Stan Brod, Joseph Bottoni

e l i

ELI KINCE 990 Anderson Avenue #6a Bronx NY 10452 (212) 538 0418

EMPLOYMENT: 1/82-9/82 SELF-EMPLOYED-New York New York
 Published "Visual Puns In Designs" with Billboard Publications, Inc.,
 Watson-Guptill Publications label. Wrote text, collected images, and
 obtained permissions for the images. Created layouts and designed
 the book with Bob Fillie.

 5/81-1/82 ANSPACH GROSSMAN PORTUGAL-New York New York
 Assisted in design of bank interior, furniture and color selection as
 well as logo, poster and brochure design.

 8/80-3/81 PENTAGRAM DESIGNS-New York New York
 Junior Designer for Annual Report Season. Responsible for sketches,
 presentations, layouts, editing of photographs and mechanicals.

 6/79-9/79 IBM-San Jose California
 Designed safety posters, brochures, and a temporary signage system.

 1/78-9/78 THE ART WAREHOUSE-Cincinnati Ohio
 Designed and supervised the production of two exhibitions, posters,
 logos, and three packages.

 9/77-1/78 CUYAHOGA COUNTY HOSPITAL-Cleveland Ohio
 Responsibility included writing a proposal for the hospital signage
 system, the conceptual design of that system, as well as material
 and bidder selection.

 4/77-6/77 G DESIGNS INC-Atlanta Georgia
 Designed brochures, display stands, and wrote proposals.

 6/76-1/77 UNIVERSITY PUBLICATIONS-Cincinnati Ohio
 Contact with clients, composers, editors, photographers and printers.

 1/76-3/76 DANNE & BLACKBURN-New York New York
 Type spec, mechanicals and general assistance.

EDUCATION: 9/78-5/80 YALE UNIVERSITY, School of Art; New Haven Connecticut,
 Master of Fine Arts in Graphic Design.

 6/74-6/78 UNIVERSITY OF CINCINNATI, College of Design Architecture and Art;
 Cincinnati Ohio, Bachelor of Science.

 9/71-6/74 BOWLING GREEN STATE UNIVERSITY, Bowling Green Ohio;
 Accounting Major.

 9/68-6/71 GLENVILLE HIGH SCHOOL, Cleveland Ohio.

REFERENCES: Anspach Grossman Portugal (Eugene Grossman)
 Pentagram Designs (Colin Forbes)
 Yale University-School of Art (Alvin Eisenman, Paul Rand and
 Inge Druckery)
 University of Cincinnati-Graphic Design Department (Gordon Salchow,
 Joseph Bottoni and Stan Brod)

1982

Virginia Gehshan

1234 South 8th Street
Philadelphia Pa 19147
215.952.1234

work experience

Daroff Design Inc.
Philadelphia Pa
interior design consulting firm
October 1979 to present

Director of DDI Graphics, a division
of Daroff Design, with complete
responsibility for design direction,
administrative coordination,
production supervision and
business development.

corporate identity, marketing
communications, architectural signage,
display and exhibit design.

representative clients:
E. I. du Pont de Nemours & Co.
Merrill Lynch & Co.
Prudential Insurance Company
R. J. Reynolds Tobacco Company
SmithKline Corporation
Subaru of America

Noel Mayo Associates, Inc.
Philadelphia Pa
industrial design consulting firm
June 1974 to October 1979

responsible for design and direction
of all graphic projects.

representative clients:
Balch Institute
Barrit Furniture Corporation
Basco Stores
Hammarplast
Museum of American Jewish History

teaching experience

Philadelphia College of Art
Philadelphia Pa
Department of Industrial Design
September 1978 to present

curriculum development and
instruction for graphic design
studio courses.

education

Cornell University
Bachelor of Science cum laude
Design and Environmental Analysis
June 1974
product and graphic design

Philadelphia College of Art
student in Industrial Design
Fall 1973

continuing education

design and business courses taken
for professional development.
1976 to present

Pratt Center for Computer Graphics
in Design
Harvard Graduate School of Design
Kodak Design Profession Workshop
Temple University Business School
AIA Professional Practice Course
Illuminated Engineering Society

free-lance projects

representative clients:

Barger Construction, Inc.
Canadian Consulate
Collab 20th Century
Tom Crane Photographer, Inc.
KennedyWalker

honors

publications:
architectural signage projects
for Daroff Design published in
The Office Book; Interior Design,
Corporate Design and Architectural
Record magazines.

awards:
Philadelphia Art Directors Club
Neographics
Industrial Design Magazine
Strathmore Paper Graphics Gallery
Industrial Design Society of America

Covering Letter

A covering letter adds a personal touch to your resume while allowing you to highlight information you feel is important. Unlike the resume, which is basically an impersonal photocopy, the covering letter must be individually typed and, ideally, addressed to a specific person. Most important, a covering letter elicits a response, whereas a resume by itself does not.

The covering letter should be brief—two or three paragraphs—and never more than one page. The first paragraph should explain why you are writing: for example, in response to an ad, on speculation, or in response to a referral (in which case, be sure to mention the person's name and company).

Next, summarize your resume and perhaps elaborate on some area of interest to the prospective employer. Then go on to express your desire to arrange an interview and show your portfolio. The overall tone should be one of sincerity; by overselling yourself or your skills you risk alienating the prospective employer.

Like all business letters, your covering letter must show your address in the upper right- or left-hand corner and the party's name, title, company, and address on the left. In closing, be sure to type your name under the signature. Make copies of all your covering letters in the event that a follow-up letter or call is necessary.

Handwritten letters are not a good idea unless you have a beautiful hand. Generally speaking, they are more difficult to read and place an unnecessary burden on the reader.

Follow-Up

It is general corporate practice to answer all written applications within two weeks. If you do not receive an answer during this time, phone or write a follow-up letter. Refer to your earlier letter, but do not be critical about the slow response; it's possible that the person for whom the letter was intended was on vacation, sick, transferred or deceased—or that the letter may never have arrived. You may even have forgotten to mail it!

```
                                    21 Oak Lane
                                    Larchmont, N.Y. 10538
                                    January 6, 1983

Mr. Robert Brown
Art Director
Creative Publications, Inc.
1500 Broadway
New York, N.Y. 10036

Dear Mr. Brown:

I am applying for a position in your Art Department,
ideally as a design assistant with an opportunity to
improve my skills in book design.

I have recently graduated from The Cooper Union and
have been fortunate enough to have had a freelance job
during school which gave me some valuable experience
plus a love for book design.  I have also had some
experience in the design of ads and promotional pieces.

I would welcome the opportunity to stop by your office
one day and show you my portfolio.  You can write to
me at the above address or phone me at (212) 777-9999.

Your consideration is greatly appreciated.

                                    Sincerely,

                                    Mary Smith

Enclosure
```

INTERVIEWS

There are several reasons for arranging an interview: to apply for a specific job, to introduce yourself to a potential client or employment agency, or to have an art director critique your portfolio. In all cases, interviews should be taken seriously.

First impressions are very important; how you present yourself and your work will go a long way toward determining whether you are the right person for the job. Also, the impression the art director makes on you will help you determine whether you are interested in the job.

Arranging an Interview

You have updated your portfolio and written your resume, and now it's time to arrange interviews. There are two basic ways to do this: by letter or by phone. Never show up unannounced.

By Letter. The most effective way to arrange an interview is by letter. This allows you time to compose your thoughts and be precise about what you wish to say. Your letter can be just a simple inquiry about job opportunities and the possibility of showing your portfolio. The letter should always be typewritten and, where possible, addressed to a specific person. Include a return address and, if you wish, a phone number and time when you can be reached. Enclose a copy of your resume with the letter (see Resumes, page 72).

By Phone. Phoning for an appointment is convenient, but it is definitely the second-best method. First, you may not be able to get through to the art director—and if you do, there is always the possibility that your call will be an interruption, in which case you may be less warmly received than if you had written.

Second, you can't possibly cover the same amount of material over the phone that you can in a letter with a resume. Writing allows the art director to know much more about you before you arrive and will probably help the interview move along more smoothly.

If you do decide to phone, be brief. If there are no jobs available, the art director may still be willing to look over your portfolio and offer suggestions. Most art directors are sympathetic to job hunters; they remember what it was like going from agency to agency, publisher to publisher, studio to studio.

Setting a Time. Let the art director set the time. This will ensure that your interview will be at a time when you can have the art director's undivided attention—not three minutes crammed in between meetings or just before lunch.

Once the appointment is established, be there—and be on time. Being late might jeopardize your chances for the job. If you can't make the appointment, call as far in advance as possible, explain your predicament, apologize, and request a new appointment.

If your appointment was made weeks in advance, you may wish to call the art director a day or two before the appointment as a gentle reminder. Art directors have been known to overlook such matters when busy.

Preparing for an Interview

There are a number of ways to ensure a successful interview. You can do a little research into the company and art director who will be interviewing you. If it's an advertising agency, find out who their major accounts are. Look through some recent editions of the *Art Directors Annual* and see if they are included. Perhaps the art director you are seeing is an award winner.

If you are being interviewed at a magazine, make sure you have seen their most recent issues—styles can change suddenly. Glance at the names of the people working on the magazine; these are shown on the masthead, which can usually be found on page 2 or 3. This way you'll be familiar with the key people in the organization. You may even have the opportunity to meet them.

The same principle applies to book publishing. Visit a bookstore and look around the racks for books the firm has published, or call the company and ask for a catalog. This way you can be familiar with both the type and quality of the books they publish.

You will probably be nervous—most people are—and so before the interview, make sure you have the names of the art director and company correct. Mispronouncing either could be embarrassing. If you are uncertain how to address the art director, then use the formal Mr. or Ms. unless invited to do otherwise.

Being prepared for the interview will give you more confidence, which in turn will enable you to make a better impression.

Annuals are excellent places not only to look for ideas but also to study the work of prospective employers. Shown here are the annuals of the American Institute of Graphic Arts, the Art Directors Club of New York, and The Type Directors Club.

What to Wear

Fortunately, when you are applying for a job as a graphic designer, you do not need to dress as formally as you would for a position with a national bank. However, do not confuse informality with sloppiness. Although art directors are not looking for people in three-piece suits, they are looking for people whose work is neat and precise. How you dress could certainly be a reflection on how you work; if in doubt, dress conservatively.

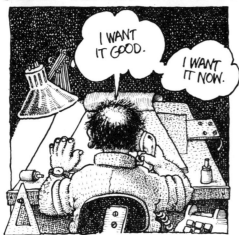

Meeting the Art Director

Your meeting with the art director will probably be pleasant; most art directors enjoy meeting designers and looking at portfolios. You will find the art director will want to control the pace and ask questions if necessary. Avoid making excuses, apologizing for why a certain piece is not completely successful, or explaining what you intended to do. The portfolio should speak for itself.

You may have to leave your portfolio with the art director for a day or two. There are times when he or she may be too busy to give your portfolio the attention it deserves and may wish to look it over at a more leisurely pace. The art director may even wish to discuss it with other staff members.

When meeting with an art director, try to keep a positive attitude. Most art directors are looking for enthusiastic, dependable, hard-working people, so don't be afraid to show your interest in the job and your willingness to work overtime, if necessary.

If the interview has been successful but there are no jobs available, ask about others that might require your services. It's just possible the art director may know of someone.

What Not to Do

When it comes time to meet the art director, be aware that small, inconsiderate acts might offend:

If you smoke, ask permission to do so. However, if you don't see an ashtray on the desk, it might be wise not to smoke at all—especially today, when so many people have strong anti-smoking attitudes.

Some habits, such as gum chewing, may be socially acceptable, but are offensive during an interview.

When the art director is reviewing your portfolio, don't be defensive or argumentative. Remember, you too are being reviewed. This doesn't mean you shouldn't correct some misunderstanding; just don't pursue it unto death.

Don't go into an interview on your way home from a shopping trip with bags and excess luggage. Look professional.

Some of these points may seem petty, but remember that the art director is looking for the best person and will probably be seeing a number of applicants before making a decision. You should do everything possible to make sure you are the one who is chosen.

The Subject of Money

The subject of money should arise only if a firm job offer has been made. If you bring up the subject too early, you may give the impression that you are more interested in money than the job and the opportunities it offers. Salary should be secondary.

If an offer has been made, consider the salary in relation to the job and the growth opportunities. If you're interested in the job but feel the salary is too low, remember that salaries are often negotiable—within limits. If it is not negotiable but you still want the job, find out when you may expect your first increase and approximately how much it would be. You may find that in a reasonably short period of time you will be able to close the gap between what you need and what they are willing to pay.

Don't lose sight of your goal, and that is to get a job and experience; the money will come later.

Thank-You Letter

It is a good idea to write and thank the art director for his or her time. Although this is not a routine business practice, thoughtfulness is always appreciated. The letter should be simple, sincere, and can be handwritten.

```
                    12 Lakeview Drive
                    Boca Raton, FL  33433
                    January 11, 1983

Mr. Robert Adams
Adams Advertising, Inc.
197 Main Street
Miami, FL  33124

Dear Mr. Adams,

Thank you for taking the time to see me and
review my portfolio.  I thoroughly enjoyed our
talk and appreciate your excellent criticism.
Everything you said was carefully noted.

Thanks also for the leads.  I plan to follow
through on all of them--that is, once I get
my portfolio revised.

Most of all thanks for your time and
encouragement.

Sincerely,

Sheila West
```

Employment. 1: use, purpose
2: an instance of such activity
3: the act of employing: the
state of being employed.

EMPLOY-MENT

Getting a job is one thing, but starting a career is another. Accepting a job as a meaningful first step in a career and taking a job for the money or convenience are two different things. Understanding this difference is important if you want to avoid drifting from job to job with no goal or direction.

SETTING PRIORITIES

To get the right—or ideal—job, you must define your goals and set priorities. Knowing your priorities will give you confidence and direction. Among the things you should consider are: your definition of the ideal job, where you wish to locate, and how important money is to you.

Defining Your Ideal Job

Your first priority is to decide which area of the graphic design industry you are best suited for and which you feel would be the most fulfilling. Knowing this will help you define the ideal job.

For example, if you have a strong interest in a specific area, such as advertising, do research. Find out which agency is responsible for the ads you most admire and then find out all you can about the agency. Likewise, if you think you would like to be a book designer, be aware of which publishers consistently produce the kind of books that interest you. Researching companies and their products will give you a better understanding of the area that interests you and may help you decide whether it is what you really want.

If your problem is that you don't know which area of the industry interests you, perhaps it would help if you considered your interests or hobbies and tried combining them with your career. For example, if you enjoy music, you might think about working for a company that publishes books or magazines on that subject. Or an advertising agency with accounts in this field. By sharing a common interest with a prospective employer, you offer more than just your design skills. You are also more likely to enjoy your work and to succeed.

If, in the end, you can't find the ideal job, then be realistic and look for a job—even part-time or freelance—that represents a good step forward in your career. This could even be in an area that you never considered seriously before, such as computer graphics, exhibition design, or audio-visual presentations. It may even redefine your goals. However, if you are reluctant to take such a job because you feel you will outgrow it and have to leave, don't worry; changing jobs is very common in the graphic design field. Today, it is a rare employer who expects someone to stay forever.

Location

One way to start looking for a job is by deciding where you would like to live, whether in a city or the suburbs, on the East or the West Coast, or somewhere in between. Naturally, there will be more job opportunities in major cities where there are publishing, advertising, and other professions that hire designers. However, within a hundred miles of most cities there are design opportunities with local publishers and industries.

Don't be intimidated by larger cities. Many would-be designers fear that their work might not measure up to big-city standards, and so they don't even try. This is unfortunate, since most of the top designers in any large city were not born there—but came from all over the country—or world—to develop their careers. Also, keep in mind that large cities hire more designers—of widely varying talents—than smaller cities and rural areas.

If you do decide to work in a distant city, plan on visiting it for a week or two with your portfolio. Mailing a resume is not enough; an art director is not likely to ask someone to travel hundreds of miles in order to review a portfolio. Plan your trip well in advance; write to various art directors notifying them of your upcoming trip and requesting interviews. After a week or two of making the rounds and showing your portfolio, you will have a good idea of your potential and a pretty good indication of whether you would enjoy working and living in that particular city.

New York is the world's center for the advertising and communications industry.
New York has 17,308 designers, 4,000 ad agencies, 5,619 photographers, 10,860 draftsmen, and 21,165 editors and reporters.

Department of Labor, manpower projection, 1970 through 1980.

Salaries

If you are just starting your career, the subject of money can be complex. While no one expects you to give away your services, it is important to realize that at this stage of your career, what you need most is experience. Like a doctor, you have finished your education and must now serve out an internship at a salary that may seem less than you're worth.

It is difficult for anyone starting a new career to determine what is a fair salary. This is especially true for students who are unfamiliar with market salaries and therefore have difficulty putting a price on their skills. One way to get an idea of current salaries is to ask your instructors or practicing designers for guidelines. They can tell you how well various segments of the industry are paying for various jobs. Also, keep in mind that the salary for the same job in a publishing company, a design studio, or an advertising agency will differ. Unlike some professions, the graphic design field has no union to set wages. You may wish to pick up a copy of the latest *Pricing and Ethical Guidelines,* which will help you establish a reference point from which to work (see Bibliography).

In most cases, however, employers will not ask how much you want; instead, they will tell you how much the job pays. Most positions are budgeted, often with a high and a low figure to cover applicants with varying amounts of experience.

Before refusing a job that you feel pays too little, figure out just how much money you are talking about. For example, if the job offers $10.00 a week less than you wanted, you are talking about $520.00 a year. You could probably make that much money with one freelance job. It's more important that you like the job, in which case you will do better work—and as you become more valuable, your employer should raise your salary.

New designers do not always make money for their employers during the first few months—keep this in mind when calculating a fair salary. It often takes an art director more time to explain and supervise a job than to simply do it. By training you, the employer is making an investment in your future, looking toward the day when you have experience and can work unsupervised.

Benefits

Just as money is not the most important factor, neither are benefits. Pension plans, savings plans, and medical insurance should not be the determining factors when you are in your twenties and looking for experience. A pension plan that starts paying at age sixty-five should not be your prime concern, especially in a field as mobile as graphic design.

Companies offer benefit plans not only as a means of helping you, but of holding you. The plans appear so attractive that you lose sight of their true value. If benefits are a factor in choosing one job over the other, sit down with a pencil and paper and calculate their true worth; they may not amount to as much as you think. In such a case, you would do better to take the job that offers the best experience. You can always buy benefits.

Neither wealth nor splendour can take the place of tranquility and an occupation that gives happiness.

FINDING A JOB

Getting a job takes time; getting the right job takes even longer. The important thing is to get started: once you enter the job market and start applying your energies, opportunities will present themselves. Don't get discouraged—it's unlikely you'll find a job in a few weeks. Allow time; it may take months—or even a year—but during this period you will be meeting people in the industry, improving your interviewing techniques, and improving your portfolio.

If you are a student, keep in mind that when you do find a job it will be either at the bottom or quite near the bottom. Take heart; the bottom is an ideal place to start. You are free to learn, unencumbered by creative responsibility. You will probably be supervised, and your first job will no doubt be well within your abilities.

As you progress, you will be asked to share in design decisions, and if you are both talented and not afraid of responsibility, it won't be long before entire jobs are turned over to you.

You may also wonder if you are fast enough. Don't worry, for most art directors realize that, because you are a beginner, your creative skills may be a little slow and it will take time for you to develop both design skills and a sense of confidence.

Places to Start
Here are some suggestions that might help you find a job.

Ask Friends. As most people prefer hiring someone they know, or someone recommended by a friend, the best place to start looking for a job is close to home. Once your relatives, friends, and neighbors realize that you're in the job market, they will let you know if they hear of any job opportunities. You may also wish to suggest that they inquire about the job possibilities among their suppliers and clients, who might include advertising agencies, design studios, and printers. Be sure to give everyone a copy of your resume so they can speak more intelligently about you and your skills.

Career Counseling and Job Placement. If you are a student, another good place to start is your school job-counseling service. They usually have a list of potential employers who have inquired whether there are any students interested in part-time or full-time work.

Classified Ads. One of the first places you should look is the classified ad section of the local newspaper. Turn to the Help Wanted section and go through the ads listed under Advertising, Art, Graphic Artist, and Designer. Many companies do not list their phone numbers but request that you reply to a newspaper box number so they can screen the applicants.

It generally doesn't pay to place an ad yourself, although you may wish to give it a try. If you do, spend a little time beforehand looking over ads to determine where you want it listed and also how to write it as professionally as possible. Don't mention money; salary should be open to negotiation.

Clubs and Organizations. Art directors clubs, advertising clubs, illustrators clubs, and similar organizations are valuable places for making contacts in a natural, informal way. It gives everyone an opportunity to get to know one another in a relaxed atmosphere away from phones and the steady stream of interruptions that are a part of everyone's life.

Contact the clubs in your area and ask about job listings, special programs, lectures, portfolio reviews, and evenings designed to bring people together. Many of the clubs also offer special memberships for students and young designers.

Employment Agencies. Although most employment agencies prefer to deal with experienced designers who can command high salaries, they will often take on an inexperienced individual with strong potential.

If you decide to try an agency, make sure it is one that specializes in placing graphic designers. Graphic design is a specialized field, and most regular agencies will not handle this type of applicant.

1. LMP (*Literary Market Place*) lists all major book publishers in both the United States and Canada.

2. *Standard Directory of Advertising Agencies*, called the agency red book, lists advertising agencies along with other pertinent information.

LMP with NAMES & NUMBERS 1982

LITERARY MARKET PLACE / DIRECTORY OF AMERICAN BOOK PUBLISHING AGENTS, ARTISTS & ART SERVICES, ASSOCIATIONS, BOOK CLUBS, BOOK LISTS, BOOK MANUFACTURING, BOOK PUBLISHERS, BOOK REVIEWERS, CALENDAR OF TRADE EVENTS, COLUMNISTS & COMMENTATORS, COURSES FOR THE BOOK TRADE, DIRECT MAIL & PROMOTION, EDITORIAL SERVICES, EXPORTERS & IMPORTERS, GOVERNMENT AGENCIES, LITERARY PRIZES & AWARDS, MAGAZINES, NEWSPAPERS & NEWS SERVICES, PAPER MILLS, PHOTOGRAPHERS, PUBLIC RELATIONS SERVICES, RADIO & TELEVISION, SALES REPRESENTATIVES, SERVICES, SHIPPING, SUPPLIERS, TRANSLATORS, TYPING, WHOLESALERS, & WRITERS' CONFERENCES

1

Agency services do not come free of charge. There is a fee, which is generally paid by the employer. Fees may be a percentage of your annual salary or one month's pay.

You may also wish to check out your state and federal government employment agencies. The federal government spends more on advertising than do many of the largest corporations. Although a great deal of this may be done through private advertising agencies, there are still many graphic designers employed by the government. After all, the U.S. government is the largest publisher of printed materials in the world!

Faculty. Being recommended by your instructors is one of the most effective ways of getting a job. Because a recommendation is a reflection on the instructor and on the school, only the best students will be chosen. In most cases, two or three students will be selected so that the prospective employer can choose the one best suited to the job. Keep in mind that "best" does not necessarily mean "most talented." What may be of greater concern are such characteristics as reliability, maturity, pleasant personality, and the ability to work hard.

What makes this arrangement so agreeable is that the instructor can vouch for both parties and may help determine a fair starting salary.

Publications. Every major industry publishes a trade magazine designed to inform the reader of news in the industry. While these publications do not specialize in listing jobs, they may be of help to anyone who is seeking a job. For example, if you are interested in book publishing, there is the *Literary Market Place*, more commonly called LMP. This has a complete listing of publishers classified by field of activity and subject matter. If you are interested in a particular subject—say, music or photography—LMP will tell you all the publishers specializing in those fields. It also shows their mailing addresses and phone numbers.

There is also a directory published by the Standard Rates and Data Service, more commonly called SRDS, listing all the magazines. Both the SRDS and LMP are very large books used mainly for business purposes, but they contain a wealth of information for an enterprising job-hunter. If copies are not available at your local library, you could ask a local publisher if they have a copy you could review.

For anyone interested in advertising there is the *Standard Directory of Advertising Agencies*, more commonly referred to as the agency red book. This lists all agencies, foreign offices, key personnel, and main accounts.

Another useful book for the graphic designer is *The Creative Black Book*, which lists agencies, photographers, designers, etc., both in the United States and abroad. This book is available in most art stores.

2

School Alumni. Most major art schools keep an up-to-date listing of their alumni along with their titles, company names, addresses, and phone numbers. The list is usually available through the dean of students.

As a graduate you are part of the "Old Boy" or "Old Girl" network. You will find that alumni are fond of hiring people from their alma mater—providing, that is, they were pleased with their own education!

As an alumnus you share common experiences with the employer, speak the same "language," and may even have had the same instructors. Working through alumni also distinguishes you from other applicants who did not attend your school.

Yellow Pages. Let your fingers do the walking. While the yellow pages do not list job opportunities, they do list companies that hire designers. (See the index in the back of the telephone book listing all the categories alphabetically.) The companies are conveniently classified as follows: advertising agencies, advertising display designers, advertising layout artists, magazine and book publishers, and so on. One of the advantages of using the yellow pages is that all the companies listed will be in your area.

ON THE JOB

Your first day on the job will probably be one of anxiety: you'll be happy to be starting, yet nervous. This is true whether it's your first job or your fifth job; a new job means meeting new people, new challenges, and new responsibilities.

Whether you are working for a company, a studio, or yourself, you will find that one of the greatest assets you can have is an ability to work effectively with others. As a graphic designer, you have welcomed into your life a variety of people: art directors, copywriters, editors, account executives, promotion managers, research specialists, typesetters, production people, and, of course, clients. How well you work with this "supporting cast" will, to a great degree, determine your success.

Working with Art Directors
Most experienced designers realize that a successful working relationship between an art director and a designer depends on how well their skills and personalities complement one another.

The best art directors are those who are talented, confident, and able to communicate. They should be generous enough to share their knowledge. As the title suggests, the art director should be able to direct, and that includes directing you to your full potential.

Many people like to work only from nine to five. Unfortunately, there are very few nine-to-five design jobs. To ensure a good working relationship, be reliable, enthusiastic, and willing to stay at the drawing board as long as it takes to get a job done. Often art directors have crises where deadlines must be met, and it is during these times of stress that your reliability will be valued.

1. The company rules for an 1850s studio make work today seem easy.

2. Ad by United Technologies offers good advice for both designers and copywriters.

Company Rules

1. Office employees will daily sweep the floors, dust the furniture, shelves and showcases.

2. Each artist will bring in a bucket of water and a scuttle of coal for the day's business.

3. Artists will each day fill lamps, clean chimneys, trim wicks. Wash the windows once a week.

4. Make your pens carefully. You may whittle nibs to your individual taste.

5. This office will open at 7 A.M. and close at 8 P.M. daily, except on the Sabbath, on which day it will remain closed.

6. Man employees will be given an evening off each week for courting purposes, or two evenings a week if they go regularly to church.

7. Every employer should lay aside from each pay a goodly sum of his earnings for his benefits during his declining years, so that he will not become a burden upon the charity of his betters.

8. Any employee who smokes Spanish cigars, uses liquor in any form, gets shaved at a barber shop, or frequents pool or public halls, will give me good reason to suspect his worth, intentions, integrity and honesty.

9. The employee who has performed his labors faithfully and without fault for a period of five years in my service, who has been thrifty and attentive to his religious duties, and is looked upon by his fellow men as a substantial and law abiding citizen, will be given an increase of five cents per day in his pay, providing a just return to profits from the business permits it.

Working with Non-Designers

As a graphic designer, you will be working with writers, production people, executives, and others who initiate and approve all jobs. Understanding their interests and responsibilities will make you more effective and appreciated.

In many ways, working with an art director is simple compared to working with non-designers. Unlike the art director, they seldom have an art or design background, and many of their likes and dislikes are based more on personal preferences than principles of good design. However, while their design judgment may leave something to be desired, they are experts in their repective fields, and so their views should be taken seriously. Here are some of the people with whom you may be working:

Writers. Writers, including copywriters, editors, and journalists, are responsible for writing the copy that the designer must work with. Many writers were English majors in college and have an appreciation for the written word and the rules of grammar. To work effectively with this group the designer, too, should be literate. If time permits and English courses are available, improve your grammar and your creative writing skills.

Production People. Production people are responsible for seeing that jobs are produced properly and within budget. To communicate intelligently with this group, you will have to understand production, from typesetting through printing. If you have not taken any courses in production, you may wish to read up on the subject.

Executives. This group includes presidents, vice-presidents, editors-in-chief—in short, everyone who has control over your work. They are primarily business people and know more about P/L (profit and loss) and GNP (gross national product) than they do about white space or typography. The more you understand business, the better you will understand how executives think. They, in turn, will no longer see you simply as a designer, but as one who also understands their problems.

Keep It Simple

Strike three.
Get your hand off my knee.
You're overdrawn.
Your horse won.
Yes.
No.
You have the account.
Walk.
Don't walk.
Mother's dead.
Basic events
require simple language.
Idiosyncratically euphuistic
eccentricities are the
promulgators of
triturable obfuscation.
What did you do last night?
Enter into a meaningful
romantic involvement
or
fall in love?
What did you have for
breakfast this morning?
The upper part of a hog's
hind leg with two oval
bodies encased in a shell
laid by a female bird
or
ham and eggs?
David Belasco, the great
American theatrical producer,
once said, "If you can't
write your idea on the
back of my calling
card,
you don't have a clear idea."

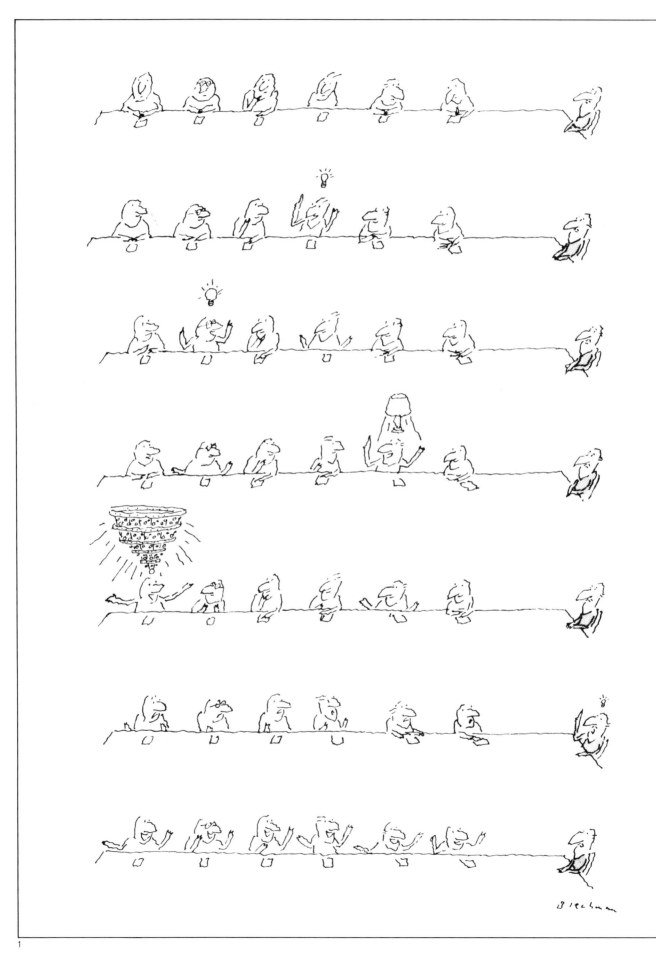

Design Meetings

Design meetings are an important part of a designer's job. At their finest, they benefit everyone; ideas are constructively evaluated, and the project improves with each contribution. At their worst, they can deteriorate into a free-for-all where office politics may play a great role.

In many ways, meetings are a designer's best friend. When all key personnel and decision-makers are present, jobs are discussed and questions answered in an open forum rather than being passed down—and reinterpreted—from one person to another before reaching the designer. Also, being present at a meeting gives you the opportunity to explain—or defend—your design decisions.

Design Approval

Design approval is seldom in the hands of the designer or the art director. In some companies approval is given by a single person, while in others you may have to go through what seems like the entire organization before the job is approved. What makes the latter situation so frustrating is not just the time consumed, but the temptation for everybody to change the copy or modify the design before giving their approval.

If the job is rejected, it may not be due to the design; in fact, the design may be the only part everybody likes or agrees upon. The problem could be the copy, the entire concept, or even the budget.

When this happens to you, remember that no designer has every job approved. Top designers routinely have jobs rejected or modified; it's part of the business. Most professionals take rejection rather well—or at least they behave professionally. They listen to the criticism, weigh it, and then try to solve the problem.

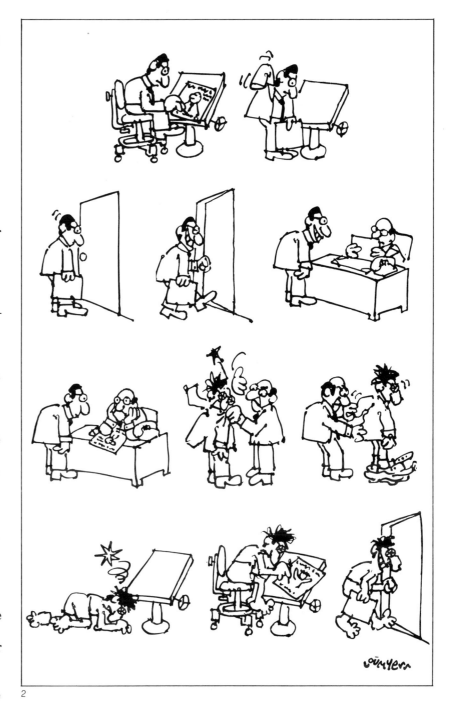

2

1. Design meeting can become political, as illustrated by R. O. Blechman.

2. Not every job you do will please the client, but keep trying. Illustration by Lou Myers.

FREELANCING

Working freelance is very common in the graphic design field; according to recent figures, over one-third of all graphic designers are freelance. One reason is that many companies do not require the full-time services of a graphic designer and find it more convenient to hire designers on a part-time basis. Other companies find they can create more diversity in their graphics by using a number of freelance designers as opposed to a few staff designers.

There are many advantages to being a freelance designer: you are your own boss; you can select your own clients; develop your own working schedule; bill for each job independently; and work from your own home or studio.

There are also disadvantages: there is no art director to help you make design decisions and take responsibility. You must work directly with the client. There are no company benefits, such as paid vacations, medical programs, and pension funds; if you are sick, there is no one to take over for you; and when times are tough, your client may choose to keep all work in-house. As a freelance designer, you are also responsible for all your own operating costs, such as rent, gas, electricity, business equipment, phones, and messenger service. In the event a client fails to pay a bill, you will either have to take a loss or pay a lawyer's fees should you decide to take legal action.

Apart from its advantages and disadvantages, freelancing is often a question of temperament; some people enjoy the freedom associated with freelance work, while others would panic not knowing where the next job or paycheck was coming from.

Setting Up a Practice

There is more to being a freelance designer than just creating designs for a variety of clients. You are running a business, which involves all the complexities of any business operation.

Besides having a place to work and all the necessary equipment, you will need a good accountant—one who is familiar with the graphic design business and can advise you on business matters, and can help you open the right kind of bank account. Don't use your personal account; not only is it unprofessional, but sooner or later it will become a nightmare. Your business and personal expenses become hopelessly confused and can present many problems should you be audited. Once you have a bank account, you can begin to establish credit which will allow you to open accounts with typesetters, stat houses, and art supply stores.

Don't Overextend Yourself. As a freelance designer you will be working with a wide range of clients requiring different services. Some will use only your design abilities, while others will expect you to be responsible for entire jobs, from concept to printed piece. While the former should not present any problems, the latter might.

The challenge of taking the responsibility for entire jobs is not the design, which you should be able to handle, but coordinating all the suppliers, from typesetters to printers, to ensure that deadlines are met. For example, when preparing schedules, beware of holidays, for they may not be counted as working days by the supplier. A simple oversight such as this can play havoc with your schedules and may mean missing the deadline.

Another consideration is whether you are solvent enough to cover cash expenditures. If you are just beginning, your suppliers may wish to be paid before they do the job; this could run into thousands of dollars. If the client does not pay until sixty or ninety days after delivery, you may find you are operating at a loss. And what if the client doesn't pay?

No matter what the job is, make sure you understand what you are getting into before making the commitment.

Good design
starts with
good copy.

Understanding the Client's Needs

In order to do your job—that is, design—you must understand the client's objectives. This should not be a problem if the people with whom you are working are professional and accustomed to working with designers. You will find that they have thought the project through and know what they wish to accomplish. It will be your job to give it form.

Unfortunately, not everyone knows what they want; some clients may be working with designers for the first time, or they may be inexperienced. In this case, getting the necessary information may be difficult, especially for beginning designers who don't know the right questions to ask. It's a little like two people trying to dance when neither knows how to dance and neither will admit it. However, it will be your job to help the client define the problem (see Solving Graphic Design Problems, page 133).

If you still find it difficult to get a direction, try asking about solutions that have worked in the past or reviewing what the competition is doing. This is done, not with the intent of copying, but to get some point of departure.

Be aware that any line of questioning has to be handled carefully. It is not uncommon to have a client remind you that *you* are the designer. This is unfortunate because the client is confusing discussing the job with doing the job. Remind the client that a designer's job is very similar to an architect's, and you would not ask an architect to build a house for you without first discussing your needs. As your design skills improve, so will your verbal skills, and you will soon learn the questions to ask.

Also keep in mind that if you hope to get your ideas across, you must communicate in a language the client can understand. Although you may not be aware of it, you could be using terms that are confusing at best and meaningless at worst, such as *white space, activate, tensions,* and so on. While any designer will know exactly what you are talking about, don't be surprised if the client is confused. You may not be communicating as well as you think.

Color. Understanding your client's ideas on color will not solve the major design problem, but color is one aspect of a job where people have strong likes and dislikes. It is an area where designers and their clients often disagree.

From the designer's point of view, it may seem that clients like to splash color around; after all, they're paying extra for color and want their money's worth. Clients also like to use color to stress important points. While designers agree with this in principle, they differ when clients feel that every second word is important.

From the client's point of view, many designers strive too hard to be tasteful, preferring to use color the way a woman should use perfume—sparingly. They feel the designer may know design but doesn't understand the market and how to get the reader's attention. And so on.

A great deal of this misunderstanding can be put out of the way if you can both agree on how much color to use, and where.

> The designer has the responsibility to help define the problems which he must later solve. He is not one who expounds some particular point of view or style. He is a borrower, coordinator, assimilator, and juggler. He is a collector of past and present technology, and from himself. His style and individuality come from the consistency of his own attitude and approach to the expression and communication of a problem.
>
> *Ivan Chermayeff*

How Many Designs Do I Do?

There are no rules governing the number of designs you should do for a client; some are satisfied with one, whereas others want a choice. One of the problems with offering too many solutions is that the client won't be able to decide which design is best and will probably want a composite.

Ideally, one good design should suffice. This is especially true if you have had a design conference and a general agreement with regard to the direction. If, during the design process, you have come up with a design that you feel is better than the original, then make an extra comp and show both.

If neither solution is acceptable, then find out why; it may only be a minor adjustment or change of type style. If it's major, then you may want to suggest another design conference so everyone can rethink the project.

If your designs are rejected again and both you and the client feel the job should be given to another designer, then you should get a *rejection fee*. This will not be the full design fee, but a percentage based on the amount of work done and the expenses involved.

"Do Something You Like"

When a client is uncertain about just what is needed, it is not unusual for a designer to be told "just do something you like." At first this might seem like a vote of confidence in your abilities, but unless you know the client very well and this arrangement has worked for you in the past, it is merely a way for the client to say, "I don't have the faintest idea of what I want."

Open projects are usually too good to be true. Often you will exhaust yourself to come up with something original only to find the client is disappointed. Or the client may love it but be unable to produce it within budget.

Generally speaking, it is better to get a job that has been discussed and agreed upon. Not only does this give you a direction in which to work, but also, when the design is finally presented, it won't come as a surprise to anyone.

Establishing Your Design Fee

How much to charge is probably one of the most difficult questions to answer. In part, your fee will be determined by your talents, ability to negotiate, and the segment of the industry you are catering to. Advertising, which is often more demanding, will pay more than publishing, even though the jobs may be similar. (Some jobs you may wish to do for nothing—for example, as a contribution to a worthy cause or for a piece that will greatly benefit your career.)

Never take a job until you have agreed upon a fee. If you don't know how much to charge, try asking the client if a design fee has been established. Reasonable clients or art directors will usually give you the figure. If the client doesn't have a figure, you will just have to estimate the job based on the number of hours you expect it will take multiplied by an hourly rate. Don't forget to add such expenses as photostats, type, paper, and printing.

To ensure there are no misunderstandings, give the client a written estimate specifying the price and exactly what it does and doesn't cover. You may

> By making something absolutely clear, somebody will be confused.
>
> *Murphy's Law*

wish to stipulate that your price is for estimating purposes only and will not be finalized until you are given all the details.

Estimating a job by the hour is better suited to mechanical work than to creative work. A method that is inherently more fair to the designer is measuring the job's value by its results. If the solution is good, then time has little to do with it. You wouldn't evaluate a painting based on the number of hours it took the artist to complete it!

This does not mean the sky is the limit and you will get whatever you ask for; the marketplace will determine the final value of your efforts. The greater your talents and reputation, the more you will be able to charge. If you are of average talent and ask too much, the client will simply call in another equally talented, but less expensive, designer.

While there are no agreed-upon standard prices in the graphic design industry, figures that can be used for estimating purposes are listed in *Pricing & Ethical Guide Lines*, published by the Graphic Artists Guild.

As in all businesses, it is in your interest to get as much as you can for your services, just as it's the client's job to buy services as inexpensively as possible. At first you may tend to undersell your skills, but as you progress you will not only get more for your services but also weed out unprofitable, unfulfilling jobs.

Being paid a proper fee often involves educating the client, who may not be aware of the work that is involved in creating a design. Where you see a minor masterpiece, the client may see nothing more than a couple of photographs and some type. When you present a bill for hundreds of dollars, the client is naturally confused and asks, "Why so much?"

One of the difficulties of trying to establish a fair price is the fact that good design often looks effortless. Some clients feel it should be priced accordingly. What is too often overlooked is the fact that if good design were so simple, there would be no bad design around. And we know this is not true.

1. What you see and the client sees may be two different things. Courtesy Charles Schultz from *Peanuts*. © 1960 United Features Syndicate, Inc.

```
                              JEC Corporation
                              212 Laguna Road
                              Kent, OH  45221
                              November, 16, 1982

Ms. Susan Rizzo
22 Mountain Street
Salem, OH  45222

Dear Ms. Rizzo,

This letter will serve as our agreement
for the services to be rendered by you
in the design of our two-color, four-page
brochure.  The dimensions are 8½ x 11.

These services include a rough layout for
approval followed by a finished comp with
display type, illustrations, and color
indicated.  Following final approval you
will provide us with a camera-ready
mechanical.

The agreed upon fee for the above services
is $2,000.00 to be paid upon completion
of the mechanicals.

Please sign both copies of this agreement
and return one to the JEC Corporation.

Cordially,

John Dupont          Susan Rizzo
Art Buyer
```

1

Contracts

Beginning designers are often poor business people and can be easily exploited. They have difficulty discussing fees and seldom ask for a contract, no matter how big the commitment.

If you are about to take on a job with a new client, get something in writing. This does not have to be a contract drawn up by lawyers; it can be a purchase order or a simple letter of agreement signed by both parties. Such an agreement is very important when you are involved in a job that may continue over months or years, and one party or the other may forget the terms. A signed agreement becomes even more important should you have to sue.

If the client refuses to sign any agreement but you wish to take the job anyway, at least write down the terms as you understand them and send the client a copy by registered mail. It's not a contract, nor is it a letter of agreement, but it's better than nothing.

Changes and Corrections

It is not unusual for a design to be approved, the type ordered, and the mechanicals prepared, and then have the client change the design by adding new copy. This may ruin your design and may even spoil your day, but if the client wants the change, it must be made. Your problem is to make the change without ruining your design.

Whether or not you charge the client for the extra work involved depends a great deal on the nature of the changes and who the client is. If the changes are minor, then there is no need to charge. Just consider it part of the service. If the changes are major, discuss the situation with the client and see if you can arrive at some compromise to cover the extra work involved. If the client refuses to compromise and you don't wish to lose the business, you will just have to write it off. The next time you quote on a job for the same client make allowances for alterations.

Generally speaking, you should be able to charge extra for changes and corrections, providing they are not your errors. One thing is certain: the typesetter will charge for resetting the type and the printer, for stripping in the corrections.

1. A simple letter of agreement can get a job started on the right foot.

2. Although the author is unknown, he or she certainly saw the humorous side of a very touchy subject.

OK with corrections

I dread to take a picture to the man who wants to change things;
　Who says, "That's fine, just what I want, but let us rearrange things.

Let's move that building over and give the man a cane
　And add an umbrella just in case it starts to rain.

And change the girl's expression to one of glad surprise.
　If it isn't too much trouble, change the color of her eyes.

Don't clutter up the picture with meaningless detail,
　But get a clock in somewhere with a boat about to sail.

I suggest a troop of soldiers and a fat man with the gout,
　Also a railroad station with a train just pulling out.

The man is running for the train and fears he may be late,
　So have him looking at his watch with hands at half-past eight.

Don't let the thing get crowded—we must have room for copy—
　But give the girl galoshes because the weather's sloppy.

And make the oak a maple, and make the horse a cow;
　And make the hen a rooster, and make that rake a plow.

With these few minor changes, everything's OK;
　We're much behind our deadline, please finish it today."

　　　　　　　　　　　　　　　　　—*Author Unknown*

2

This form is designed to help organize instructions to the typesetter.

Date: Job Number:

Typographer: System:

Type (typeface, type size, linespacing, and measure)

Type Arrangement

Justified

Unjustified

Flush left, ragged right Minimum line picas

Flush right, ragged left Minimum line picas

Centered

OK to hyphenate

Letterspacing

Normal

Loose

Tight

Very tight

Touching

Letterspacing acceptable to justify line ☐ Yes ☐ No

Wordspacing

Normal

Loose

Tight

Very tight

If justified, set with units minimum and units maximum wordspacing.

Paragraphs

Indent all paragraphs em(s)

First paragraph flush, indent all others em(s)

All paragraphs flush left with line(s) space between.

Minimum acceptable widow is characters.

Special instructions

Typesetting Charges

Typesetting charges can run into hundreds, if not thousands, of dollars, and for that reason it is terribly important to clarify at the outset who is paying for this service, you or the client.

If the client has a typographer, it is very simple; order the type and have it billed directly to the client. This way the client is responsible for both the typesetting charges and the quality of the type.

If the client doesn't have a typographer, you will have to order the type and then bill the client. You are entitled to add 15 percent to the type cost as a service charge. (The same applies to any other service you will be handling for the client, such as photostats, paper, printing, binding, and shipping.)

When quoting on a job involving typesetting, don't forget to make allowances for the cost of corrections, also known as author's alterations (AA's). You can cover yourself for these charges by adding a percentage to the typesetting charges or by simply stating that the price does not include author's alterations.

Mechanical Charges

At many agencies and studios where records must be kept on how time is spent on each job, clients are charged separately for design time and mechanical time—with design time being the most expensive. In cases where the charge for mechanical time is relatively small, you may wish to include it as part of the design fee.

Rush Jobs

Rush jobs are quite common in the graphic design field. Although a job may be planned well in advance, with adequate time allotted for each phase, somehow it doesn't always work out. Somewhere along the way, time is lost, and it usually becomes the designer's responsibility to make up the time and put things back on schedule.

This burden is seldom put on the printer; press time is scheduled months in advance, and changes are expensive. Should the press time have to be rescheduled, there is the possibility that the printed piece will not make its deadline, which can be critical.

Whatever the reason for the rush, usually the designer is asked to do the job in a fraction of the time required. Fortunately, most clients are aware that rush jobs are demanding and cost more. However, don't be surprised if a client gives you an overnight job and then expects a discount because it only took one night! In order to get paid a proper fee, remind the client that one pays a premium for all rush services—typesetting, film processing, and design.

If a client continually gives you rush jobs, there may be something wrong with the way the jobs are being organized. Make the client aware of how much extra the jobs cost in wear, tear, and *dollars*—it may help.

If you can't come in Sunday, don't come in Monday.

Sweatshop sign

Controlling Quality

There is a computer term, GIGO, short for "garbage in/garbage out," which simply means that if you program a computer with garbage, it will give you back the same garbage. GIGO also applies to design.

If a client gives you bad photographs or poorly written copy, then the best design in the world will be of little value. These shortcomings will be evident in the printed piece. Furthermore, as the designer you will probably be held responsible for its quality.

Good design starts with good copy. Before taking on a job, look over everything that is being given to you and point out what can be improved. If changes can't be made, at least you're on record as having discussed the matter. You may also wish to remind the client that the best and least expensive time to upgrade the quality of photographs and illustrations is when they are first made, and the most expensive—and least effective—is when the job is at the printer's.

Designer's Checklist

When you are starting a career as a freelance designer there is a tendency to take on jobs before you fully understand them. This often stems from the desire to appear confident and therefore avoid asking questions. However, if you don't ask questions, you may end up wasting a great deal of time—both yours and the client's.

Here are some questions you might consider asking. They are broken down into four categories: design, schedules, production, and finance.

Design
Is the copy complete and edited?
What are the dimensions?
Do the dimensions include bleeds?
How many colors?
How many pages?
Must all copy be used, or can it be cut?
What copy (or illustrations) should be emphasized?
Can photographs be cropped?
Are the number and quality of photographs acceptable?

Schedules
When are layouts or comps due?
When are finished mechanicals due?
When are printed pieces due?

Production
Who is the printer?
What kind of paper will be used?
What is the printing process?
Who is responsible for checking proofs?

Finances
Has the price been agreed upon?
What are the terms of payment?
Does it include type?
Does it include mechanicals?
Does it include photostats?
Does it include paper, printing, etc.?
Does it include any original art you may have to do?

Copyright and registered marks are used to protect logos, trademarks, illustrations, photographs, etc.

Agents and Representatives

There are freelance artists who prefer to work through agents and representatives rather than spend their time looking for clients, picking up and delivering jobs, and so on.

The agent handles everything, including negotiations, meetings, and billing the clients. At times there is also the advantage that the agent can get better paying clients than the artist could find independently. In such a case, the agent's fee will pay for itself.

Agents usually work for 25 percent of the gross billing. All work must be billed through the agent, including work that you bring in yourself. Should you decide to cancel the contract with the agent, you will find you must pay commissions for a period extending beyond the date of cancellation.

Working through agents is much more common with illustrators and photographers than with graphic designers. If you are interested in working through an agent, you will find them listed in the yellow pages or *The Creative Black Book*.

Copyright

The United States Constitution gives Congress the power "to promote the progress of science and useful arts, by securing for limited times to authors and inventors the exclusive right to their respective writings and discoveries." Since the Constitution was written there have been many revisions of the copyright law, including one that permits artists and graphic designers to protect their work. Copyrighting is a legal process which involves filling out an application for copyright registration and paying a small fee.

Getting works copyrighted is much more common with illustrators and photographers than with graphic designers. Copyrighting permits the artist to sell the client a restricted use of the art, after which time the rights, along with the original art, revert back to the artist.

Copyright laws are very complex and well beyond the scope of this book. Anyone interested in copyrighting their work may wish to read *Copyright Handbook* by Donald F. Johnston or *The Visual Artist's Guide to the New Copyright Law* by Tad Crawford.

HOW I GOT MY FIRST JOB

Every designer had to start some-where, and just in case there are some readers who feel that today's successful designers had it easy or their careers were handed to them on a platter, read on.

Ed Benguiat
Vice President, International Typeface Corp. and Photolettering, Inc.

My first job was to fill glue pots and cut mats. I felt that to get any job that gave me experience would be better than waiting for the job that would never be. You know . . . more money, etc. What I had was good designers around me, and, believe me, it paid off in the end—I did everything and any-thing to get experience, and more than anything I was always keeping myself busy. Patience and promptness is all one needs to get started.

1

1. Poster designed by Ed Benguiat for Photolettering, Inc.

2. Book cover by Betty Binns.

3. Logo designed by Pieter Brattinga for a Dutch gallery.

2

3

Betty Binns
Graphic Designer

After carefully preparing myself for the real world by taking a liberal arts degree and specializing in mathematical philosophy, I entered the job market with the vague notion that I was a "word person." After some adventures, I found myself working as a clerk in the production department of a small publishing house, where I saw my first type-specimen book, fell passionately in love with Bodoni, and decided to become a graphic designer. I wormed myself into the dummying department of a much larger publishing house and soon after became a junior designer. All too soon after that, I became the art director of their college department.

Clearly, all my training has been on the job; much of it, under pressure to learn, and use what I learned, immediately. The learning and the pressure still go on every working day. I have sometimes felt the lack of an art-school background in that my craft skills (mechanicals, comps, etc.) remain poor; but I am constantly grateful for my training in problem-solving, and for the respect for content and structure that my liberal arts background gave me.

In hiring, I tend to discount art-school training and look for people with visual flair, a balanced education, and good hands.

Pieter Brattinga
Management Consultant for Art and Design, Amsterdam, Holland

My first job was such a long time ago that I really do not remember how I behaved during its presentation or acceptance. Now, a long time afterwards, I could tell students that flexibility of mind and the ability to understand the reasoning of the client are among the most important assets of the designer.

After the first discussion with the client, the designer should jot down, in order of their importance, all the elements that were brought forward during the briefing. Then, in the same order, try to reason, and write down on paper, a possible solution for each of those points. After you have elaborated on the thumbnails, a first rough will develop. Ideally, this should be put away for a few hours—or, preferably, for several days—and then looked at again and judged against the client's needs.

If you are convinced that you have enough creative talent and you have a logical way of thinking, your first job might be a tremendous success.

Aaron Burns

President, International Typeface Corp.

When I came out of the service in 1946, I had great difficulty trying to get my first job. Hundreds of thousands of veterans were clogging up the job market, and jobs were not to be had easily.

I had no experience. I had gone to school before the war, and I didn't even know how to do a paste-up or mechanical as it is known today.

I was fortunate to find a small advertising agency that allowed me to work for them for three weeks *at no pay* just so that I could learn to do paste-ups properly. This was a breakthrough for me because it gave me the opportunity to gain some experience.

At the agency a copywriter helped me write the copy for a postcard ad that I sent out to 120 art directors at 120 different advertising agencies.

The cost for the penny postcards was $1.20. The printing and typesetting was $7.50. I did my own addressing by hand. The headline copy read:

NEW AND STIMULATING
TALENT FOR YOUR ART
DEPARTMENT

The text followed:

If you are looking for someone for your art department who is new, young, inexperienced and anxious to learn and for whom salary is secondary to the opportunity to learn and gain experiences then please call or write me. Aaron Burns (address and phone).

This simply written postcard brought me seven job opportunities. I interviewed the seven companies who responded to my card and took a job with a small advertising agency as assistant to the art director and production manager.

But I remained there only two months. The advertising agency for whom I had first worked for no pay called to tell me that they had recommended me very highly to an outstanding graphic designer who was associated with one of the finest printing houses in New York.

I took the new job and was on my way at last to becoming a graphic designer, my future goal.

But it all would not have happened were it not for the penny postcard self-advertising campaign and my willingness to take a job for no pay just to learn.

It turned out to be the biggest payoff in my life.

1

1. Announcement for a lecture on typography. Early design by Aaron Burns.

2. Cover design for a student project by Cipe Pineles Burtin.

Cipe Pineles Burtin
Graphic Designer

I had a hard time finding my first job in the depression years of the early thirties. After lugging my portfolio around to every studio, agency, and publisher in town for a whole year, I finally landed a job in what surely was one of the first industrial design studios; it was called Contempora.

Actually, I had been offered a job six months earlier, when I had left my portfolio at an ad agency. But when I showed up for the interview the following day, they said, "Very sorry, no job; we didn't know you were a woman."

Contempora billed itself as a group of famous professional designers, artists, and architects who were ready to design anything from an aircraft to a coffee pot—and, of course, we mainly had coffee pots. The international artists listed were, among others, Lucien Bernhardt, Marcel Breuer, Vally Wieselthier and Wolfgang and Pola Hoffmann (from Weiner Werkstadte).

My job was to be assistant to Vally Wieselthier, a ceramic sculpture artist, who had just finished the reliefs for the elevator doors of the Squibb building and was working on a group of garden fountain figures. My task was to cover all works with huge damp cloths the minute Vally stopped working, which was frequently. Eventually, I was put to work on painting swatches for fabrics to be printed on cotton in an attempt to make cotton cloth into a fashion fabric and take it out of the housedress category. That meant going around town to all the most expensive, exclusive shops as well as following the dictates of *Vogue, Harper's Bazaar, Jardin de Mode, Silberspiegel*, etc., to discover, in the first place, what's fashionable, stylish, smart, chic, what's coming in, what's going out. My salary was $23.00 a week, but it was mainly owed to me, since business was very bad. However, Contempora's parties were very good and they gave many of them at their sleek black-and-white showrooms on Madison Avenue in the fifties.

That's where and how I met Mr. Condé Nast, who admired my shoe-box window displays filled with paper dolls wearing chic dresses made from the above-named smart cotton fabrics. Mr. Condé Nast offered to introduce me to the art director of Condé Nast Publications, which included *Vogue, Vanity Fair, The American Golfer,* and *House and Garden.*

Dr. M. F. Agha hired me as his assistant, and I got paid every week for the next twelve years on that job.

My advice to students is don't worry about how much money you get on your first job. Don't be concerned with your title, nor with how sleek the office decor is, nor how many windows your workspace has, nor how many others are in the bullpen with you, nor how you are stuck with one mechanical after another.

Your only concern is to choose your first job as though you were choosing a post-graduate course in graphic design at some university that's very costly, like Yale.

Apply for a first job by showing your portfolio to every top designer whose work you especially admire—and there must be at least twenty-five of them on your list. When you have exhausted that list, go to the next three hundred to five hundred good designers,* all ready to give you a post-graduate course and a salary as well.

*Who, though not as well known or as much publicized as the top names, are nevertheless designers you can learn a lot from.

2

Cipe Pineles Burtin

Seymour Chwast
Illustrator, Graphic Designer

I wanted to be a cartoonist and work for Walt Disney from the age of seven, but this goal was thwarted by my art teacher at Abraham Lincoln High School in Brooklyn, who showed me the light. Leon Friend was his name. He said that with "10 percent inspiration and 90 percent perspiration," my fellow budding artists and I would become great and glorious GRAPHIC DESIGNERS. Well, I sweated a lot for two years in high school and later at Cooper Union.

Three weeks after graduation, an art director recommended me to the promotion department at *The New York Times*. This was my first job. I learned about typography from George Krikorian, my art director.

The next three to four jobs were not so idyllic. I was fired from each one of them. Milton Glaser, Ed Sorel, and I published a mailing piece called The Pushpin Almanack. It was successful in acquiring freelance design and illustration work for us, leading to the formation of Pushpin Studios.

I still perspire a lot.

End Bad Breath.

David Epstein
President, Dave Epstein, Inc.

Remember my first job? I can remember my very first *interview*. It was with CBS, and I was roasted for stacking type flush left instead of running it in one line. I'm still not sure what I did wrong. But I was just out of school and impressionable. After that interview things could only get better.

My first bona fide job was with a small fashion/furniture agency working with Morris Rosenblum, the late Creative Director of Macy's. I got $35.00 a week to do a lot of promotion and catalog work, and I learned quite a bit about page layout and, even though I didn't realize it at the time, about the grid system. But it is my *second* job that I would rather talk about, because it was there that I learned what I consider the essential ingredient.

I got a job in the design studio of a wonderful, daring graphic designer (and human being) named Al Ross, who was a friend and contemporary of the late Herb Lubalin and Lester Beall. It was there that I met and worked with Aaron and Florence Burns and Jack Kunz, the great Swiss illustrator. The work consisted of all sorts of things—advertising, promotion, etc. I was practicing my craft and learned many professional studio tricks, which I still use. But what Al Ross really taught me was an attitude of "excellence." This was the prerequisite to everything else . . . *to create a standard below which you will not go.*

That would be my advice to young people entering the field. No matter what the job or assignment, no matter who the employer, maintain a standard of excellence in your work. Your employer or client derives the obvious benefits, but you are really doing it for yourself. It will be the underpinning for all that follows.

It's that attitude of excellence that I personally look for in new people because it presupposes patience, diligence, hard work and caring . . . in a word, *professionalism.*

1. "End Bad Breath" by Seymour Chwast.

2. Volkswagen of America's "Rabbit" car logo, designed by Dave Epstein.

3. Book jacket by Lidia Ferrara.

4. Book jacket by Colin Forbes.

2

3

Lidia Ferrara
Art Director, Alfred A. Knopf, Inc.

Parsons School of Design was a turning point in my life. I enjoyed it tremendously, was very stimulated by this whole new world that was opening up for me, and in turn worked very hard. I was an Honors Graduate, and at the same time I obtained a Bachelor of Fine Arts degree from New York University.

I was always interested in the development of images, and I had developed, illustrated, and designed visual books, which I carried through by printing and binding them. These book were a major part of my portfolio. One of my teachers, who had been one of my strongest influences, sent me to see a Parsons graduate who was working at CBS, and she in turn sent me to the Art Director of CBS Legacy Books. He was looking for a designer to work with him on the book-record packages they produced. That meant developing and designing every aspect of the project, including the concept, format, packaging, book and book jacket, record-album cover and label, and all the promotional material.

Even though I had no previous professional experience, I got the job as designer on the strength of my portfolio, his belief in me, and his willingness to take a chance. It was the ideal and best possible first job. I worked on my own projects from initial concept all the way through to production, with complete creative freedom, and with lots of money available to develop the projects well.

I knew all along I did not want to start at the bottom. I had worked very hard and believed in my work, and that—combined with a little bit of luck—got me my first job on my first interview, and I started as a designer. Like anything else in life, there are no formulas for getting into graphic design, but I believe that talent, hard work, strong convictions, and luck are the prime ingredients in starting and staying in this field.

Colin Forbes
Partner, Pentagram Design

My first job was as part-time assistant to Herbert Spencer, the British designer. I was a student and, having studied book illustration and painting for five years, I had some commissions for freelance illustration and even sold some drawings to *House and Garden*. However, the head of my department insisted that all illustration students take a course in typographic design as an "insurance policy." I took a one-day-a-week course with Herbert Spencer for the year; and, as he hired me, I must've taken to it like a duck to water. The work was very detailed: business forms, price lists, etc., but I loved it, and from then on my future was as a designer, not an illustrator.

4

Adrien Frutiger
Typeface Designer

When a student has finished his studies in graphic design, he has a general background but is not yet a specialist in any of the many areas that exist in our profession. As soon as possible, the student should find out what are his best capabilities and then go that way. He should take the direction that is best for his temperament, where he can do outstanding, original work.

Myself, I began with a typesetter apprenticeship. After four years in a small printing shop in the Swiss-Montens I was only a typesetter. Unsatisfied, I decided to become a painter, sculptor, or graphic designer, so I quit my job and went to the Zurich Art School. During my first year I was in a freshman class, with much younger students, where we studied designing, manual drawing, perspective, etc. After three months I found out that my strengths were not in painting, nor naturalistic drawing, nor three-dimensional form, but in two-dimensional form (I would have been a terrible architect!). I soon found that my best works were those done in pure black and white (without half tones) brush or pen and ink, or wood engraving. Later I discovered that I have a much stronger affinity for abstract designs than for naturalistic or representational ones. And so I discovered that calligraphy and type design are the disciplines in which I can excel.

After six months in the Zurich School I decided to become a specialist in letter design, and so I spent two and a half years in this specialty. When I finished my studies, I was a graphic designer, but specializing in lettering. This was a great help for me to find a job easily.

My feeling is that young graphic designers don't make their choice for a specialty soon enough. Find out *as soon as possible* what is *your* area, field, direction, gift—limitations—where you can do your best work, and then forget all the other directions. Focus on one field; our world needs specialists more and more. Inside each student you will find a special domain where he or she can become a valuable specialist— a true artist.

1. The family of Univers, one of the many famous typefaces designed by Adrien Frutiger.

2. Spread for the book *Layout*, written and designed by Allen Hurlburt.

1

Allen Hurlburt
Art Director and Author

The beginning, for me, goes back long before my first job. It was the crazy thing of deciding to be an art director back in the time when the term had hardly been invented.

I put together my own course in design education. I took a course in business at the Wharton School of the University of Pennsylvania, leading to a BS in economics. But along with that, I took a rather wild selection of elective courses to back it up—architectural rendering, freehand drawing, orthographic projections, and a hell of a course in psychology. This turned out to be one of the most valuable courses I took because it centered on perception and response and went into behavior in ways that became extremely valuable to me.

During this time I became almost as involved with journalism and editing as I did in design. I was not only editor of the college magazine, but also an associate editor of the daily newspaper that was printed on the campus. These extra activities were probably more important than the courses I took.

When I graduated from college in 1932, it was rock-bottom Depression. There were no jobs in the art business, and so my primary commitment in the two years after graduating was to being a freelance magazine cartoonist, which I did with reasonable success. Yet I always felt that I was marking time.

My first design job came to me through an advertisement in *The New York Times*. It sounded intriguing, but when I applied for the job I didn't take it very seriously. I'd no idea I'd ever hear from them again. (By then, I'd answered four or five ads and never heard a word.) But I think I interested the art director because of the uniqueness of my background. Also, he was reasonably impressed with my college magazine experience, and he gave me the job as his assistant.

I was part of a group of designers that handled eight magazines. One,

American Printer, was deliberately modern in its style and design. In each issue we did some experiments with typography, using new typefaces that were being introduced. It was a time when exciting type designs were coming on the market all the time. Within a year I became art director.

During the first ten years of work, I also went to school. One night a week I was somewhere—in class drawing, studying color or composition, or taking a course in photography. I was extending my education.

What bothers me a bit about the educational pattern today is that there seems to be an expectation that when you train a designer for a role in commerce, he or she will be a completely developed person upon graduation. But I think the learning process only begins when you get your first job. Everything else is preparation, getting your mind ready. The technical skills—the use of rubber cement, or of a straightedge—you can pick up in a short time in a good art department if your mind is right and you're willing to work.

2

Walter Kaprielian

President, Ketchum Advertising/
New York, and President, The Art
Directors Club of New York

All men are not created equal.
When looking for a job, never forget
that.
That's what portfolios are all about.
That's what interviews are for.
That's what this profession is all about.
Being special.
Being remembered.
Being wanted.
Doing things in a special way.
Caring about things that others take
for granted.
Being someone who adds to what's been
done.
Not one who diminishes it.
Every interviewer, no matter at what
level, is secretly searching for a dia-
mond in the rough.
A special person.
Someone who is more than what the
job requires.
Because who the hell wants less?
Always give more than what is asked
for.
There are plenty who only give what
they have to.
And you'll be remembered.
And be called back.
And you'll get the job.
And you'll be successful.
If you give more, do more, and be
more,
You'll also probably earn more.
And that's more than your parents ever
thought an artist could make.
Who wants to be equal anyway?

You wear it on your body and in your mind. Zen
Perfume/Cologne

1

2

Jim Miho
Graphic Designer

In 1951 I had received a B.A. in business and was about to enter into my father's business when I realized that I was just not interested in a business career. While contemplating my future, I decided to visit the family temple in Kyoto, Japan, perhaps hoping for a miracle. While in the temple I was struck by the beauty of both the religious works and the architecture; I decided at once to become an architect.

Back in the U.S.A., I was all set to start my new career when, unfortunately, I got drafted into the armed services for the Korean War. After the war, still determined to follow an artistic career, I now decided to become a fine artist—a painter. While searching for the right school, I spent one half-day at Otis, one hour at Chouinard, and attended one class at UCLA along with one thousand other students. Finally I enrolled in the Art Center in Los Angeles. For the next five years I worked steadily without vacations, studying both design and painting while putting together a strong portfolio.

After graduation I received a call from Don Kubly of the Art Center Alumni, telling me of a job opening at N. W. Ayer & Son in Philadelphia. I made the trip East, showed my portfolio, and got the job. It was five years of hard work and sacrifice, but it was worth it.

Today, besides designing, I still paint regularly, take long cultural vacations, and continue to grow. It's a never-ending process.

Tobias Moss
Art Director, A.I. Friedman, Inc.

Informal, quick, random thoughts . . . the youngsters (art-school grads) don't want to start at the bottom—they want "top" jobs, with titles. They should get into a place where they can watch procedures and *learn*. This on-the-job experience is the best teacher, and it is the springboard into a real position.

Hard work and perseverance. There aren't any shortcuts or rose beds. Study the work of good designers, experiment. Can I do as well—or better? Though creativity is often stifled by clients (discouragement), there are reasons why the novel approach is negated—that's business. The client wants the safe approach—he holds the purse strings.

Who has the final say? I once had two covers for a magazine—the publisher was uncertain. He said, "Let's get the reaction from the man on the street." So he called in the elevator operator for an opinion. The gentleman said, "I like this design, but I think the man on the street will go for the other!"

It is difficult for students to define their job goals—too often they are "blue sky" about what they want to do. Set a target (advertising, magazine layout, promotion matter, type director, production, etc.) and key the portfolio to a *specific* target.

I suspect all of this is trite, banal advice, but it's sound. Hope it's helpful.

1. Ad designed by Walter Kaprielian for Zen perfume.

2. Ad designed by James Miho for Atlantic Richfield Company.

3. Announcement by Tobias Moss.

Pointing to a very good year.

3

Alan Peckolick
Graphic Designer and Partner,
Pushpin, Lubalin, Peckolick

While I was attending Pratt night
school, I was also working a full-time
job. It was a grueling schedule of get-
ting to work, in a supermarket, at 7:00
in the morning (six days a week), then
on to my night classes at Pratt, then
working on class assignments to all
hours of the morning. The pace became
too much and I decided to try to find a
job that didn't require me to get up so
early in the morning. I sought the help
of an uncle in the printing business,
who arranged a job for me as a mes-
senger for a printing company. The job
paid $45.00 a week and started at 8:00
A.M., but I had to get up at 6:00 in the
morning, because the company was far-
ther away from my home.

After I had worked there about six
months, the president of the printing
firm noticed me leaving every night
with a portfolio, and he asked to see it.
He offered me a job in their art depart-
ment, which consisted of one man who
did everything from paste-ups to ren-
derings. I saw this as a great opportu-
nity for some on-the-job experience. Of
course, there was one stipulation—I
had to take a *$10.00 cut* in salary, but I
saw it as a chance to "work on the
board," so I took it. The job consisted of
everything from getting coffee to cut-
ting mat boards and even doing me-
chanicals (for ugly brochures and
mailers for junk mail).

During this job, which lasted about a
year and a half, I was kicked out of
Pratt—TWICE, my instructors felt my
work didn't show that I had the poten-
tial to make a good graphic designer.
But I stuck with it, obviously, and by
my last year, my work dominated the
senior show. Though it was difficult to
juggle a job and go to school, I feel my
first job gave me the practical experi-
ence I needed to get a bona fide job in
an ad agency, which came next.

1

Edward Rondthaler
President Emeritus,
Photolettering, Inc.

In my last year of college, I found an
old New York telephone book in the
Chapel Hill Library, and I wrote to
several typographers applying for any
kind of a job. Only three answered, and
none of these gave me the slightest
encouragement.

One of the letters, however, was writ-
ten on very impressive stationery and
signed "Harry Roberts, Art Director."
That was glamour enough to bring me
to New York with a portfolio assembled
from bits of experience in a North
Carolina print shop—and a Phi Beta
Kappa key that I hoped might help a
little.

Mr. Roberts was pleasant, but the
portfolio didn't impress him. He gave it
a benevolent smile. Before drawing the
conversation to a close, however, he
asked me how much money I'd brought
to New York.

"Seventy-seven dollars." (Read "five
or six hundred" today.)

"How long can you live on that?"

"About eight weeks."

"It may be hard for you to realize
this," he said, "but you are worth
nothing at all to us without experience
in precisely the kinds of things we
do. Would you be willing to work as
my assistant for eight weeks without
pay on the remote possibility that
you might be worth $10 a week
thereafter?"

I jumped at the chance, and I have
never regretted it. I'm sure I did not
grasp the whole truth of what Mr.
Roberts was saying at the time, but at
least I had sense enough not to turn
the offer down. Occasionally, I've put a
similar proposition to young job-
seekers, but none has ever accepted it.

There's a postscript to this story: in
two years' time, I had Mr. Roberts' job.

Gordon Salchow

Professor of Graphic Design
University of Cincinnati

My first position after graduate school paid only half the salary of any other available job. I took it because I respected, and knew that I would continue to learn from, my associates there. I think it is critical that the beginner place himself in a professionally stimulating environment where there are other designers who are, in some ways, better than he. I also felt that this first position (teaching) would give me a year to search for a "real" job. Instead, I found myself doing lots of design while teaching, and I was gaining enormously from the cross-fertilization. All jobs are "real," just as school is a real experience which should be appreciated on its own terms instead of simply as preparation for later activities. Three years later, I was offered a department headship and found that administration allowed me to apply the designer's problem-solving process to people and programming. Graduates should take advantage of such unexpected applications of their knowledge. In a career, just as in a design project, we must be responsible enough to recognize latent opportunities. Sometimes these come in the form of obstacles which, when capitalized on instead of complained about, create the specialness of an undertaking.

Graphic design recognizes that *how* something is communicated communicates a great deal. Therefore, the most critical judgment I make concerning job applicants is based on their initial presentation of application material. I immediately see whether or not they are genuine in terms of their comprehension and motivation, no matter what the content of their letter, resume, or slides may suggest. If an applicant types his letter according to the exact form presented by the high school typing teacher, I know that he has separated the study of typography from its application. For that matter, I am suspicious of any applicant who professes a dedication to visual literacy if he presents himself unclearly, dresses poorly, or eats or furnishes his environment with junk.

A professional designer needs an education, as opposed to training, which creates the basis for continued growth and contribution. Working in two or three design offices while in school can be valuable and provide some of that more specific vocational training. A mediocre office experience can immunize a student, while an excellent job can motivate a student and provide valuable contacts. Either offers practical experience to complement the more theoretical value of a good education.

1. Star Channel TV logo by Alan Peckolick for Warner Communications.

2. Ballet poster for Cincinnati Ballet Company by Gordon Salchow.

2

Eileen Hedy Schultz
Design Director, Hearst Magazines

Thinking back now on looking for that impossible first job that always required "experience" before anyone would see you, it seems I was forever traipsing around on interviews that were nothing short of scenarios from Fellini films.

Just when it seemed I'd exhausted every design-oriented firm in the yellow pages—sloshing through monsoon rains until even my rubber boots refused to dry (the only thing missing were the wolves nipping at my hocks, and even they were closing in)—Papa, who expected a daily progress report, stepped in with some sage advice. "Perhaps," he pointed out, "der are advantages to an early marriage. . . ." Poor Papa. I can still see his face as the piercing cry rose from my throat: "But I have so much to give to the art world!" He never brought up the subject again, but I know he's thinking there's a strain of Van Gogh madness in his daughter . . . or at least that curse called "artistic temperament." Stubbornly and persistently, I went back to the middle of the yellow pages studio listings and started again.

It was a usual rainy day, and I had a dripping umbrella in one hand and soggy portfolio in the other, when I stumbled into C. A. Parshall Studios. Dick Parshall, surely the nicest man in the world, looked through my book and hired me on the spot. We lunch together occasionally, and he claims that he still remembers my portfolio. . . . "You could actually draw!" And it's been uphill ever since. The studio, filled with expert specialists, was an invaluable learning experience and prepared me well for what was to come.

In the beginning, slicing off a part of your thumb with a mat knife taught me to cut a lot more carefully and not to bleed on the mechanical because red prints; cutting the only photograph in half when it was well past midnight, and deftly trying to sand the edges so the pieced seam didn't show, taught me how far down that sinking feeling in the pit of one's stomach can really go; and mounting the type upside down during a major demonstration taught

1

me to laugh more easily at myself because none of us is infallible. Those first tough years equipped me with a superb foundation and great respect for the field.

My next job was in Honolulu, as Editorial Art Director of the island's major publication, *Paradise of the Pacific*. Then came a stint at an advertising agency, where I also began freelancing as an illustrator and photographer. From there I went into promotion and, finally, corporate design—which is an exciting adventure in itself—into multi-facted design.

Traveling all over the world as a photographer, lecturer, judge, and educator; instructor at the School of Visual Arts and Visiting Professor at Syracuse University; "giving back" to the profession by working in various art organizations (first woman President of the Art Directors Club in its sixty-year history) and on several boards of directors and trustees; writing articles, columns, books—all add up to what I consider a well-rounded, satisfying, and very exciting career.

Yet, I still feel as if I've only just begun. There are a million more stars to reach for and a lot more areas to explore. Throughout these years I have put in some very hard work (sometimes I could just lie down and die from fatigue), but then, nobody ever accomplishes anything really worthwhile without working plenty hard for it. What I tell my students on that final day before graduation is, yes, talent is important. But perseverance and hard work are more important. Be optimistic. Have faith and have confidence in yourself. (Full-blown egos are never appreciated, however. I consider humility a major asset when I hire, and I hire not only the talent but also the person as well.) Everyone has something to give to this world. Just make sure it's the *best* you can give, and there will surely be a place for you in this marvelous profession. *All* the best to you!

1. Design for the 50th annual of the Art Directors Club of New York, by Eileen Hedy Schultz.

2. Design of *Typography 1: The Annual of The Type Directors Club* by Jack Tauss.

2

Jack George Tauss
President, Jack G. Tauss
Design Associates

I was one of those students so eager to start working that I jumped at the first job offered to me. It was at J. C. Penney's advertising department. I only stayed four months, because I kept looking for a better position in a "top agency." I learned a fantastic amount in those four months. How to do layouts fast and accurately, how to assign photography and illustration, and how to work with a production department. In the fourth month I landed a "dream job," I thought, with Fletcher Richards Advertising, and a lot of funny things happened in the first few weeks. The agency was a beauty, located in Rockefeller Center on a high floor.

I pictured myself working on the U.S. Rubber account doing fantastic double-page tire ads for insertion in *Life* and *Look* magazines. However, the agency was expanding at a fast pace. There was no room for me, so they put me in the office of the head art director, Jack Cherry. He was "mad as hell" to have a young kid put in his room. It didn't help when, on the first day, I spilled his rubber cement on his beautiful gray flannel suit.

The second day, I was assigned the two accounts I would be working on instead of the tire account. U.S. Rubber made a machine that removed the hair from slaughtered hogs. I was to do a full-page ad for a trade magazine. I spent days looking at photographs of dead pigs hung upside down waiting to be fed into these machines to have their bristles removed. The second account was a bowling-ball company, and they delivered to me almost twenty balls, which I put in Jack Cherry's office on a long table. When he returned and saw the bowling balls, he got so angry he gave a line of them a push.

The first ball hit the floor with a noise I still can hear and then crashed through the glass door of our office, as about four more balls hit the floor. We had about eight art directors working on that floor. Most had jumped clear out of their seats, sure that a series of bombs had gone off. Some left for the rest of the day, their nerves permanently damaged.

I never did recover from the bowling-ball fiasco. But the hog-dehairing-machine ad was a great success. I had commissioned a good cartoonist to show a smiling pig in a barber's chair waiting to be shaved. There was a small halftone photograph of the machine on the bottom of the ad. The U.S. Rubber people loved it, and I think ran it for years.

Jack G. Tauss

1

2 Durch das Experiment suche ich neue Gestaltungselemente und nicht nur die bekannten neu zu arrangieren.
Zu diesem Begriff ‹Experiment› gehört, daß die klassischen Spielregeln der Typographie aufgehoben sind.

Weingart
Graphic Designer

I do not remember my first job. Was it when I started the typesetter-training program? Or when, as a six-year-old, I cooked for myself? Or when I started teaching at the Basel School of Design? Or was it when I made the first big wall poster?

You see, I have a problem with the word *job*. I have never considered doing what I enjoy to be a job. Hard work, yes, but not a job. I find pleasure in everything I totally believe in, and is deep within me. At night I dream about my day-work and day-problems. For me it is proof that I am really in love with my work. That is the secret of my happiness—and it also allows me to make a little money to survive.

A well-planned, systematic education from a respected design school will be your best guarantee for a successful future career. But I believe one must not spend too many years in design schools to learn graphic design, photography, or typography. You must feel or sense your creativity, believe that you were born to be a creative designer, and be ready to start without help from outside. And that will make you different from other designers.

So, I cannot answer the academic question of how to find a job. Everyone will find the wrong or right one.

Henry Wolf
President, Henry Wolf Productions, Inc.

I got my first job in March 1946, fresh out of the army, back from seven months in Japan. I went to the New York Employment office in Queens; they referred me to a small art studio on the West Side doing book jackets and packages. One of the first things I did was retouching the script on the Ballantine Scotch label. I believe it's still being used. I earned $65.00 a week: $35.00 in salary and $30.00 from the veterans' training program. It took me thirty years to become a millionaire. I think I was happier in 1946.

1. Cover design by Weingart for *Idea* magazine.

2. Experimental typography by Weingart.

3. Two magazine covers by Henry Wolf.

3

Study, studies. 1: a state of contemplation: reverie **2a:** application of the mental faculties to the aquisition of knowledge **b:** such application in a particular field or to a specific subject **c:** careful or extended consideration **d (1):** a careful examination or analysis of a phenomena, development, or question **(2):** a paper in which such a study is published **3:** a building or room devoted to study or literary pursuits **4:** purpose, intent **5a:** a branch or department of learning: subject **b:** the activity of work of a student **c:** an object of study or deliberation **d:** a literary or artistic production intended as a preliminary outline or an experimental interpretation of specific features or characteristics **6:** a musical composition for the practice of a point of technique.

GRAPHIC DESIGN STUDIES

There are many roads that lead to a career in graphic design. Some people come to it through related fields such as editing, copywriting, production, or typesetting. Others may have started their careers in other creative professions and later turned to graphic design; some of the best graphic designers started out as fine artists, architects, and industrial designers. But the most direct route to a successful career in graphic design is through a school offering a design education.

THE GRAPHIC DESIGNER AS AN ARTIST

How you perceive the role of the graphic designer can have a major effect on your attitude toward graphic design as a career.

In art schools there is often an unspoken hierarchy among students—and instructors. This "pecking order" usually places students in the fine arts (painters, sculptors, printmakers, etc.) at the top, with all other students below. This attitude can have a serious effect on both fine arts and graphic design students.

The fine arts students often see themselves as struggling, romantic figures and would seldom consider taking a graphic design course for fear of compromising the "purity of their art." This is in spite of the fact that many famous artists have done commercial or public work. Renoir painted china, Toulouse-Lautrec painted posters, Gainsborough painted portraits on the docks, Picasso did menus, and Andy Warhol started his career as a graphic designer. Perhaps more pertinent, however, is the fact that ten years after graduation the vast majority of fine arts students are no longer practicing their art but have gone into other professions. Many have even become graphic designers!

Graphic design students who also believe in the mystique of the fine artist often feel that by choosing a career in graphic design they have somehow compromised their ideals. They do not realize that a career in graphic design is an excellent choice. Graphic Designers and fine artists do have differences, but they also have much in common. Both are artists. Fine artists are involved with the creative process on the highest level of self-expression. They are interested, first and foremost in giving form to their unique way of seeing and understanding the world. They strive for personal excellence and do not have to compromise. The same holds true for graphic designers, but they must never forget that their first goal is to meet the client's needs.

New York Coliseum
March 8-12

Whether you are a student, a practicing designer who wishes to grow, or a non-designer who would simply like to learn about graphic design, the best approach is through a recognized art school. There are several categories of schools offering such an education: universities, colleges, technical schools, schools of continuing education, and graduate schools. Each category, and the typical programs it offers, will be discussed in this section of the book.

Art schools can be private, state, or city, with private schools generally being the most expensive. City and state institutions are usually less expensive because they are subsidized by local governments.

Universities and Colleges

Although a four-year college education is not an absolute necessity, it is the path most graphic designers follow. If you were to make a study of the successful graphic designers in the country, you would find that the vast majority have a college education.

A college education is important for a number of reasons. It develops you as a complete artist, giving you a broad base from which to grow. The more you know and the broader your interests, the greater your chances for success. As a graphic designer you will be dealing with a wide range of people interested in selling their products or services. You will find many of these people literate, intelligent, and successful; they will expect the same qualities of you. Finally, the personal contacts you make in college could well assist you in your future career.

Both universities and college offer students a four-year program leading to a Bachelor of Fine Arts (BFA) degree. Although the degree is in fine art, you can major in graphic design or some other related field. This program is designed to give the student a wide and varied education. Besides courses in art, referred to as studio courses (drawing, painting, and designing), you will also be expected to take some courses in letters and science. These are usually lecture courses and cover subjects such as the humanities, social sciences, and art history.

During your freshman and sophomore years, many of the courses will be required, or prerequisites. These courses are designed to provide a broad exposure to the world of art and design and thus help students identify their strengths and interests. The courses also provide the necessary foundation for advanced courses taken during the junior and senior years, many of which are optional, or electives.

Each course is assigned a number of credits, based loosely on the number of hours required in class and at home. You must earn 128 credits to be awarded a BFA degree; that's 32 credits a year, or 16 a semester.

Some schools also offer a four- or five-year work-study program, also referred to as a professional-practice or co-op program. The object is to supplement the more theoretical education with practical experience gained on the job. Work-study programs are a twelve-month-a-year commitment; when you're not in school, you're working. Jobs start when you're a sophomore, last from three to six months per year, and are usually arranged by the school at minimum pay.

Community Colleges

These are generally two-year programs covering the basics of graphic design or fine arts. Community colleges are attractive to students who cannot afford to spend four years at college but would like to spend at least a couple of years furthering their education.

The program is similar to that of a four-year college in that students are expected to take non-art courses as well as art courses. Upon graduation, community colleges generally offer the students a degree, such as Associate of Art, or a Certificate of Achievement.

Obviously, it's not possible to cover the material in the same depth in two years that you could in four. However, you can cover a great deal of ground, certainly enough to get you started on a graphic design career. But because you only have two years, it is especially important to choose your courses wisely.

Information about community colleges is available from your state department of education.

Poster by Ivan Chermayeff for the New York Coliseum.

Schools of Art

Long before graphic design became available at some of the better known universities and colleges in the country, independent schools of art were the primary training ground for designers. Many of these schools are still operating and offer students individual courses or programs that may lead to a degree. Some have expanded their services to include adult education courses for both day and evening students. Others have become accredited colleges offering four-year degrees. Professional schools of art are particularly attractive to those who are strong in artistic talent as opposed to academic talent.

Schools of Continuing Education

For those who have full-time jobs and cannot attend day classes, many art schools offer evening courses. Often these courses may be taken for credit, as well as without credit. Courses taken for credit are sometimes part of a degree or certificate program and may involve both studio and lecture courses in the liberal arts.

Most major cities have one or more schools offering art and design courses. The schools may be city, state, or private, and the faculty is usually made up of practicing professionals. Most of the major graphic designers and illustrators have taught at one time or another—many, in the evenings.

Designers use these institutions to brush up on skills they may have overlooked in college, or to learn about the latest equipment and technology.

To find the school nearest you, look in the yellow pages or call a local college and ask if they are offering continuing education courses.

Technical Schools

Technical schools offer programs that vary in length, usually two or three years, and lead to a certificate. Unlike colleges, they are not accredited by the regional Association of Colleges and Schools or the National Association of Schools of Art and Design, and therefore, they cannot offer a degree. Often their programs focus on the more technical aspects of the design field and may not include liberal arts courses.

Technical schools can be privately-or government-run and are ideally suited to anyone who likes to work with equipment, such as printing presses, phototypesetting machines, etc. While there may be courses in design, these are apt to be peripheral to the technical curriculum.

Graduate Schools

Graduate schools are designed for people who have already completed four years of college, and have a BFA, and would like to continue their education and earn a Master of Fine Arts (MFA). The programs offered allow students to specialize in a particular area of graphic design, such as corporate design, photography, film, etc.

Although an undergraduate degree is desirable for admission to a graduate school, it isn't always necessary. Some graduate schools have been known to bend a little for exceptional applicants, especially if they can bring unique talents to the programs.

Among the many attractions of graduate schools is the opportunity to work with some of the finest designers and instructors in the country, if not the world. Because education is at an advanced level, the instructors must be the best. Programs often involve lectures by visiting designers and other professionals.

Graduate schools are also very attractive to working designers who wish to revitalize their careers.

Art Schools Abroad

When it comes to graphic design at an undergraduate level, there are probably more good art schools in the United States than in any other country in the world. Therefore, consider finding a school here unless there are strong reasons for going abroad. As a compromise, you may want to choose a school in the United States that offers the option of spending time abroad as part of its program. Many do.

If you do decide to study abroad, then consider only countries where there is a strong interest in graphic design as an art form, such as Great Britain, Switzerland, Germany, The Netherlands, and Italy.

COURSES

One way to ensure a fine education is through a wise selection of courses taught by good instructors. Course selection should be done with a counselor who makes recommendations based on your needs. In well-organized schools, courses build upon one another so that by the time you graduate, you will have received a complete education rather than a random collection of courses.

Whether you are working toward a degree or simply taking the odd course to brush up on a neglected skill, the courses listed in this chapter should help give you an idea of what is available. Not all courses will be available at every school. Course titles may vary, but the courses are essentially the same; for example, Typography may be listed a Typography 1, Basic Typography, or Beginning Typography. Courses in book and magazine design may be found under Editorial Design, and so on.

Typical Design Courses

Some of the more popular courses are listed alphabetically below: each is followed by a brief description.

Advertising Design. This course is designed to help you understand and develop successful advertisements. You learn to create advertising programs, from concept to rough layouts to final presentation. You also learn about storyboards, packaging, principles of advertising, marketing, copywriting, and production.

Art History. An understanding of the traditions and history of Western art is essential to anyone serious about a career in graphic design. It is the foundation upon which all the visual arts are based. Exposure to art history helps you understand composition and visual perception. It also gives you a historical context within which to work.

Book Design. Book design may be offered as an individual course or as part of an advanced typography course. Either way, you will learn what is involved in the design of a book and how to copyfit a manuscript so it is both a functional and an esthetic success.

Calligrapy. Calligraphy is defined as the art of beautiful writing, and it is excellent training for anyone who has an interest in or love for lettering. You will work with special broad-edged pens to reproduce historical letterforms such as rustica, square caps, italic, and roman.

Color and Perception. How we see color is a major aspect of the graphic designer's life; color touches everything. Some schools offer specialized courses in color theory, where color perception is explored by means of specific exercises and projects. Other schools include color theory as a part of the basic graphic design courses.

Computer Graphics. It is likely that anyone planning a career in graphic design will be involved with computers at some point in his or her career. Computers will be one of the major tools available to the graphic designer. Courses are designed to bring you along from solving basic design problems to more advanced techniques used in animation or in the creation of abstract and surreal imagery.

Corporate Design. This involves an understanding of contemporary design as it relates to corporations: designing symbols, logos, and publications. You may use a systems approach to developing "corporate programs" including the design of logos, stationery, outdoor graphics (environmental design), and other corporate requirements. This type of project often will require you to work in groups.

Drawing. Drawing is a basic skill that all graphic designers need as a means of conceptualizing and communicating ideas. Drawing also helps you understand complex spatial relationships. Study in drawing is particularily important to anyone wishing to major in illustration.

Film and Video. These courses show you how to use film and video media as tools for graphic design; they teach techniques in making sound effects, fades, multiple exposure, mixes, and so on. Courses also may be offered in animation and video techniques as applied to advertising.

1, 2. Logos by Dutch designer Roger van den Bergh; the top logo was for a county council and the bottom one for a road advertising company.

1

2

Poster for the School of Visual Arts by Milton Glaser recommends that designers consider multiple careers.

Graphic Design. This is usually a basic course and may fall under titles such as Design Theory, Visual Communication, or Two-Dimensional Design. The course serves as an introduction to graphic design and visual communication through investigating letterforms, symbols, and other graphic elements. The course may also include lectures on the history of graphic design.

Illustration. Some schools treat illustration as a separate course, while others structure their drawing and painting courses to give you the same skills. You are then expected to adapt these skills to illustration. Schools that do offer courses in illustration often have you experiment with various media and use your art to illustrate a story or product. Storyboards may also be a part of the course. Understanding concepts and knowing how to interpret stories are important skills for illustrators.

Letters and Science. These courses combine the social sciences and the humanities. Such a course is designed to make you aware of the social environment and to help you gain insight into major social issues by understanding people, their activities, and problems. The courses may touch on subjects such as anthropology, economics, history, languages, literature, mathematics, philosophy, political science, psychology, and sociology.

Packaging. Courses in packaging involve much more than simply learning how to make a box and add a label. The would-be designer is also involved in innovative packaging, point-of-purchase appeal, marketing, and practicality of design. Anyone seriously interested in packaging should also consider courses in sculpture as a means of developing a greater awareness of three-dimensional form.

Painting. This is the study of technical, esthetic, and conceptual aspects of painting. Through painting you become sensitive to the interaction of color, value, line, plane, shape, light, and texture. These experiences develop a heightened awareness of the fundamentals of design.

Photography. You will be introduced to the medium of photography as a means of visual communication. This course deals with cameras, film, darkroom practice, exposure control, papers, developers, and so on. You are taught photography as an art form. For a graphic designer photography is an absolute necessity; it is part of both the creative and the printing processes.

Production Techniques. This is primarily a course on how to prepare your art for the printer. Mechanical production involves an understanding of printing techniques, paper, binding, color separations, etc. Graphic designers need a working knowledge of production techniques to ensure that their jobs will be printed correctly. Many schools do not teach production as an individual course but include aspects of it in their overall program.

Publication Design. This course prepares you for a career in magazine design. Structures and systems fundamental to good design are learned through analyzing and often redesigning publications. You will incorporate graphic elements such as type, photographs, and illustrations to create effective page layouts.

Shop Techniques. Anyone interested in three-dimensional projects will find a course in shop techniques very useful. It involves the use of power tools on a variety of materials: wood, metal, plastics, and so on. Understanding shop techniques is particularly useful for anyone interested in a career in exhibition design or industrial design. They're also handy skills to have around the house!

Storyboards. A storyboard is a panel divided into small sequential frames. In each frame is a rough drawing, usually done in markers, depicting successive scenes in a TV show or commercial. The storyboard is shown to the client for approval and then used as a guide for producing the finished commercial. This course is recommended for anyone interested in a course in advertising or TV, along with other courses in drawing, painting, or illustration.

Three-Dimensional Design. An understanding of three-dimensional form and space is essential to anyone interested in a career in packaging or exhibition design. Working in three dimensions is very different from working with two-dimensional graphics. The designer must be able to solve all the two-dimensional problems, such as signs and other graphics, along with all the additional graphic problems that come from working in three dimensions.

Typography. Typography is the art of designing with type. It is impossible to overstate the importance of typography for the graphic designer. No client is going to produce an ad, poster, or TV commercial without adding a message, even if it's only the name of the product or company. In many cases, such as book jackets, announcements, and posters, type will be the only design element you have to work with.

Courses in typography start from the basics: the history of the alphabet, type design, letterforms, "comping" type, layouts, copyfitting, and typesetting methods. As the courses advance, you will become more involved with type as a design element and learn how it is used in conjunction with illustrations, photographs, symbols, and signs. Advanced typography courses include subjects such as corporate graphics and contemporary typography.

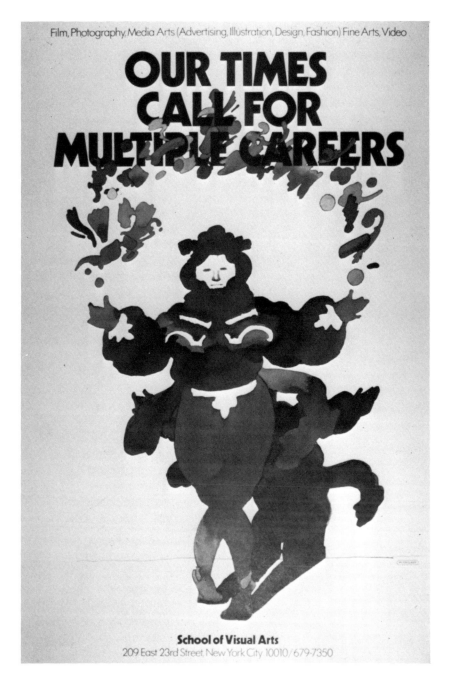

Film, Photography, Media Arts (Advertising, Illustration, Design, Fashion) Fine Arts, Video

OUR TIMES CALL FOR MULTIPLE CAREERS

School of Visual Arts
209 East 23rd Street, New York City 10010 / 679-7350

CHOOSING THE RIGHT SCHOOL

There is a great difference between finding a part-time school where you can improve your skills and finding a full-time school where you intend to spend the next four years working toward a degree. While finding the right school may be important in both cases, in the second, it's critical. Although this chapter is directed primarily to the person wishing to earn a college degree, it should concern anyone looking for the right school to attend—for any reason.

Researching Schools

The process of finding the right school can be exhausting but rewarding. The school you select will determine your education and, to an extent, the success of your career. The better the school, the better your education, and the better others perceive it—including your future clients!

Before you can make an intelligent decision, you must gather information from many sources. It may help to discuss your situation with those close to you. Ask relatives and friends if they know any graphic designers who may be able to spare some time to discuss schools and careers. If you live in a major city with an art directors club or similar organization, you may be able to obtain advice from them about schools offering a graphic design education.

Sometimes you may even have to be a little adventurous. If you see something you like in a magazine or book and the designer's name is shown, call the designer, explain your situation, and ask for help. You may be pleasantly surprised.

Here are some sources of information that help you make intelligent decisions about a school:

Alumni. Perhaps the best way to judge a school is by the success of the students it produces, the alumni. Ask the school to give you a list of its alumni and look it over. Some lists include a record of alumni achievements, which should tell you a great deal about what the former students have accomplished since graduation.

Catalogs. Catalogs contain a wide range of information. They tell you about the history of the school and its facilities, including the size of the campus, student life, alumni associations, library facilities, and so on. You will find all the information you need regarding admissions policies and tuition. There is also valuable information for foreign and transfer students, and on the possibility of being given credit for courses taken elsewhere. Many school catalogs even show the approximate living expenses a student may anticipate per year; these costs include room and board, books, etc.

1

If money is a problem, the catalog usually contains information about financial aid, covering everything from outright grants to student loans that can be arranged through either the school or a government agency. Scholarship information is also included.

Catalogs have a complete listing and brief description of the courses offered, showing which are required and which are optional on a year-by-year basis. Perhaps most important is a listing of the entire faculty, along with a brief biography of each person and the courses he or she teaches.

Curriculum. You may also wish to look into school programs to make sure they are up-to-date, have the latest equipment, and that the instructors understand the new technologies. With the communications field growing so rapidly, it is important that you learn about the technologies that will affect your future.

Enrollment Policy. Enrollment policies can be revealing. If a school accepts anyone who can afford the tuition, chances are that the students will not be of the best caliber. This in turn may affect the quality of the instructors. The better schools are selective in their standards for both students and faculty.

Faculty. The faculty is another good measure of a school's standing. Good art schools attract a good faculty of well-known designers and instructors. Many of the instructors are also practicing designers, which means they are able to share practical experience with the students.

Location. The location of a school may be a factor to consider: a rural versus a suburban or urban setting. If you choose a school situated in the countryside, you will have to weigh the advantages of a pastoral life-style against the possibility of feeling isolated and the potential lack of part-time jobs. On the other hand, if you choose a city college, you will have all the cultural amenities city life can offer, such as museums, galleries, and theaters; but there will also be the pressures of city life, plus higher living expenses.

Reputation. You will want to know all about the school and its reputation in the field of graphic design. Unfortunately, you can't measure a school's reputation simply by its name or size. Although a school may be nationally known, it may not have made its name in graphic design but in some other field. Therefore, if you're heading for a school whose name is a household word, find out if the art department lives up to the school's reputation.

Size. Size is not a very good criterion because some of the best schools in the country are relatively small and can only accept a limited number of students. More important than size is the number of students in each class. Try to choose a school where studio classes have no more than fifteen to twenty students so that you will be able to discuss your designs and concepts one-to-one with the instructors. Lecture classes are another matter, of course, and may be larger.

Too few people per class can be as much of a handicap as too many, since you learn a great deal from one another. Small classes limit exposure to new ideas.

Visiting Schools

When you have narrowed your choice down to a few desirable schools, take the time to visit each before committing yourself. If possible, try to arrange a visit around the time they are having their year-end exhibition of student work. These shows cover all levels of student design and will give you a good indication of the quality of work done. The show will also reflect the caliber of the faculty and may help you decide on both instructors and courses.

Regardless of how much it costs to visit the schools, the expense will seem minor compared to the cost of tuition, room and board, art supplies, and the time wasted should you choose the wrong school.

Make sure you let the school know of your visit so they will be expecting you. They will be happy to answer all your questions; after all, they're as interested in you as you are in them. You're their future.

1. Both covers of a single catalog advertising two affiliated schools. One half of the book, along with one cover, is allotted to each school: the Parsons School of Design in New York (The Big Apple) and the Otis Art Institute in Los Angeles (The Big Orange).

2. Announcement for an undergraduate art show at Yale University.

Yale School of Art
Undergraduate Work

2

Transfer students are usually asked to have faculty members of their present school fill out an evaluation form similar to the one shown here.

Go as far
as you can see.
When you get there
you will be able
to see further.

Thomas Carlyle

Getting into the Right School

Choosing the right school and being accepted are two different matters. The better the school, the more applicants; this is especially true of schools that are not only good but also have low tuition.

When you have found a school that interests you, write or phone the admissions office and request an application form along with instructions on how to proceed. There are specific dates when applications must be received, so start planning months in advance. You will also be asked to pay a small fee for the school's handling your application.

If accepted, you will have to pay an advance enrollment fee, which is substantially more. After paying this fee, if you choose not to attend the school you will forfeit all or part of your deposit. Keep this added expense in mind when you are applying to more than one college.

Art schools are looking for two basic qualities in the applicants: academic and artistic talent. To find the students having the right combination of these two qualities, they will be interested in the following:

Entrance Exams. You may be asked to take an entrance exam involving a series of design projects. The results of the exam allow the school to evaluate applicants' talents, selecting only those who are best suited to a particular curriculum.

If the exam is held in the school, you should allow a day or two to do them; if the projects can be done on your own (home exams) you should allow a week. To get the best results on an entrance exam, it is important that you don't overextend yourself by applying to too many schools; pick one or two of the best schools and put all your efforts into being accepted by them.

Portfolios. Many schools require that you submit a portfolio of your work before being admitted. A good portfolio should reflect both your talents and your interests. To improve your chances of acceptance, start to build up your portfolio as early as possible. Show it to your teachers, or to professional designers, for a critique before presenting your work to the school. You may also wish to ask the admissions officer for advice about preparing a portfolio—or attend the school's year-end student show so you can study the type of work that is likely to appeal to the faculty (see Portfolios, page 64).

SAT Scores. Some schools request your SAT (Scholastic Aptitude Test of the College Entrance Examination Board) scores and your grades for the last four years of high school. Obviously, the higher your scores, the better your chances of being accepted.

Transfer Students

It is not unusual for students to be halfway through their education before realizing that they have made a mistake in their choice of either their major or their school. Rather than spend the rest of the term just marking time to end up with an unwanted degree, it is better to consider transferring to another school.

First make sure that you can't get the desired education at the school you are presently attending; it is much easier to transfer within the same institution than to go elsewhere. Should this fail, write to the new institution—or call—and ask about the possibility of transferring. If it looks promising, request a transfer form. This form is usually very simple, requiring that you give your reasons for transferring along with recommendations from two of your instructors. At the same time, ask how many of your credits will be accepted; this may help you decide whether or not you wish to transfer.

Most schools have somewhat flexible policies regarding transfer students. If enrollment is down, there is a good chance you will be accepted; if enrollment is high, you may be placed on a waiting list.

Faculty Evaluation of Transfer Applicant

Name of applicant

I hereby waive future access to this recommendation which I am requesting from:

Name of reference

Position

Signature of applicant

Dear Colleague: The Admissions Committee will appreciate your evaluation of the applicant's talents and, specifically, commitment to hard work beyond the call of duty, showing up for class, and whatever else you feel that we should know. Do you think that it is a good idea for the student to transfer rather than to stay at your school? Why?

Do **not** use additional space, if needed.

Name of faculty

Signature

Discipline

School

Starting a Second Career

For anyone who has been out of school for a number of years and is returning with the hope of starting a second career, the choice of a school is very important, not only in terms of education, but also in terms of how well the school will be able to accommodate you.

Colleges today are much more flexible than you may remember, and an absence of ten years or more should not present any insurmountable problems. Now that the baby boom is over, colleges are reaching out to an entirely new group of potential students, including older people who may be starting second careers or even going to college for the first time.

Chances are, you will not have to start as a freshman. Many older students can qualify for credits based on work and life experience. There are also accelerated courses which can speed up your education.

Returning to school after a long absence can be intimidating. Among the more common anxieties is the feeling that you are too old and have been out of school too long. It is encouraging to note, however, that the vast majority of those who have returned to school have discovered that most of their fears were unfounded. Students are very accepting, and in many ways they like having older, more experienced people in the class. Besides, once you get settled, you will find all your energies are directed toward solving design problems, not social or personal ones.

Sometimes older students are concerned that there might not be enough time to handle both the school work and other personal commitments, such as raising a family or working part time. Schools realize that time is an important factor in many people's lives, and to alleviate some of this pressure, many are developing programs that are much more flexible and adaptable to a variety of life-styles.

Whatever your anxiety about returning to school may be, you at least owe it to yourself to check out various institutions to see what they can offer. If you do decide to return to school, you'll never regret it.

TUITION

Assuming you have found the best school and have been accepted, there is still the problem of paying for your education. It is no secret that the cost of education is rising every year. You not only have to worry about the cost of tuition but also must bear in mind living expenses, room and board, art supplies, fees, books, and so on. These costs will vary widely, depending on the type of college you attend—private, city, or state—and your living arrangements—at home, on campus, or off campus.

Financial Aid

Fortunately, financial aid is now a part of higher education. Few students can manage without some form of financial help. However, qualifying for aid is a complex matter, and although school catalogs do give some information regarding various programs, it would be wise to discuss your situation with the financial aid officer on campus. Here are some of the types of grants and scholarships that might be offered:

Government Grants. While the government is interested in helping needy students, it is certainly not in the business of handing out money indiscriminately. To be eligible, you must be enrolled as a full-time student, meet citizenship or residential requirements, and able to demonstrate financial need.

To demonstrate financial need, you must be able to document that you have a relatively low income. This involves a complex financial analysis based on items such as income, number of dependent children, the age of your parents, the value of your house, and so on. These figures are then analyzed to determine financial need.

School Grants. Most schools have their own funds that they make available to needy, qualified students. The amount will vary from one case to another, but it may range from a couple of hundred dollars to over a thousand. School grants, like government grants, usually require that you submit some kind of financial statement.

Often schools will "package" these awards, which means that besides the grant there will be a loan to be paid back at a specific rate and time. There

may also be the offer of a part-time job on or off campus. It is assumed the student will accept the entire package and do everything possible to make ends meet.

Prizes are another means of aiding students. Of course, these seldom amount to much, but they are encouraging because they reward talent and hard work.

Private Scholarships. Private scholarships offer another possible source of revenue. These scholarships are sponsored by businesses, unions, foundations, individuals, foreign governments, etc., and the rules of eligibility are as varied as the donors. Once again, this information is available through your financial aid officer on campus.

Responsibilities

Along with financial aid comes responsibility. If you are granted a loan, you will be required to sign a legally binding promissory note, based on the terms defined at the time of the loan.

Students who qualify for aid in their first year tend to continue to be aided in accordance with their financial circumstances from year to year. The assistance and the way it is packaged will vary depending upon the availability of funds, the student's capacity for self-help, and continued appropriations from the federal government. One important factor is that the student must continue in good standing and be making satisfactory progress.

Most schools will do everything possible to help the student and his or her family meet educational costs, but the school cannot assume the role of substitute for the family. However, do apply for financial aid. No qualified student should feel that he or she can't get the desired education at a chosen institution due to lack of funds. Very often something can be worked out—much can be achieved if you are truly "motivated."

In school you will learn the basic principles of design (such as form, space, line, balance, symmetry, and color) and how they are applied to individual projects. What you may not learn in school, however, is that the art of solving design problems does not lie solely in your understanding of these principles, but in your ability to analyze a problem, do research, and make decisions.

Analyzing the Problem

Before you can create a satisfactory design, you must first understand the problem to be solved. Otherwise you will spend your time simply moving shapes around while hoping to stumble on a pleasing design—which, in all probability, would be more cosmetic than functional.

If you do not understand the problem, then ask questions; not how to do the design—that's your job—but questions concerning the purpose of the project. Who is the client, what is the message, and who is the intended audience? Are there any limitations regarding size and color? Answers to these questions, and others like them, will give you direction, and the design will begin to take shape.

Research

If you have ever watched a professional house painter at work you are probably aware that more time is spent preparing the house to be painted than actually painting. In many ways it's the same with design; gathering information often takes more time than the actual designing.

Sometimes successful research means finding the one perfect photograph, illustration, or idea that will solve a difficult design problem. Other times it means simply collecting the right background information, without which your solution would not be authentic. An example would be an illustration in which the costumes and buildings must be accurate.

Get into the habit of collecting reference books, annuals, and typographic specimens that appeal to you, until you have your own research library. Illustrators know the value of research and keep extensive picture files. Many also use public libraries and the services of

professional researchers who know where to get the right information or photographs. Remember, time spent researching is time well spent.

Using the Library. Get to know your library. Most art schools have good libraries with many excellent books and periodicals of direct interest to graphic designers. Also, your local public library, no matter how small, can have useful materials. In fact, most libraries today are part of networks that allow them to borrow books and periodicals from other libraries. This is called an inter-library loan.

Get to know your librarian; most work very hard at being helpful and finding the information you need. If librarians know the general areas you're interested in, they'll keep an eye out for new materials that might be useful.

Get to know the card catalog. If you're looking for a specific book, you'll need to use the card catalog—or its computer equivalent—which is a guide to all books owned by or available to the library. These are listed by author, subject, or title. If you're just browsing, you may wish to start looking under the subject: "Design."

To find magazine and journal articles you must use a periodicals index. The art index, for example, will guide you to articles from art and design publications. There are also indexes for education, business, music, the social sciences, and many others. General magazine articles can be found under the reader's guide.

There are also special encyclopedias and directories located in the library reference rooms. These are excellent sources of information for designers. Your librarian is the best guide to what you can find in any given reference room.

Also, keep in mind that the U.S. government is responsible for materials on different topics, many of which are available in your local library. These publications are not copyrighted and may be used without permission.

There are no absolutes in art, but there are standards.

Cover for *Idea* magazine by Elwood H. Smith.

Whatever you can do, or dream you can, begin it. Boldness has genius, power, and magic in it.

Goethe

Making Decisions

Graphic design is a decision-making process. As you discuss the project with your instructor or client, each new piece of information must be weighed, a new direction explored, and decisions made. To make these decisions you must draw on everything you have: your understanding of the project, the client, the intended audience, your design skills, and the work of other designers. The wider your knowledge, the more you have to draw on.

There is a tendency with many students—as well as professional designers—to think too long about a problem before acting. You start by dreaming of one solution, then drift off into another. Each one is weighed and then rejected, half formed, as you strive for the "perfect" solution.

Most people have had similar experiences when getting dressed. You go to the closet and try on various combinations, none of which works. You keep trying things on until you run out of time and must make a decision. The result may not be all you would have liked, but at least you're dressed!

If you have difficulty making design decisions, the problem may be that you have too many choices; to remedy this, try imposing some limitations. You will find that they may give you the focus and direction you need to solve the problem.

Making decisions is essential to getting the job done. Unfortunately, there is no magic formula for turning chronic procrastinators into dynamic decision-makers; you will just have to learn to make decisions and live with the results.

Getting It Down on Paper

After you have analyzed the design problem and done the necessary research, the next step is to start putting your ideas down on paper so they can be visualized. This is done through the use of thumbnails, layouts (rough), comps, and storyboards.

Thumbnail Sketches. The first step for most designers is to work out their ideas in thumbnails, or small sketches. Although thumbnails are small, the various elements should be accurate. If a printed piece is to be rectangular with a square photograph, the thumbnail must show this.

The thumbnail stage is the time to be experimental. Put down all your ideas and then choose the best to be developed further. If you can afford the time, you may wish to put the thumbnails aside for a few days and then look at them again before making a final choice. Waiting allows you to judge your work more objectively.

Designers use thumbnails in different ways: some are even suspicious of their early attempts, which they feel are likely to be the more obvious solutions, and believe that only through continued effort will they come up with a truly original idea.

Layouts. Having chosen a thumbnail that you feel has the right potential, it's now time to turn it into a full-size layout (rough) so you can determine whether your design works—and if not, what changes must be made. Layouts are usually done in pencil and marker on tracing or visualizing paper with all elements drawn to scale and color added where necessary.

Comprehensives. A comprehensive, more commonly called a comp, is made to look as much like the printed piece as possible. It is not unusual for the designer to have some type set—usually the display—and photostats made showing accurate reproductions of all photographs and illustrations. Comps take more time to prepare than layouts, but they eliminate many potential problems. As all details must be resolved, both you and the client will know exactly what to expect when the job is printed.

Achieving Better Solutions

The solution all designers strive for is the "elegant" solution: simple, original, visually exciting, and it works. It is also a design that can be reproduced within budget without compromising the quality. Even the best designers in the world can't consistently come up with ideal solutions, so don't expect it to happen every time.

One way you can develop better solutions is by getting into the habit of creating more than one design for every problem. This will not only add depth to your creative skills, but also bolster your confidence as well. Besides, in the event that a particular design is rejected, you will always have something to fall back on.

Whatever solution you choose to pursue, make sure it's one you can handle within the schedule. Don't start on a concept that requires all kinds of outside services or is technically over your head. Use the same judgment you would use if you were a student chef and had to pick a recipe from a cookbook. Choose something simple that has a good chance of success.

It is worth noting that in school, the instructor will accept whatever you do and grade you accordingly. In business, the job is either accepted or it is not. The client is not going to grade your efforts.

While all designers and students strive for the elegant solution, unfortunately many of their efforts fall into the following categories:

Glorious Failure. An attempt that deserves more praise than it gets is the "glorious failure." Its approach shows a sense of adventure on the part of the designer. Although it doesn't work, you admire the effort and can't help thinking that if pursued, the results might be rewarding.

Conventional. Then there is the "conventional" solution, which works, but doesn't show any depth, exploration, or individuality on the part of the designer. This is often the kind of solution that designers have to come up with when a client doesn't allow the proper amount of time to do the job correctly—or when the more creative ideas are constantly rejected.

Overly Complex. The opposite of the mundane solution is the "overly complex" one in which the designer has come up with an unnecessarily complicated design. This can occur when the designer or the client feels that *everything* is important and should be emphasized; the result is too many competing design elements. Ironically, overly complex solutions may also indicate that you are trying too hard to "design." Your concept of designing is to do something different—which isn't bad in itself—but often, trying too hard to be different gets in the way of finding a simpler, and sometimes better, solution.

Knocked-Out. Next, there is the hurriedly "knocked-out" solution, usually done shortly before it is due and presented with a certain amount of anxiety. Knocked-out solutions are usually bad, not because they only took ten minutes, but because beginning designers generally don't have the skills to produce a good design in so short a time. Solving design problems in the least acceptable amount of time is difficult enough for professionals, let alone beginners.

Multiple. Another approach is the "multiple" solution. In this case, the designer has failed to come up with one good idea and therefore presents the art director with half a dozen not-so-good ideas. If the designer had spent the same amount of time on one or two of the designs, the results probably would have been more acceptable. Most art directors would rather settle for one well-thought-out solution that shows a sincere effort than several half-thought-through ideas.

Eclectic. This is primarily a student solution. Some students realize that if they procrastinate long enough, all they have to do is look around the class and borrow a little bit from each student, reassemble the pieces, and then sign their names. The problem is not that an "eclectic" solution is bad design, but that such students are limiting their own development. Should this type of student pursue a career in graphic design, he or she should never consider working alone.

Invisible. Then there is the "invisible" solution. In this case the designer doesn't have a solution but does have lots of ideas to discuss with the art director, usually accompanied by extravagant hand motions. This approach reflects the designer's practical, efficient nature: why spend a great deal of time developing designs if your ideas are no good to start with? While this may seem logical, the problem is that in visual arts the art director must have something to look at in order to give an intelligent criticism. Comps speak louder than words.

"Death in the Family." This is where the designer has failed to meet the deadline. He or she has either procrastinated too long or is incapable of solving the problem but doesn't dare admit the real reason to the client. Somehow inventing an unassailable excuse seems to be the most convenient solution. Not only is the excuse rarely challenged, but the designer also gets sympathy.

The more you get out of school, the better your chances of success. But how do you get more out of school? Some of the ways are rather obvious, such as selecting the best courses, working hard, and developing your design skills and good working habits. Other ways are less apparent and involve your attitude toward instructors, projects, other students, and even the school itself.

Perhaps the first step toward getting the most out of school is by realizing that the quality of your education is very much in your hands.

The Learning Process

The rate and process by which one learns will vary from student to student. Unlike the runner, whose efforts can be measured against a clock, the artist has no such yardstick. Art can't be measured or weighed. Some artists develop early in life and others, late. Artists like Picasso continue to develop throughout their lives, while others may level off, give up, or move into other fields. As there is no way of predicting your potential, you will just have to work hard and maintain a positive attitude.

In school the learning process is accelerated as you come into contact with a wide range of influences, not only from instructors and fellow students, but also from the world around you. You must keep an open mind, weigh everything carefully, and select what seems right for you. Little by little you will develop a unique style.

This experience is similar to that of learning handwriting. After you have been taught the correct forms, you spend your early years imitating others, copying a certain letter or stroke that pleases you. As you mature you will keep the embellishments that suit you and discard the others until at some point you have a writing style that everyone recognizes as yours. Artists do the same; early Van Goghs look like paintings by Seurat or Gaugin, while early Beethoven pieces sound as if they might have been composed by Haydn.

The rate at which you absorb influences also varies. One student may absorb a number of different styles in a short period, while another may re-
quire much more time. The speed with which you absorb these influences or produce work does not dictate your success, nor does it reflect the excellence of your work. Some artists turn out prodigious amounts of work, while others suffer over every brush stroke or word.

At times you may find yourself overwhelmed by the amount of information to be absorbed, especially technical matter. If you feel that this is happening to you in a particular class, or if you don't understand what the instructor is saying, say so. Once you start slipping, you'll just continue to fall farther behind.

Dealing with Competition

The art school atmosphere, with talented students all striving to outdo one another, can be very competitive. Added to this are pressures from your family, instructors, and yourself to succeed. Many of these pressures are common to all students—and to many practicing designers as well.

There is no way to stop students from competing with one another, nor would one want to. Competition can be healthy and help bring out the best in everyone. It can also prepare the student for the outside world. However, when competition becomes unbearable, then students can suffer, become discouraged, and even drop out.

The time you spend in school is a little like a marathon race in which all types compete and the lead changes many times. Some students come into school with prior training and for a while they excel, but before long other students start to close the gap. It is not unusual to see gifted students falling behind because they lack self-discipline, without which it's impossible to succeed.

If, by graduation day, someone is a better designer than you, take heart. The end of school is not the end of personal growth; your career is just beginning. Besides your design skills, you have other marketable qualities, such as your personality, self-discipline, enthusiasm, reliability—and, hopefully, a sense of humor.

Success is achieving the goals you set for yourself.

Overcoming Fear of Failure

Many students, and professionals, share the same anxiety when they start a new project: a fear of the unknown, a fear that the gift of creativity will desert them and they will fail.

The only way to avoid failure is to work solely within the safe bounds of your present knowledge. While this will certainly reduce your failure rate, it will also dramatically stunt your artistic growth. To develop, you must venture beyond what you already know; after all, that's the essence of learning. School offers you a safe environment in which to experiment and grow—they can't fire you from school!

Don't be afraid of failure. Although everyone wants to succeed, failure is often the better teacher. You seldom forget a lesson taught by failure. Besides, knowing what won't work is often the first step toward knowing what will.

Working Through Designer's Block

All creative people at one time or another fail to come up with satisfactory ideas. Writers call this writer's block and designers would probably call it designer's block. Because this is a normal part of all designers' lives, they must deal with it in some way. Many designers choose this time to clean their desks, sharpen their pencils, and otherwise kill time until lunch, hoping that later things will look better. Other designers like to sleep on the problem, hoping that the pieces will fall into place overnight. Every designer has a different approach.

Students, too, are affected by blocks. It is not uncommon for students to spend hours making thumbnails only to end up discouraged. The dialogue (or monologue) usually goes, "Well, I could do this, or this, or maybe this. . . ." and with each new thought, a new thumbnail appears.

One way to break this cycle is to take your most promising thumbnail and start working it up to actual size. This not only forces you to make design decisions, but also committing yourself to a specific approach frees your mind making it more receptive to new ideas that may emerge.

There are as many ways of dealing with designer's block as there are designers; experience will teach you which approach is best for you.

Accepting Assignments

Focus your energies on the assignment and not on demanding to know why it was given. Some students spend a great deal of time questioning the value of certain assignments. This is not serious if the student is honestly confused and wants a better understanding of the problem. Too often, however, it is just a form of procrastination. The student is unsure and really doesn't know what to do; asking questions gives the illusion of activity.

Whether you *like* the problem or not is relatively unimportant. In business, the client seldom asks whether you like a particular job. Having engaged you as a professional, the client has the right to expect that you will do the job whether you like it or not.

If it is not the assignment but the type of solution you question, then you have an option. Solve the problem twice: once the way it is being asked, and a second time the way you feel it should be handled. Show both solutions to the instructor.

Keep in mind that instructors have reasons for giving particular assignments So, ask questions until you understand the project, then design.

Evaluating the Instructor

While you may not like an instructor— at least respect his or her position. Students are seldom in a position to judge instructors fairly and will often show preferences for the wrong reasons. This attitude will hurt the student more than the instructor.

Rather than expend energy on criticizing the instructors, just accept the

fact that not all teachers—nor all subjects—are equal. One person's favorite is another's least favorite. It will be the same when you are working; you will undoubtedly like some clients more than others. However, this should not prevent your doing a professional job.

In school try to work with each instructor, regardless of what you think of them personally, to get the most out of each experience. Concentrate on the creative challenge of solving the problem and then comparing your design with those of other students.

Remember, as you progress through school you continue to grow and change. You may even outgrow your teachers—or think you have!

Contending with Criticism

How you accept criticism will affect your working relationship with the instructors. They have more experience than you, and they are more often right than wrong. If you become too defensive or argumentative you might discourage instructors from speaking their mind. This would be your loss, not theirs. Be open and receptive to new ideas and approaches; realize that it is your work that is being judged and not you personally.

Although there are times when instructors agree on a particular solution, it often comes as a surprise to students when they disagree. Most students find this disconcerting; they would rather everyone agree so that their direction would be clearly defined. Having instructors disagree just creates confusion. But when you consider the situation, you shouldn't be surprised. Instructors, after all, are individuals with their own preferences in typefaces, colors, and so on. It would be equally impossible to get a general agreement from a group of students about a movie or TV show—let alone a design.

Another reason for conflicting opinions may be in what you are showing the instructors. For example, a thumbnail or rough layout may leave a great deal to the imagination, and each instructor will interpret the information differently. The more unresolved your design, the more it is open to interpretation by the viewer.

If you must show your work to several instructors, and their opinions vary, bear in mind that the final decision remains in your hands. Take all the critiques into consideration and select only what you feel is relevant.

Learning from Other Students

When students think about the quality of the education they are receiving, they tend to focus on the school, curriculum, and faculty. What they fail to realize is how much of their education depends on one another.

Class discussions and critiques are all areas in which students unknowingly help both themselves and each other. By entering into discussions they learn how to verbalize about design and to communicate ideas and concepts. These are skills you will need if you wish to become an art director or freelance designer, where you often have to sell your design concepts with words. The sooner you learn these skills, the easier it will be for you to adapt to the business world when you graduate.

You also should learn to express your ideas in a positive way. Avoid harsh criticism or remarks that put down your fellow students. A sharp comment might seem funny at the time, but you risk polarizing the situation, after which no one benefits. Besides, you would not display this attitude toward a client.

Students don't realize how much they fail each other when they neglect to do assignments. Most see this only as a loss to the delinquent; they don't realize that it's everyone's loss. Every piece of work is a part of your education: if it's good, you learn something, and if it's bad, you learn something. Everyone benefits from the experience. Students who continually fail to do assignments deprive other students of a part of their education—they take without giving anything in return.

Remember, in school you are not just working for a good mark, nor for the instructor; you are working for yourself and for the other students.

Self-Motivation

There are times in school when you become discouraged and are ready to quit. At such times it's easy to blame the instructors, claiming they don't inspire or motivate you. Before doing something drastic, consider for a moment that the problem may lie not with the faculty, but with you. Perhaps you have forgotten what it feels like to be self-motivated.

There are very few people who have not been inspired or motivated to do something that no one asked them to do. As children we have all been involved in projects that delighted us, whether it was making a gift for someone or planning a picnic. No amount of work was too great; in fact, you could hardly sleep waiting for the next day so you could get back to work. You didn't need teachers to inspire or motivate you; it all came from within.

If you're interested in a career in graphic design, the goal alone should inspire you. If you don't feel this way, try to understand why—but always start with yourself.

Should I Graduate?

Yes. There are many good reasons for finishing school besides getting your education. There's the degree, which shows a prospective employer that you have not only the skills but also the discipline to see a job through. Having a degree also means that clients are more apt to take your work and your counsel seriously. Would you patronize a doctor who had quit halfway through medical school?

Also, when it comes time to find a job, your contacts with professors and alumni can be useful. Professors can provide you with references, and alumni are well-known for hiring graduates from their alma mater.

All things considered, there are few good reasons not to finish school. School is one major design problem that deserves a complete solution.

The hero setting off into the world to seek his fortune. From *The Fool of the World and the Flying Ship* by Arthur Ransome and illustrated by Uri Shulevitz © 1968. Reprinted by permission of Farrar, Straus and Giroux, Inc.

APPEN-DIXES

ADVERTISING AGENCIES

Below are listed some of the major advertising agencies in the United States. Although many have New York addresses, many have branches nationwide and in many cases, worldwide.

For a more complete listing, refer to the *Standard Directory of Advertising Agencies*, more commonly referred to as the agency red book. This directory lists not only the agencies but also the key personnel, foreign offices, and major accounts.

Another source worth looking into is *The Creative Black Book*, which lists agencies by geographical districts: Northeast, Midwest, West, and South. *The Creative Black Book* is available in most art supply stores.

You may also wish to refer to the magazine, *Advertising Age*, published by Crain Communications, Inc., 740 Rush Street, Chicago, IL 60611. Once a year they publish a special issue listing all the major agencies and showing how they rank in size, income, billing, accounts, and so on.

To find the agencies in your area, refer to the telephone book under the agency name or the yellow pages under Advertising Agencies.

Please note that space has been allotted at the end of the book for additional names and addresses.

Ally & Gargano
437 Madison Avenue
New York, NY 10022

N.W. Ayer, Inc.
1345 Avenue of the Americas
New York, NY 10105

Ted Bates
1515 Broadway
New York, NY 10036

Batten, Barton, Durstine & Osborn
383 Madison Avenue
New York, NY 10017

Benton & Bowles
909 Third Avenue
New York, NY 10022

Bozell & Jacobs, Inc.
1250 Regency Circle
Omaha, NE 68114

Leo Burnett Co. Inc.
767 Third Avenue
New York, NY 10153

Burstin-Marsteller, Inc.
1 East Wacker Drive
Chicago, IL 60601

Campbell-Mithun, Inc.
Northstar Center
Victoria Place, MN 55400

Chiat/Day
517 South Olive Street
Los Angeles, CA 90013

Compton Advertising, Inc.
625 Madison Avenue
New York, NY 10022

Creamer, Inc.
One Oliver Plaza
Pittsburgh, PA 15222

Cunningham & Walsh
260 Madison Avenue
New York, NY 10016

Dailey & Associates
3055 Wilshire Boulevard
Los Angeles, CA 94133

Dancer, Fitzgerald, Sample
405 Lexington Avenue
New York, NY 10174

D'Arcy-MacManus & Masius
437 Madison Avenue
New York, NY 10022

Dellafemina, Travisano & Partners
625 Madison Avenue
New York, NY 10022

W. B. Doner & Co.
2305 North Charles Street
Baltimore, MD 21218

Doremus & Co.
120 Broadway
New York, NY 10271

Doyle Dane Bernbach
437 Madison Avenue
New York, NY 10022

Eisaman, Johns and Laws
488 Madison Avenue
New York, NY 10022

William Esty Co. Inc.
100 East 42 Street
New York, NY 10017

Foote, Cone & Belding
200 Park Avenue
New York, NY 10178

Grey Advertising
777 Third Avenue
New York, NY 10017

Keller Crescent
P.O. Box 61028
Dallas, TX 75261

Kenyon & Eckhardt
200 Park Avenue
New York, NY 10178

Ketchum Communications
90 Park Avenue
New York, NY 10036

Leber Katz Partners, Inc.
767 Fifth Avenue
New York, NY 10153

McCaffey and McCall
575 Lexington Avenue
New York, NY 10022

McCann-Erickson, Inc.
485 Lexington Avenue
New York, NY 10017

Needham, Harper & Steers
303 East Wacker Drive
Chicago, IL 60601

Norman, Craig & Kummel, Inc.
919 Third Avenue
New York, NY 10022

Ogilvy & Mather
2 East 48 Street
New York, NY 10017

SSC&B
1 Dag Hammerskjold Plaza
New York, NY 10017

Scali, McCabe, Sloves, Inc.
800 Third Avenue
New York, NY 10022

Sudler & Hennessey, Inc.
130 East 59 Street
New York, NY 10019

Tatham-Laird & Kudner
625 N. Michigan Avenue
Chicago, IL 60611

J. Walter Thompson
420 Madison Avenue
New York, NY 10022

Tracy-Locke Advertising, Inc.
7503 Marin Drive
Englewood, CO 80111

Warwick Advertising, Inc.
875 Third Avenue
New York, NY 10022

Wells, Rich, Greene, Inc.
767 Fifth Avenue
New York, NY 10153

Wunderman, Ricotta & Kline
575 Third Avenue
New York, NY 10022

Young & Rubicam
285 Madison Avenue
New York, NY 10017

BOOK PUBLISHERS

There are hundreds of publishers throughout the country, ranging from small privately owned companies to large corporations that publish books under a number of different imprints. The size of the art departments range accordingly.

Below are the names and addresses of a variety of publishers located across the country. A complete listing is available in *Literary Market Place*, published by R. R. Bowker, 1180 Avenue of the Americas, New York, NY 10036.

Harry M. Abrams, Inc.
110 East 59 Street
New York, NY 10022

Addison-Wesley Publishing
Co. Inc.
Reading, MA 01867

Avon Books
959 Eighth Avenue
New York, NY 10019

Basic Books
10 East 53 Street
New York, NY 10022

George Braziller, Inc.
One Park Avenue
New York, NY 10016

CBS Educational and
Professional Publishing
383 Madison Avenue
New York, NY 10017

California Living Books
223 Hearst Building
San Francisco, CA 94103

Cambridge University Press
32 East 57 Street
New York, NY 10022

Computer Science Press
11 Taft Crescent
Rockville, MD 20850

Consumer Reports Books
256 Washington Street
Mt. Vernon, NY 10550

Cornell University Press
124 Roberts Place
Ithaca, NY 14850

Crown Publishers Inc.
One Park Avenue
New York, NY 10016

The Dial Press
One Dag Hammarskjold
Plaza
New York, NY 10017

Dodd, Mead & Co.
79 Madison Avenue
New York, NY 10016

Doubleday & Co. Inc.
245 Park Avenue
New York, NY

Dover Publications Inc.
180 Varick Street
New York, NY 10014

E. P. Dutton Inc.
2 Park Avenue
New York, NY 10016

Eastman Kodak Co.
343 State Street
Rochester, NY 14650

Encyclopaedia Britannica
425 North Michigan Avenue
Chicago, IL 60611

Farrar, Straus & Giroux, Inc.
19 Union Square West
New York, NY 10003

Fawcett Books Group
1515 Broadway
New York, NY 10036

Folcroft Library Editions
842 Main Street
Darby, PA 19023

Funk & Wagnalls, Inc.
53 East 77 Street
New York, NY 10021

David R. Godine Publisher,
Inc.
306 Dartmouth Street
Boston, MA 02116

Graphic Arts Technical
Foundation
4615 Forbes Avenue
Pittsburgh, PA 15213

Grolier, Inc.
Sherman Turnpike
Danbury, CT 06816

Grosset & Dunlap, Inc.
51 Madison Avenue
New York, NY 10010

Grove Press
196 West Houston Street
New York, NY 10014

Harcourt Brace Jovanovich
757 Third Avenue
New York, NY 10017

Harper & Row, Publishers
Inc.
10 East 53 Street
New York, NY 10022

Harvard University Press
79 Garden Street
Cambridge, MA 02138

Hastings House, Publishers
Inc.
10 East 40 Street
New York, NY 10016

Holt Rinehart & Winston
521 Fifth Avenue
New York, NY 10175

Houghton Mifflin Co.
One Beacon Street
Boston, MA 02107

Indiana University Press
Tenth and Morton Street
Bloomington, IN 47405

Alfred A. Knopf, Inc.
201 East 50 Street
New York, NY 10022

Land Publishing
Menlo Park, CA 94025

Leisure Books
2 Park Avenue
New York, NY 10016

J. B. Lippincott Co.
East Washington Square
Philadelphia, PA 19105

Little, Brown & Co.
34 Beacon Street
Boston, MA 02106

The MIT Press
28 Carelton Street
Cambridge, Ma 02142

McGraw-Hill Inc.
1221 Avenue of the
Americas
New York, NY 10020

Macmillan Inc.
866 Third Avenue
New York, NY 10022

Charles E. Merrill
Publishing Co.
1300 Alum Creek Drive
Columbus, OH 43216

William Morrow
105 Madison Avenue
New York, NY 10016

The Museum of Modern Art
11 West 53 Street
New York, NY 10019

Music Sales Corp.
33 West 60 Street
New York, NY 10023

National Textbook Co.
8259 Niles Center Road
Skokie, IL 60007

The New American Library
1633 Broadway
New York, NY 10019

New York Graphic Society
Books
41 Mount Vernon Street
Boston, MA 02106

Nordon Publications
2 Park Avenue
New York, NY 10016

W. W. Norton & Co.
500 Fifth Avenue
New York, NY 10110

Oxford University Press
Inc.
200 Madison Avenue
New York, NY 10016

Pantheon Books Inc.
201 East 50 Street
New York, NY 10022

Penguin Books
625 Madison Avenue
New York, NY 10022

Pergamon Press Inc.
Maxwell House, Fairview
Park
Elmsford, NY 10523

Pitman Learning Inc.
6 Davis Drive
Belmont, CA 94002

Playboy Press
1633 Broadway
New York, NY 10019

Pocket Books
1230 Avenue of the
Americas
New York, NY 10020

Praeger Publishers
521 Fifth Avenue
New York, NY 10017

Prentice-Hall Inc.
Englewood Cliffs, NJ 07632

G. P. Putnam's Sons
200 Madison Avenue
New York, NY 10016

Raintree Publishers Inc.
205 West Highland Avenue
Milwaukee, WI 53203

Rand McNally & Company
8255 Central Park Avenue
Skokie, IL 60076

Random House
201 East 50 Street
New York, NY 10022

St. Martin's Press
175 Fifth Avenue
New York, NY 10010

Schocken Books, Inc.
200 Madison Avenue
New York, NY 10016

Scholastic Inc.
50 West 44 Street
New York, NY 10036

Science Research Associates
Inc.
155 North Wacker Drive
Chicago, IL 60606

Charles Scribner's & Sons
597 Fifth Avenue
New York, NY 10017

Sierra Club Books
530 Bush Street
San Francisco, CA 94108

Simon & Schuster
1230 Avenue of the
Americas
New York, NY 10020

W. H. Smith Publishers Inc.
112 Madison Avenue
New York, NY 10016

Smithsonian Institutional
Press
Washington, DC 20560

Stein & Day Publishers
Briarcliff Manor, NY 10510

Times Books
3 Park Avenue
New York, NY 10016

Van Nostrand Reinhold
135 West 50 Street
New York, NY 10020

The Viking Press
625 Madison Avenue
New York, NY 10022

Warner Books
75 Rockefeller Plaza
New York. NY 10019

Watson-Guptill Publications
1515 Broadway
New York, NY 10036

Western Publishing
Company Inc.
1220 Mound Avenue
Racine, WI 53404

John Wiley & Sons Inc.
605 Third Avenue
New York, NY 10158

Xerox Educational
Publications
245 Long Hill Road
Middletown, CT 06457

Yale University Press
302 Temple Street
New Haven, CT 06520

MAGAZINE PUBLISHERS

There are over 10,000 magazines printed annually in the United States and Canada. This number grows to 60,000 if you include the many smaller publications that do not qualify as magazines.

Below are listed some of the more popular consumer magazines, along with the names of the parent companies. If you are interested in a complete listing, you should refer to the *Standard Rate and Data Service* (SRDS) directory, which is available in most major libraries, or the *Standard Periodical Directory*, which lists all 60,000 periodicals in the United States and Canada. For magazines in your area check the yellow pages under Publishing (Periodical).

Better Homes & Gardens
Meredith Corporation
750 Third Avenue
New York, NY 10017

Bicycling
Rodale Press
Emmaus, PA 18049

Black Enterprise
295 Madison Avenue
New York, NY 10017

Bon Appetit
9 West 57 Street
New York, NY 10019

Bride
The Condé Nast
Publications Inc.
350 Madison Avenue
New York, NY 10017

Business Week
McGraw-Hill Publications
Company
1221 Avenue of the
Americas
New York, NY 10020

The Condé Nast
Publications Inc.
350 Madison Avenue
New York, NY 10017

Cosmopolitan
The Hearst Corporation
224 West 57 Street
New York, NY 10019

Discover
Time Incorporated
1271 Avenue of the
Americas
New York, NY 10020

Family Circle
New York Times Magazine
Group
488 Madison Avenue
New York, NY 10022

Field & Stream
CBS Publications
1515 Broadway
New York, NY 10036

Forbes Magazine
60 Fifth Avenue
New York, NY 10011

Fortune Magazine
Time Incorporated
1271 Avenue of the
Americas
New York, NY 10020

Forum Magazine
Penthouse Magazine
Publications
909 Third Avenue
New York, NY 10022

Glamour
The Condé Nast
Publications Inc.
350 Madison Avenue
New York, NY 10017

Good Housekeeping
The Hearst Corporation
959 Eighth Avenue
New York, NY 10019

Gourmet Magazine
560 Lexington Avenue
New York, NY 10022

Harper's Bazaar
The Hearst Corporation
1700 Broadway
New York, NY 10019

The Hearst Corporation
244 West 57 Street
New York, NY 10019

High Fidelity
ABC Publishing Company
825 Seventh Avenue
New York, NY 10019

House & Garden
The Condé Nast
Publications Inc.
350 Madison Avenue
New York, NY 10019

House Beautiful
The Condé Nast
Publications Inc.
224 West 57 Street
New York, NY 10019

Ladies Home Journal
641 Lexington Avenue
New York, NY 10022

Life
Time Incorporated
1271 Avenue of the
Americas
New York, NY 10020

Mademoiselle
The Condé Nast
Publications Inc.
350 Madison Avenue
New York, NY 10017

McCall's Magazine
McCall's Publishing
Company
230 Park Avenue
New York, NY 10169

McGraw-Hill Publications
Company
1221 Avenue of the
Americas
New York, NY 10020

Mechanics Illustrated
CBS Publications
1515 Broadway
New York, NY 10036

Metropolitan Home
Meredith Corporation
750 Third Avenue
New York, NY 10017

Modern Photography
ABC Publishing Company
825 Seventh Avenue
New York, NY 10019

Ms Magazine
119 W 40 Street
New York, NY 10018

Money Magazine
Time Incorporated
1271 Avenue of the
Americas
New York, NY 10020

Motor
The Hearst Corporation
224 West 57 Street
New York, NY 10019

Motor Boating & Sailing
The Hearst Corporation
224 West 57 Street
New York, NY 10019

Musical America
ABC Publishing Company
825 Seventh Avenue
New York, NY 10019

National Lampoon
635 Madison Avenue
New York, NY 10022

Newsweek
444 Madison Avenue
New York, NY 10022

Omni Magazine
Penthouse Magazine
Publications
909 Third Avenue
New York, NY 10022

Oui
Playboy Publications, Inc.
919 North Michigan Avenue
Chicago, IL 60611

Penthouse
Meredith Corporation
909 Third Avenue
New York, NY 10022

People
Time Incorporated
1271 Avenue of the
Americas
New York, NY 10020

Playboy
Playboy Enterprises
Incorporated
919 North Michigan Avenue
Chicago, IL 60611

Popular Mechanics
The Hearst Corporation
224 West 57 Street
New York, NY 10019

Prevention
Rodale Press
Emmaus, PA 18049

Road & Track
CBS Publications
1515 Broadway
New York, NY 10036

Self
The Condé Nast
Publications Inc.
350 Madison Avenue
New York, NY 10017

Seventeen
Triangle Communications
Incorporated
850 Third Avenue
New York, NY 10022

Sports Illustrated
Time Incorporated
1271 Avenue of the
Americas
New York, NY 10020

Spring
Rodale Press
Emmaus, PA 18049

Successful Farming
Meredith Corporation
750 Third Avenue
New York, NY 10017

Time Magazine
Time Incorporated
1271 Avenue of the
Americas
New York, NY 10020

Town & Country
The Hearst Corporation
1700 Broadway
New York, NY 10019

TV Guide
Triangle Publications Inc.
1290 Avenue of the
Americas
New York, NY 10104

US News & World Report
45 Rockefeller Plaza
New York, NY 10020

Viva
Penthouse Magazine
Publications
909 Third Avenue
New York, NY 10022

Vogue
The Condé Nast
Publications Inc.
350 Madison Avenue
New York, NY 10017

Working Mother
McCall's Publications
230 Park Avenue
New York, NY 10169

Working Woman
1180 Avenue of the
Americas
New York, NY 10036

Woman's Day
CBS Publications
1515 Broadway
New York, NY 10036

World Tennis
CBS Publications
1515 Broadway
New York, NY 10036

ART SCHOOLS

On the following pages is a list of the major art schools both in the United States and abroad. Included in the list are universities, colleges, community colleges, technical schools, schools of continuing education, and graduate schools. All the schools listed offer courses in some aspect of graphic design. For more complete information phone or write to the art department of the specific school and request a catalog.

For a more complete listing of schools, write to the National Association of Schools of Art, 11250 Roger Bacon Drive #5, Reston, VA 22090 or to the State Department of Education in the state you wish to study. Among the publications you may wish to refer to are *American Art School Directory*, published by the R. R. Bowker Company, New York, NY 10036; or the *American Artist Directory of Art Schools*, published by American Artist, 1515 Broadway, New York, NY 10036.

United States

Alabama

Alabama State University
Montgomery 36111

Athens College
Athens 35611

Auburn University
Auburn 36830

Samford University
Birmingham 35209

University of Alabama
Birmingham 35294

University of Alabama
Huntsville 35899

University of Alabama
University 35486

University of North Alabama
Florence 35630

University of South Alabama
Mobile 3668

Alaska

University of Alaska
Anchorage 99504

University of Alaska
Fairbanks 99701

Arizona

Arizona State University
Tempe 85281

Cochise College
Douglas 85607

Maricopa Technical Community College
Phoenix 85004

Mesa Community College
Mesa 85202

Northern Arizona University
Flagstaff 86001

Phoenix College
Phoenix 85013

Yavapai College
Prescott 86301

Arkansas

Arkansas State University
Jonesboro 72467

Arkansas Tech University
Russellville 72801

Harding University
Searcy 72143

Ouachita Baptist University
Arkadelphia 71923

North Arkansas Community College
Harrison 72601

University of Arkansas
Fayetteville 72701

University of Arkansas
Little Rock 72204

California

Academy of Art College
San Francisco 94102

Art Center College of Design
Pasadena 91103

California College of Arts and Crafts
Oakland 94618

California State College
Bakersfield 93309

California State College
San Bernardino 92407

California State Polytechnic University
San Luis Obispo 93407

California State University
Fresno 93740

California State University
Fullerton 92634

California State University
Northbridge 91330

California State University
Los Angeles 90032

Citrus Community College
Azusa 91702

City College of San Francisco
San Francisco 94112

College of Marin
Kentfield 94904

Compton Community College
Compton 90221

Cuesta Community College
San Luis Obispo 93406

Cypress College
Cypress 90630

De Anza College
Cupertino 95014

El Camino College
Los Angeles 90506

Foothill College
Los Altos Hills 94022

Golden West College
Huntington Beach 92647

Humboldt State University
Arcata 95521

Laney College
Oakland 94607

Loma Linda University
Riverside 92515

Long Beach City College
Long Beach 90808

Los Angeles City College
Los Angeles 90029

Modesto Junior College
Modesto 95350

Monterey Peninsula College
Monterey 93940

Otis Art Institute of Parsons School of Design
Los Angeles 90057

Pasadena City College
Pasadena 91106

Pomona College
Claremont 91711

Sacramento City College
Sacramento 95822

San Diego State University
San Diego 92182

San Jose State University
San Jose 95192

Santa Barbara City College
Santa Barbara 93105

Stanford University
Stanford 94305

University of California at
San Diego
La Jolla 92093

West Hills College
Coalinga 93210

Woodbury University
Los Angeles 90017

Colorado

Colorado College
Colorado Springs 80203

Colorado Institute of Art
Denver 80203

Colorado State University
Fort Collins 80523

Metropolitan State College
Denver 80204

University of Denver
Denver 80208

University of Southern
Colorado
Pueblo 81001

Connecticut

Central Connecticut State
College
New Britain 06050

Hartford Art School
West Hartford 06117

Housatonic Community
College
Bridgeport 06608

Southern Connecticut State
College
New Haven 06515

University of Bridgeport
Bridgeport 06602

University of Connecticut
Storrs 06268

Wesleyan University
Middletown 06457

Yale University
New Haven 06520

Delaware

Delaware State College
Dover 19901

University of Delaware
Newark 19711

District of Columbia

American University
Washington 20016

Corcoran School of Art
Washington 20006

George Washington
University
Washington 20052

Howard University
Washington 20059

Trinity College
Washington 20017

University of the District of
Columbia
Washington 20001

Florida

Art Institute of Fort
Lauderdale
Fort Lauderdale 33316

College of Boca Raton
Boca Raton 33431

Daytona Beach Community
College
Daytona Beach 32015

Florida State University
Tallahassee 32306

Ringling School of Art and
Design
Sarasota 33580

University of Central
Florida
Orlando 32816

University of Florida
Gainesville 32611

University of Miami
Coral Gables 33124

University of North Florida
Jacksonville 32216

Georgia

Art Institute of Atlanta
Atlanta 30326

Atlanta College of Art
Atlanta 30309

Georgia Southern College
Statesboro 30458

Georgia State University
Atlanta 30303

University of Georgia
Athens 30602

Valdosta State College
Valdosta 31698

Wesleyan College
Macon 31297

Hawaii

Honolulu Community
College
Honolulu 96817

Maui Community College
Kahului 96732

University of Hawaii
Honolulu 96822

Idaho

Boise State University
Boise 83725

Idaho State University
Pocatello 83209

Illinois

American Academy of Art
Chicago 60604

Bradley University
Peoria 61625

City Colleges of Chicago
Chicago 60601

Eastern Illinois University
Charleston 61920

Illinois Central College
East Peoria 61653

Illinois State University
Normal 61761

Northern Illinois University
De Kalb 60115

School of the Art Institute
of Chicago
Chicago 60603

Southern Illinois University
Carbondale 62902

Southern Illinois University
Edwardsville 62026

University of Illinois
Champaign 61820

University of Illinois
Chicago 60680

Western Illinois University
Macomb 61455

Wheaton College
Wheaton 60187

Indiana

Anderson College
Anderson 46011

Ball State University
Muncie 47306

Depauw University
Greencastle 46135

Hanover College
Hanover 47243

Herron School of Art
Indianapolis 46202

Indiana Central University
Indianapolis 46227

Indiana University
Bloomington 47401

Indiana University-Purdue
University
Fort Wayne 46804

Indiana University
South Bend 46615

Marion College
Marion 46952

Purdue University
West Lafayette 47907

University of Notre Dame
Notre Dame 46556

Iowa

Drake University
Des Moines 50311

Iowa State University
Ames 50010

Saint Ambrose College
Davenport 52803

University of Iowa
Iowa City 52242

University of Northern Iowa
Cedar Falls 50614

Kansas

Fort Hays State University
Fort Hays 67601

University of Kansas
Lawrence 66045

Wichita State University
Wichita 67208

Kentucky

Jefferson Community
College
Louisville 40201

Murray State University
Murray 42071

Northern Kentucky
University
Highland Heights 41076

University of Kentucky
Lexington 40506

University of Louisville
Louisville 40292

Western Kentucky
University
Bowling Green 42101

Louisiana

Grambling State University
Grambling 71245

Louisiana State University
Baton Rouge 70803

Louisiana Tech University
Ruston 71270

New Orleans Art Institute
New Orleans 70119

Nicholls State University
Thibodaux 70301

Northwestern State
University of Louisiana
Natchitoches 71457

University of New Orleans
New Orleans 70122

University of Southern
Louisiana
Lafayette 70504

Maine

Portland School of Art
Portland 04101

University of Maine
Augusta 04330

Maryland

College of Notre Dame of
Maryland
Baltimore 21210

Community College of
Baltimore
Baltimore 21215

Johns Hopkins University
Baltimore 21205

Maryland College of Art
and Design
Silver Springs 20902

Maryland Institute
Baltimore 21217

Salisbury State College
Salisbury 21801

University of Maryland
Cantonsville 21228

Massachusetts

Art Institute of Boston
Boston 02215

Boston Center for Adult
Education
Boston 02116

Boston University
Boston 02215

Brandeis University
Waltham 02154

Clark University
Worcester 01618

Endicott College
Beverly 01915

Harvard University
Cambridge 02138

Massachusetts College of
Art
Boston 02215

Massachusetts Institute of
Technology
Cambridge 02139

Montserrat School of Visual
Art
Beverly 01915

New England School of Art
and Design
Boston 02116

Northeastern University
Boston 02115

Smith College
Northampton 01063

Southeastern Massachusetts
University
North Dartmouth 02747

Springfield College
Springfield 01109

Swain School of Design
New Bedford 02740

Wellesley College
Wellesley 02181

Wheaton College
Norton 02766

Michigan

Center for Creative Studies-
College of Art and Design
Detroit 48202

Cranbrook Academy of Art
Bloomfield Hills 48013

Eastern Michigan
University
Ypsilanti 48197

Kendall School of Design
Flint 49502

Michigan State University
East Lansing 48824

Northern Michigan
University
Marquette 49855

Southwestern Michigan
College
Dowagiac 49047

University of Michigan
Ann Arbor 48109

Wayne State University
Detroit 48202

Western Michigan
University
Kalamazoo 49012

Minnesota

Bemidji State University
Bemidji 56601

Bethel College
St. Paul 55112

College of Saint Benedict
Saint Joseph 56374

College of Saint Thomas
St. Paul 55108

Concordia College
Moorhead 56560

Minneapolis College of Art
and Design
Minneapolis 55404

Moorhead State University
Moorhead 56560

Saint Cloud State
University
Saint Cloud 56301

School of Associated Arts
St. Paul 55102

University of Minnesota
Duluth 55812

Mississippi

Delta State University
Cleveland 38733

Jackson State University
Jackson 39217

Mississippi State University
Mississippi State 39762

Mississippi University for
Women
Columbus 39701

Mississippi Valley State
University
Itta Bena 38941

University of Mississippi
University 38677

University of Southern
Mississippi
Hattiesburg 39401

Missouri

Kansas City Art Institute
Kansas City 64111

Southwest Baptist
University
Bolivar 65613

Southwest Missouri State
University
Springfield 65802

Stephens College
Columbia 65201

University of Missouri
Columbia 65211

Washington University
St. Louis 63130

Montana

Montana State University
Bozeman 59717

Rocky Mountain College
Billings 59102

Nebraska

Creighton University
Omaha 68178

University of Nebraska
Lincoln 68588

Wayne State College
Wayne 68787

Nevada

University of Nevada
Las Vegas 89154

University of Nevada
Reno 89557

New Hampshire

Dartmouth College
Hanover 03755

Notre Dame College
Manchester 03104

River College
Nashua 03060

New Jersey

Jersey City State College
Jersey City 07305

Kean College of New Jersey
Union 07083

Princeton University
Princeton 08540

Rutgers University
Newark 07102

Rutgers University
New Brunswick 08903

Seton Hall University
South Orange 07079

Trenton State College
Trenton 08625

New Mexico

Eastern New Mexico
University
Portales 88130

New Mexico State
University
Las Cruces 88003

University of Albuquerque
Albuquerque 87120

Western New Mexico
University
Silver City 88061

New York

Adelphi University
Garden City 11530

College of Saint Rose
Albany 12203

Cooper Union
New York 10003

Cornell University
Ithaca 14853

Daemen College
Amherst 14226

Fashion Institute of
Technology
New York 10001

Fordham University
New York 10023

Hofstra University
Hempstead 11550

Ithaca College
Ithaca 14850

Long Island University
Greenvale 11548

Long Island University
Southampton 11968

Manhattan College
Bronx 10471

Mohawk Valley Community
College
Uitca 13510

New School for Social
Research
New York 10011

New York City Community
College
Brooklyn 71210

New York Institute of
Technology
Old Westbury 11568

Parsons School of Design
New York 10011

Pratt Institute
Brooklyn 11205

Pratt-Phoenix School of
Design
New York 10016

Rochester Institute of
Technology
Rochester 14623

School of Visual Arts
New York 10010

State University of New
York
Buffalo 14214

State University of New York
Farmingdale 11735

State University of New York
Purchase 10577

Union College
Schenectady 12308

North Carolina

North Carolina Central University
Durham 27707

Pembroke State University
Pembroke 28372

University of North Carolina
Asheville 28814

Wake Forest University
Winston-Salem 27109

Western Carolina University
Cullowhee 28723

North Dakota

Dickinson State College
Dickinson 58601

Valley City State College
Valley City 58072

Ohio

Art Academy of Cincinnati
Cincinnati 45202

Bowling Green State University
Bowling Green 43403

Cleveland Institute of Art
Cleveland 44106

Kent State University
Canton 44720

Kent State University
Kent 44242

Miami University
Oxford 45056

Ohio State University
Columbus 43210

Ohio University
Athens 45701

University of Akron
Akron 44325

University of Cincinnati
Cincinnati 45221

University of Dayton
Dayton 45469

Wittenberg University
Springfield 45501

Wright State University
Dayton 45435

Oklahoma

Oklahoma State University
Okmulgee 74447

Phillips University
Enid 73701

University of Oklahoma
Norman 73019

University of Tulsa
Tulsa 74104

Oregon

Portland State University
Portland 97207

Southern Oregon State College
Ashland 97520

University of Oregon
Eugene 97403

Pennsylvania

Art Institute of Philadelphia
Philadelphia 19103

Art Institute of Pittsburgh
Pittsburgh 15222

Carnegie-Mellon University
Pittsburgh 15235

Edinboro State College
Edinboro 16444

Kutztown University
Kutztown 19530

Moore College of Art
Philadelphia 19103

Pennsylvania State University
University Park 16802

Philadelphia College of Art
Philadelphia 19102

Seton Hill College
Greensburg 15601

Studio School of Art and Design
Philadelphia 19102

Temple University
Tyler School of Art
Philadelphia 19126

University of Pittsburgh
Johnstown 15904

Villanova University
Villanova 19085

Williamsport Area Community College
Williamsport 17701

Rhode Island

Rhode Island School of Design
Providence 02903

Roger Williams College
Bristol 02809

University of Rhode Island
Kingston 02881

South Carolina

Bob Jones University
Greenville 29614

University of South Carolina
Columbia 29208

Winthrop College
Rock Hill 29733

South Dakota

Northern State College
Aberdeen 57401

South Dakota State University
Brookings 57002

University of South Dakota
Vermillion 57069

Tennessee

Austin Peay State University
Clarksville 37040

Chattanooga State Technical Community College
Chattanooga 37406

East Tennessee State University
Johnson City 37601

Memphis Academy of Arts
Memphis 38112

Memphis State University
Memphis 38152

Middle Tennessee State University
Murfreesboro 37132

University of Tennessee
Chattanooga 37402

University of Tennessee
Knoxville 37916

Texas

Art Institute of Houston
Houston 77006

Baylor University
Waco 76703

East Texas State University
Commerce 75428

Lamar University
Beaumont 77710

North Texas State University
Denton 76203

Pan American University
Edinburg 78539

San Antonio College
San Antonio 78284

Southwest Texas State University
San Marcos 78666

Texas State Technical Institute
Amarillo 79111

Texas Tech University
Lubbock 79409

University of Houston
Houston 77004

University of Texas
Arlington 76019

University of Texas
Austin 78712

University of Texas
Tyler 75701

West Texas State University
Canyon 79016

Utah

Brigham Young University
Provo 84602

University of Utah
Salt Lake City 84112

Utah State University
Logan 84322

Weber State College
Ogden 84408

Vermont

Castleton State College
Castleton 05735

Goddard College
Plainsfield 05602

University of Vermont
Burlington 05405

Virginia

College of William and Mary
Williamsburg 23185

James Madison University
Harrisonburg 22801

Mary Baldwin College
Staunton 24401

Radford University
Radford 24142

Roanoke College
Salem 24153

Virginia Commonwealth University
Richmond 23284

Virginia State University
Petersburg 23803

Washington

Art Institute of Seattle
Seattle 98122

Clark College
Vancouver 98663

Cornish Institute
Seattle 98102

Pacific Lutheran University
Tacoma 98447

Spokane Falls Community College
Spokane 99204

University of Washington
Seattle 98195

West Virginia

Bethany College
Bethany 26032

Concord College
Athens 24712

Salem College
Salem 26426

West Virginia State College
Institute 25112

West Virginia University
Morgantown 26506

Wisconsin

Beloit College
Beloit 53511

Milwaukee Area Technical
College
Milwaukee 53203

Milwaukee Institute of Art
and Design
Milwaukee 53202

University of Wisconsin
Eau Claire 54701

University of Wisconsin
Madison 53706

University of Wisconsin
Menomonie 54751

University of Wisconsin
Milwaukee 53201

University of Wisconsin
River Falls 54022

University of Wisconsin
Superior 54880

Western Wisconsin
Technical Institute
La Crosse 54601

Wyoming

Casper College
Casper 82601

Sheridan College
Sheridan 82801

University of Wyoming
Laramie 82071

Canada
Alberta

Alberta College of Art
Calgary T2M 0L4

University of Alberta
Edmonton T6G 2C9

University of Calgary
Calgary T2N 1N4

British Columbia

Emily Carr College of Art
and Design
Vancouver V6H 3R9

Vancouver Community
College
Vancouver V5Y 2Z6

Manitoba

University of Manitoba
Winnepeg R3T 2N2

Université de Moncton
Moncton E1A 3E9

Nova Scotia

Nova Scotia College of Art
and Design
Halifax B3J 3J6

Ontario

George Brown College of
Applied Arts and
Technology
Toronto M5T 2T9

Ontario College of Art
Toronto M5T 1W1

Queen's University
Kingston K71 3N6

Sheridan College
Oakville L6H 2L1

York University
Downsview M3J 1P3

Quebec

Concordia University
Montreal H3G 2M5

Université Laval
Quebec G1K 7P4

Université du Québec
Montreal H3C 3P8

University of Quebec
Trois Rivieres G9A 5H7

Abroad
Australia

Adelaide College of the Arts
Underdale

Caufield Institute of
Technology
Melbourne

Randwick Tech
Sydney

Royal Melbourne Institute
of Technology
Melbourne

South Australian College
of Advanced Education
Underdale

Sydney College of the Arts
Sydney

Sydney Technical College
Sydney

Tasmanian School of Art
Tasmania

England

Central School of Art and
Design
London WC1B 4AP

City and Guilds of London
Art School
London SE 11

Harrow College of Art
London HAI 3TP

Leicester Polytechnic
Leicester LE1 PBH

London College of Printing
London SE1

Royal College of Art
London SW7

St. Martins College of Art
London

France

École Nationale Superieure
des Arts Decoratifs
Paris 75005

New Zealand

Aukland Technical Institute
Aukland

Christchurch Polytechnic
Christchurch

Wellington Polytechnic
Wellington

Switzerland

Basel School of Design
Schule für Gestaltung
Basel

BIBLIOGRAPHY

The field of graphic design is so diverse that it's impossible to list all the important books written on the subject and related areas.

Here are just a few of the many books and publications that you may find of interest. They have been broken down into categories and listed alphabetically. Not all publications are still in print, so you may have to do a little searching in libraries or second-hand bookstores.

Annuals

Art Directors Annual. The Art Directors Club of New York. New York.

Graphic Design USA. The Annual of the American Institute of Graphic Arts. New York.

Graphis Annual. Zurich, Switzerland.

Illustrators Annual. The Society of Illustrators. New York.

Penrose Annual. International Revue of the Graphic Arts. New York: Hastings House.

Typography. The Annual of the Type Directors Club. New York.

Business and Legal

Artist's Market. Cincinnati: Writers Book Digest.

How to Write Better Resumes. Adele Lewis. New York: Barrons.

Legal Guide for the Artist. Tad Crawford. New York: Hawthorn Books.

Making It Legal. M. Davidson and M. Blue. New York: McGraw-Hill.

Pricing and Ethical Guide. New York: Graphic Artists Guild.

Selling Your Graphic Design and Illustration. T. Crawford and A. Kopelman. New York: St. Martin's Press.

The Visual Artist's Guide to the New Copyright Law. Tad Crawford. New York: Hawthorn Books.

Why Should I Hire You? Melvin R. Thomson. New York: Harcourt Brace Jovanovich.

Education

American Art Directory. New York: R. R. Bowker.

Annual Register of Grant Support. Chicago: Marquis Academic.

Grants for Graduate Study Abroad. New York: Institute of International Education.

Handbook on Study in Europe for U.S. Nationals. N. Young and M. L. Taylor. New York: Institute of International Education.

Summer Study Abroad. Gail A. Cohen. New York: Institute of International Education.

U.S. College-Sponsored Programs Abroad: Academic Year. Gail A. Cohen. New York: Institute of International Education.

Graphic Design

The Art of Advertising: George Lois on Mass Communication. George Lois. New York: Harry N. Abrams, Inc.

By Design: A Graphics Sourcebook of Materials, Equipment, & Services. New York: Quick Fox.

The Bauhaus. Hans Wingler. Cambridge: The MIT Press.

Forget All the Rules You Ever Learned About Graphic Design. Bob Gill. New York: Watson-Guptill.

Graphic Design Manual. Armin Hofmann. New York: Van Nostrand Reinhold.

The Grid. Allen Hurlburt. New York: Van Nostrand Reinhold.

Layout. Allen Hurlburt. New York: Watson-Guptill.

Living by Design. Pentagram. New York: Watson-Guptill.

Magazine Design. Ruari McLean. New York: Oxford University Press.

Milton Glaser. New York: J. M. Folon.

Publication Design. Allen Hurlburt. New York: Van Nostrand Reinhold.

Symbol Source Book. Henry Dreyfuss. New York: McGraw-Hill.

Thoughts on Design. Paul Rand. New York: Van Nostrand Reinhold.

Type Sign Symbol. Adrien Frutiger. Zurich: ABC Edition.

Film

Film Form. Sergei Eisenstein. New York: Harcourt Brace Jovanovich.

Professional Fashion Photography. Robert Farber. New York: Amphoto.

The Technique of Film Editing. Karel Reisz. New York: Hastings House.

Periodicals

Advertising Age
Crain Communications, Inc.
740 Rush Street
Chicago, IL 60077

Design Quarterly
Walker Art Center
Vineland Place
Minneapolis, MN 55403

Communication Arts
410 Sherman Avenue
Palo Alto, CA 94303

Graphis
CH 8008
Zurich, Switzerland

Print
355 Lexington Avenue
New York, NY 10017

TM
9001 St. Gallen,
Switzerland

U&lc
216 East 45 Street
New York, NY 10017

Visible Language
Cleveland Museum of Art
Cleveland, OH 44106

Production

Advertising Agency and Studio Skills. Tom Cardamone. New York: Watson-Guptill.

500 Years of Printing. S. H. Steinberg. London: Penguin.

Graphic Communication '80s. Edward M. Gottschall. Englewood Cliffs: Prentice-Hall.

Graphic Designer's Production Handbook. Norman Sanders. New York: Hastings House.

Papermaking Through 18 Centuries. Dard Hunter.

Pasteups & Mechanicals. J. Demoney and S. Meyer. New York: Watson-Guptill.

Photographing for Publication. Norman Sanders, New York: R.R. Bowker.

Pocket Pal. International Paper Company. New York.

Production for the Graphic Designer. James Craig. New York: Watson-Guptill.

A Study of Writing. I. J. Gelb. Chicago: University of Chicago.

Promotion

Printing and Promotion Handbook. D. Melcher and N. Larrick. New York: McGraw-Hill.

Reference Books

Art Career Guide. Donald Holden. New York: Watson-Guptill.

The Creative Black Book
Friendly Publications, Inc.
401 Park Avenue South
New York, NY 10016

Literary Market Place
R. R. Bowker Company
1180 Avenue of the Americas
New York, NY 10036

Magazine Industry Market Place
R. R. Bowker Company
1180 Avenue of the Americas
New York, NY 10036

National Association of Schools of Art
11250 Roger Bacon Drive #5
Reston, VA 22090

Standard Directory of Advertising Agencies
National Register Company
866 Third Avenue
New York, NY 10022

Standard Rate & Data Service
McGraw-Hill Publications Company
1221 Avenue of the Americas
New York, NY 10020

U.S. Book Publishing Yearbook and Directory
Knowledge Industry Publications, Inc.
701 Westchester Avenue
White Plains, NY 10604

Typography

Asymmetric Typography. Jan Tschichold. New York: Reinhold.

Calligraphic Lettering. Ralph Douglass. New York: Watson-Guptill.

Design with Type. Carl Dair. Toronto: University of Toronto.

Designing with Type. James Craig. New York: Watson-Guptill.

Manuale Typographicum. Hermann Zapf. Cambridge: The MIT Press.

Phototypesetting: A Design Manual. James Craig. New York: Watson-Guptill.

Pioneers of Modern Typography. Herbert Spencer. London: Lund Humphreys.

Printing Types: Their History, Forms, and Use. 2 Vols. Cambridge, Mass.: The Belknap Press of Harvard University.

Type and Typography. Ben Rosen. New York: Van Nostrand Reinhold.

Typography. Emil Ruder. New York: Hastings House.

Writing and Editing

The Basics of Copy. Ed McLean. Rhinebeck, NY: The Newsletter Clearinghouse.

Dictionary of Contemporary American Usage. Bergen Evans. New York: Random House.

Editing by Design. Jan V. White. New York: R. R. Bowker.

Elements of Style. W. Strunk, Jr., and E. B. White. New York: The Macmillan Company.

Freelance Writing: Advice from the Pros. Curtis Casewut. New York: Collier Books.

Guidelines for Equal Treatment of the Sexes. New York: McGraw-Hill.

A Manual of Style. Chicago: University of Chicago Press.

Simple and Direct. Jacques. New York: Harper and Row.

CREDITS

The illustrations in this book are reproduced courtesy of the following individuals, companies, and organizations:

Pages 13/14
1. Joseph E. Seagram & Sons, Inc.
2. Courtesy The Coca-Cola Company
3. *Fortune* magazine
4. Bob Gill from *Forget All the Rules You Ever Learned About Graphic Design*

Pages 14/15
1. Seymour Chwast
4, 5. Reproduced with the permission of Johnson & Johnson Baby Products Co., 1983
1–5. All courtesy Eastman Kodak Co.

Pages 20/21
1–3. Courtesy Wendell Minor and Alfred A. Knopf, Inc.
4. Jacket design by Jurek Wajdowicz: Prentice-Hall, publisher
5–7. Jacket designs courtesy Chermayeff & Geismar Associates

Pages 22/23
1–4. Courtesy the New York Institute of Technology Computer Graphics Laboratory

Pages 24/25
1–4. Courtesy the New York Institute of Technology Computer Graphics Laboratory
2–3. Courtesy Digital Effects, Inc.
4. Designed by Nigel Holmes, copyright Time, Inc.

Pages 26/27
1–6. Courtesy IBM Corporation

Pages 28/29
1. Designed by Joe Watson
2–4. Designed by Chermayeff & Geismar Associates
5. Designed by Alan Peckolick, hand-lettered by Tony Di Spigna for Antonovich, Inc.
6. Designed by Patricia Noneman

Pages 30/31
1. Courtesy Chermayeff & Geismar Associates
2. Designed by Eli Kince
3. Designed and illustrated by Seymour Chwast for the Brooklyn Children's Museum

4. Designed by Gordon Salchow
5. Designed by Eileen H. Schultz and illustrated by Bob Peak
6. Illustrated by Seymour Chwast for Push Pin Graphics #73

Pages 32/33
1–9. Designed by Chermayeff & Geismar Associates

Pages 34/35
1–4. Courtesy Rudolph de Harak & Associates, Inc.

Pages 36/37
1, 2. Courtesy Chermayeff & Geismar Associates
3, 4. Courtesy Rudolph de Harak & Associates, Inc.

Pages 38/39
1–3. Courtesy Cinema Products Corp.
4, 5. Courtesy Canon USA

Pages 40/41
1. Illustration by Marshall Arisman
2. Record jacket by Leslie Cabarga
3. Illustration by Kim Whitesides
4. Designed by Dave Epstein
5. Designed by Alexis Brodovitch

Pages 42/43
1. Designed by Henry Wolf
2. Designed by Robert Fillie, painting by John Stuart Ingle
3. Designed by Chermayeff & Geismar Associates

Pages 44/45
1–4. Designed by Robert Fillie
5–7. Designed by John Peter for *High Fidelity* magazine

Pages 46/47
1. Courtesy The Barton-Gillet Company
2. Designed by Eli Kince
3. Courtesy 3M Company
4. Courtesy Gibbs & Soell, Inc.
5. Designed by Cato Johnson, Inc.
6. Designed by John Noneman

Pages 48/49
1, 2, 4. Courtesy *The New York Times*
3. Designed by Jurek Wajdowicz
5. Designed by Ronn Campisi, reprinted courtesy *The Boston Globe*

Pages 50/51
1. Courtesy Joseph E. Seagram & Sons, Inc.
2. Designed by Dave Epstein
3, 4. Courtesy Revlon, Inc.
6. Courtesy The Coca-Cola Company

Pages 52/53
1. Courtesy Joseph E. Seagram & Sons, Inc.
2, 5. Designed by Chermayeff & Geismar Associates
3. Illustration and design by Seymour Chwast for Pushpinoff Productions
6. Courtesy 3M Company
7. Photograph by William Bevington

Pages 54/55
1. Photograph by Robert Farber from the book *Professional Fashion Photographer*, published by Amphoto Books
3. Photograph by Tony Spina for the *Detroit Free Press*
4. Designed by Robert Fillie, photography by Tom Okada

Pages 56/57
1–5. Designed by Rudolph de Harak & Associates, Inc.

Pages 58/59
1–3. Courtesy Chermayeff & Geismar Associates
4, 5. Courtesy Rudolph de Harak & Associates, Inc.
6. Designed by Adrien Frutiger

Pages 60/61
1. Designed by a Cooper Union student
2, 3. Designed by Tom Ockerse
4. Design by Adrien Frutiger from his book *Type, Sign, Symbol*

Pages 64/65
1. Courtesy Eberhard, Faber, Inc.
2. Calligraphy by Tom Kluepfel

Pages 66/67
1. Illustration by Ellen B. Kahn
2. Jacket designed by Brian Mercer
3. Logo designed by Eli Kince
4. Photograph courtesy Eastman Kodak Co.

Pages 70/71
2, 3. Photograph by William Bevington

Page 82
Ad designed for the Advertising Typographers Association

Page 92
1. Courtesy R. O. Blechman
2. Courtesy Lou Myers

Page 97
Courtesy Charles Schultz from *Peanuts* © 1960

Pages 104/105
1. Courtesy Ed Benguiat
2. Courtesy Betty Binns
3. Courtesy Pieter Brattinga

Pages 106/107
1. Courtesy Aaron Burns
2. Courtesy Cipe Pineles Burtin

Pages 108/109
1. Courtesy Seymour Chwast
2. Courtesy Dave Epstein
3. Courtesy Lidia Ferrara
4. Courtesy Colin Forbes

Pages 110/111
1. Courtesy Adrien Frutiger
2. Courtesy Allen Hurlburt

Pages 112/113
1. Courtesy Walter Kaprielian
2. Courtesy James Miho
3. Courtesy Tobias Moss

Pages 114/115
1. Courtesy Alan Peckolick
2. Courtesy Gordon Salchow

Pages 116/117
1. Courtesy Eileen Schultz
2. Courtesy Jack Tauss

Pages 118/119
1. Courtesy Weingart
2. Courtesy Henry Wolf

Page 123
1. Designed by Ivan Chermayeff

Page 125
1, 2. Logos designed by Roger van den Bergh

Page 127
Courtesy Milton Glaser

Page 129
1. Art director, Cipe Pineles Burtin; illustrator, Janet Anendola
2. Detail from poster by Eli Kince

Page 135
Illustrated by Elwood H. Smith, reproduced courtesy Pushpin Lubalin Peckolick

Page 140
Illustration by Uri Shulevitz

GLOSSARY

A

AA. Abbreviation of "Author's Alteration." It is used to identify any alteration which is not a PE (Printer's Error).

Account executive. Person responsible for speaking with clients, getting new accounts, and coordinating work between agency and client.

Acetate. Transparent plastic sheet placed over a mechanical for overlays.

Agate. Unit of measurement used in newspapers to calculate column space: 14 agate lines equal 1 inch.

Airbrush. Small pressure gun, shaped like a fountainpen, that makes tonal images by spraying paint or ink by compressed air.

Alignment. Arrangement of lines of type so that the ends of the lines appear even on the page; that is, flush left, flush right, or both.

Art. All original copy, whether prepared by an artist, camera, or other mechanical means. Loosely, any copy to be reproduced.

Art director. Supervisor of all aspects of creative production in an advertising agency or design studio.

Ascender. That part of the lowercase letter that rises above the body of the letter, as in *b, d, f, h, k, l,* and *t.*

B

Bad copy. Any manuscript that is illegible, improperly edited, or otherwise unsatisfactory to the typesetter. Most typographers charge extra for setting type from bad copy.

Baseline. Imaginary horizontal line upon which all the characters in a given line stand.

Bleed. Area of plate or print that extends ("bleeds" off) beyond the edge of the trimmed sheet.

Blow-up. Enlargement of copy: photograph, artwork, or type.

Blue line. Blue non-reproducible line image printed on paper showing the layout. Used for a stripping guide or for mechanicals.

Body size. Depth of the body of a piece of metal type measured in points.

Boldface. Heavier version of a regular typeface, used for emphasis. Indicated *BF.*

Bulk. Thickness of printing papers, measured by pages per inch (PPI).

Bull pen. Slang term that refers to the area within a design studio in which production work is done.

C

C. & s.c. Stands for *caps* and *small caps.*

Calligraphy. Elegant handwriting, or the art of producing such handwriting.

Camera-ready art. Copy assembled and suitable for photographing by a process camera.

Capitals. Also known as *caps* or *uppercase.* Capital letters of the alphabet.

Caption. Explanatory text accompanying illustrations.

Casting-off. Calculating the length of manuscript copy in order to determine the amount of space it will occupy when set in a given typeface and measure.

Centered type. Lines of type set centered on the line measure.

Character count. Total number of characters in a line, paragraph, or piece of copy to be set in type.

Character generation. In CRT phototypesetting, the projection or formation of typographic images on the face of a cathode ray tube.

Characters. Individual letters, figures, punctuation marks, etc., of the alphabet.

Characters-per-pica (CPP). System of *copyfitting* that utilizes the average number of characters per pica as a means of determining the length of the copy when set in type.

Client. Customer or patron; the person who pays the bills.

Composition. *See* Typesetting.

Compositor. A typesetter or typographer.

Comprehensive. More commonly referred to as a *comp.* An accurate layout showing type and illustrations in position.

Computer. Used in typesetting to store information and make the mathematical, grammatical, and typographic spacing and end-of-line decisions, i.e., hyphenation and justification.

Condensed type. Narrow version of a regular type.

Contact print. Photographic print made by direct contact as opposed to enlargements or reductions made by projection where there is no direct contact.

Continuous-tone copy. Any image that has a complete range of tones from black to white, such as photographs, drawings, paintings.

Contrast. Wide range of tonal graduations between highlights and shadows.

Copy. In design and typesetting, typewritten copy. In printing, all artwork to be printed: type, photographs, illustrations.

Copyfitting. Determining the area required for a given amount of copy in a specified typeface.

Copywriter. Person on a creative team who is responsible for the written portion of the message.

Corporate design. Usually refers to graphic design activity within a corporation. Often the primary task of a corporate designer is to monitor the corporate design image and maintain consistent standards.

Counter. Space enclosed by the strokes of a letter, such as the bowl of the a, d, etc.

Crop. To eliminate part of a photograph or illustration.

D

Deadline. Time beyond which copy cannot be accepted.

Definition. Degree of sharpness in a negative or print.

Delete. Proofreader's mark meaning "take out." Looks like this:

Descenders. That part of a lowercase letter that falls below the body of the letter, as in *g, j, p, q,* and y.

Didot. Typographic system of measurement used in the non-English-speaking world. Comparable to our point system.

Display type. Type that is used to attract attention, usually 18 point or larger.

Drop initial. Display letter that is inset into the text.

Dummy. Preliminary layout of a printed piece showing how the various elements will be arranged. It may be either rough or elaborate, according to the client's needs.

E

Editing. Checking copy for fact, spelling, grammar, punctuation, and consistency of style before releasing it to the typesetter.

Elite. Smallest size of typewriter type: 12 characters per inch as compared with 10 per inch on the pica typewriter.

Emulsion. In photographic processes, the photosensitive coating that reacts to light on a substrate.

End-of-line decisions. Generally concerned with hyphenation and justification (H/J). Decisions can be made either by the keyboard operator or by the computer.

Estimating. Determining the cost of a job before it is undertaken.

Exposure. In photography, the time and intensity of illumination acting upon the light-sensitive coating (emulsion) of film or plate.

Extended. Also called *expanded.* A wide version of a regular typeface.

F

Family of type. All the type sizes and type styles of a particular typeface (roman, italic, bold, condensed, expanded, etc.).

First proofs. Proofs submitted for checking by proofreaders, editors, etc.

Fit. Space relationship between two or more letters. The fit can be modified into a "tight fit" or a "loose fit."

Flop. To turn over an image so that it faces the opposite direction.

Flush left (or right). Type that lines up vertically on the left (or right).

Folio. Page number. Also refers to a sheet of paper when folded once.

Font. Complete assembly of all the characters (upper and lowercase letters, numerals, punctuation marks, points, reference marks, etc.) of one size of one typeface: for example, 10-point Garamond roman.

Freelancer. Designer who sells his or her creative services directly to others without middleman or organizational ties.

G

Galley proof. Also called a *rough proof.* A first proof of type that allows the typographer or client to see if it has been properly set.

Gigo. "Garbage in, garbage out." Programming slang meaning that bad input produces bad output.

Glossy. Photoprint made on glossy paper. As opposed to matte.

Grain. Direction of the fibers in a sheet of paper.

Gray scale. Series of density values, ranging progressively from white through shades of gray to solid black. Used in film processing to check the degree of development.

Grid. Means of layout and organization of the printed page. Plan of the grid is based on the specific size and style of type, and combinations of these type units.

H

Hairline. Fine line or rule; the finest line that can be reproduced in printing.

Hanging punctuation. In justified type, punctuation that falls at the end of a line is set just outside the measure in order to achieve optical alignment.

Hardware. In phototypesetting and the word-processing field, a term referring to the actual computer equipment, as opposed to the procedures and programming, are known as *software.*

Heading. Bold or display type to emphasize copy.

Headline. The most important line of type in a piece of printing, enticing the reader to read further or summarizing at a glance the content of the copy which follows.

Holding lines. Lines drawn by the designer on the mechanical to indicate the exact area that is to be occupied by a halftone, color, tint, etc.

Hung initial. Display letter that is set in the left-hand margin.

Hyphenation. Determining where a word should break at the end of a line. In typesetting, computers are programmed to determine hyphenation.

I

Identity manual. Notebook that shows standards of a graphic identification program for an organization or corporation.

Illustration. General term for any form of drawing, diagram, halftone, or color image that serves to enhance a printed piece.

Imposition. In printing, the arrangement of pages in a press form so they will appear in correct order when the printed sheet is folded and trimmed. Also, the plan for such an arrangement.

Indent. Placing a line (or lines) of type in from the margin to indicate the start of a new paragraph.

Input. In computer composition, the data to be processed.

Italic. Letterform that slants to the right: *looks like this.*

J

Justified type. Lines of type that align on both the left and the right of the full measure.

K

Kerned letters. Type characters in which a part of the letter extends, or projects, beyond the adjacent character.

Keyline. *See* Mechanical.

Kicker. Also called a *teaser.* A short line above the main line of a head, printed in smaller, or accent, type.

Kill. To delete unwanted copy.

L

Layout. Plan showing the basic elements of a design in their proper positions.

Lead-in. First few words in a block of copy set in a different, contrasting typeface.

Leading. (Pronounced *ledding.*) The space between lines of type: also called *linespacing* or *film advance.*

Legibility. That quality in type and its spacing and composition that affects the speed of perception: the faster, easier, and more accurate the perception, the more legible the type.

Letterfit. The quality of the space between the individual characters. Letterfit should be uniform and allow for good legibility.

Letterspacing. Adding space between the individual letters in order to fill out a line of type to a given measure or to improve appearance.

Line copy. Any copy that is solid black, with no gradation of tones: line work, type, dots, rules, etc.

Line drawing. Any artwork created by solid black lines: usually pen and ink. A drawing free from wash or diluted tones.

Ligature. Two or three characters joined, such as *ff, ffi, ffl, Ta, Wa, Ya,* etc.

Lightface. Lighter version of a regular typeface.

Linespacing. In phototypesetting, the term for *leading.*

Lithography. In fine art, a planographic printing process in which the image area is separated from the nonimage area by means of chemical repulsion. The commercial form of lithography is *offset lithography.*

Logotype. Commonly referred to as a *logo.* Two or more type characters which are joined as a trademark or a company signature.

Lowercase. Small letters, or minuscules, as opposed to caps.

M

Margins. Areas that are left around type and/or illustrative matter on a page: the top, bottom, and sides.

Markup. In typesetting, to mark the type specifications on layout and copy for the typesetter. Generally consists of the typeface, size, line length, leading, etc.

Masthead. Any design or logotype used as identification by a newspaper or publication.

Mean line. The line that marks the tops of lowercase letters without ascenders.

Measure. Length of a line of type, normally expressed in picas.

Mechanical. Preparation of copy to make it camera-ready with all type and design elements pasted on artboard.

Metric system. Decimal system of measures and weights with the meter and the gram as the bases. Here are some of the more common measures and their equivalents:

kilometer	00.6214 mile
meter	39.37 inches
centimeter	00.3937 inch
millimeter	00.0394 inch
kilogram	02.2046 lb.
gram	15.432 gr. (av.)
inch	02.54 cm.
foot	00.3048 meter
yard	00.9144 meter
pound	00.4536 kilogram

Minuscules. Small letters, or lowercase.

Minus linespacing. Also called *minus leading.* The reduction of space between lines of type so that the baseline-to-baseline measurement is less than the point size of the type.

N

Negative. Reverse photographic image on film or paper: white becomes black and black becomes white.

O

Offset lithography. Also called *photolithography* and, most commonly, *offset.* The commercial form of lithographic printing.

Outline. Typeface with only the outline defined.

P

Pasteup. *See* Mechanical.

PE. Abbreviation of "Printer's Error," or mistake made by the typesetter, as opposed to AA.

Photocopy. Duplicate photograph, made from the original. Also, the correct generic term for Photostat, which is a trade name.

Photostat. Trade name for a photoprint, more commonly referred to as a *stat*.

Phototypesetting. Also known as *photocomposition* and erroneously as *cold type*. The preparation of manuscript for printing by projection of images of type characters onto photosensitive film or paper.

Pi characters. Special characters not usually included in a type font.

Pica. Typographic unit of measurement: 12 points = 1 pica and 6 picas = 1 inch. Also used to designate typewriter type 10 characters per inch (as opposed to elite typewriter type, which has 12 characters per inch).

Point. Smallest typographical unit of measurement: 12 points = 1 pica. Type is measured in terms of points, the standard sizes being 6, 7, 8, 9, 10, 11, 12, 14, 18, 24, 30, 36, 42, 48, 60, and 72.

Portfolio. Collection of art and design pieces which document a student's class performance or a professional's work experience.

Positive. Photographic reproduction on paper, film, or glass that corresponds exactly with the original, as opposed to a negative, in which the tonal values are reversed.

Preparation. Also called *prep work*. In printing, all the work necessary in getting a job ready for platemaking: preparing art, mechanicals, camera, stripping, proofing.

Printer's error. *See* PE.

Process camera. Also called a *copy camera* or a *graphic arts camera*. A camera specially designed for process work such as halftone-making, color separation, copying, etc.

Proofreader. Person who reads the type that has been set against the original copy to make sure it is correct and who also may read for style, consistency, and fact.

Proofreader's marks. Shorthand symbols employed by copyeditors and proofreaders to signify alterations and corrections in the copy.

Proofs. Trial print or sheet of printed material that is checked against the original manuscript and upon which corrections are made.

R

Ragged. *See* Unjustified type.

Reflection copy. Also called *reflective copy*. Any copy that is viewed by light reflected from its surface: photographs, paintings, drawings, prints, etc. As opposed to transparent copy.

Register marks. Devices, usually a cross in a circle, applied to original copy for positioning negatives in perfect register.

Reproduction proof. Also called a *repro*. A final, corrected proof to be pasted into mechanicals.

Reverse type. Type that drops out of the background and assumes the color of the paper.

Revise. Change in instruction that will alter copy in any stage of composition.

Rough. Sketch or thumbnail, usually done on tracing paper, giving a general idea of the size and position of the various elements of the design.

Rule. Black line, used for a variety of typographic effects, including borders and boxes.

Ruling pen. Mechanical drawing instrument for making even weight fine lines.

Run-around. Type in the text that runs around a display letter or illustration.

S

Sans serif. Typeface design without serifs.

Scaling. Process of calculating the percentage of enlargement or reduction of the size of artwork to be enlarged or reduced for reproduction.

Screen printing. Formerly called silk screen printing, this process refers to forcing ink through an open area in a piece of silk stretched on a frame. Excellent for printing bright, flat colors in limited editions.

Serifs. Short cross-strokes in the letterforms of some typefaces.

Show-through. Phenomenon in which printed matter on one side of a sheet shows through on the other side.

Software. Computer programs, procedures, etc., as contrasted with the computer itself, which is referred to as *hardware*.

Solid. In composition, refers to type set with no linespacing between the lines.

Spacing. Separation of letters and words in type or the separation of lines of type by insertion of space.

Spec. To specify type or other materials in the graphic arts.

Square halftone. A rectangular—not necessarily square—halftone, i.e., one with all four sides straight and perpendicular to one another.

S.S. Also indicated as *S/S*. Abbreviation for "same size."

Stat. *See* Photostat.

Stet. Proofreader's mark that indicates copy marked for correction should stand as it was before the correction was made.

Storyboard. Rough presentation of scenes to be filmed for a TV commercial. Usually done with markers.

T

Text. Body copy in a book or on a page, as opposed to the headings.

Text type. Main body type, usually smaller in size than 14 point.

Thumbnails. Small, rough sketches.

Tint. Color obtained by adding white to solid color. In printing, a photomechanical reduction of a solid color by screening.

Transfer type. Type carried on sheets that can be transferred to the working surface.

Trim. To cut off and square the edges of a printed piece or of stock before printing.

Trim size. Final size of a printed piece, after it has been trimmed.

T-square. Mechanical drawing tool used with a drawing board and other aids to make certain the image is straight or "square" and that parts of the image are aligned properly.

Type family. Range of typeface designs that are all variations of one basic style of alphabet. The usual components of a type family are roman, italic, and bold. These can also vary in width (condensed or extended) and in weight (light to extra bold). Some families have dozens of versions.

Type gauge. Commonly called a *line gauge*. A rule with calibrated picas and inches. These are used to gauge the number of lines set in a given type size; they are also useful for copyfitting.

Typesetting. Refers to type set by hand, machine (cast), typewriter (strike-on), and phototypesetting.

Typestyle. Variations within a typeface: roman, italic, bold, condensed, expanded, etc.

Typographer. Person or persons who set type.

Typographic errors. Commonly called *typos*. Errors made in copy while typing.

Typography. The art and process of working with and printing from type.

U

U. & L.C. Also written *u/lc*. Commonly used abbreviation for upper- and lowercase.

Unjustified type. Lines of type set at different lengths which align on one side (left or right) and are ragged on the other.

Uppercase. Capital letters of a type font: A, B, C, etc.

W

Weight. In composition, the variation of a letterform: light, regular, bold. In paper measurement, the weight of 500 sheets (a ream) of paper of standard size.

Widow. End of a paragraph or of a column of reading matter that is undesirably short: a single, short word; or the end of a hyphenated word, such as "ing."

Wordspace. Space between words.

X

X-height. Height of the body of lowercase letters, exclusive of ascenders and descenders.

INDEX

Additional Names and Addresses

Company

Address

City/State/Zip

Telephone

Name

Title

Company

Address

City/State/Zip

Telephone

Name

Title

Company

Address

City/State/Zip

Telephone

Name

Title

Company

Address

City/State/Zip

Telephone

Name

Title

Company

Address

City/State/Zip

Telephone

Name

Title

Company

Address

City/State/Zip

Telephone

Name

Title

Company

Address

City/State/Zip

Telephone

Name

Title

Company

Address

City/State/Zip

Telephone

Name

Title

Company

Address

City/State/Zip

Telephone

Name

Title

Company

Address

City/State/Zip

Telephone

Name

Title

Company

Address

City/State/Zip

Telephone

Name

Title

Company

Address

City/State/Zip

Telephone

Name

Title

Company

Address

City/State/Zip

Telephone

Name

Title

Company

Address

City/State/Zip

Telephone

Name

Title

Company

Address

City/State/Zip

Telephone

Name

Title

Company

Address

City/State/Zip

Telephone

Name

Title